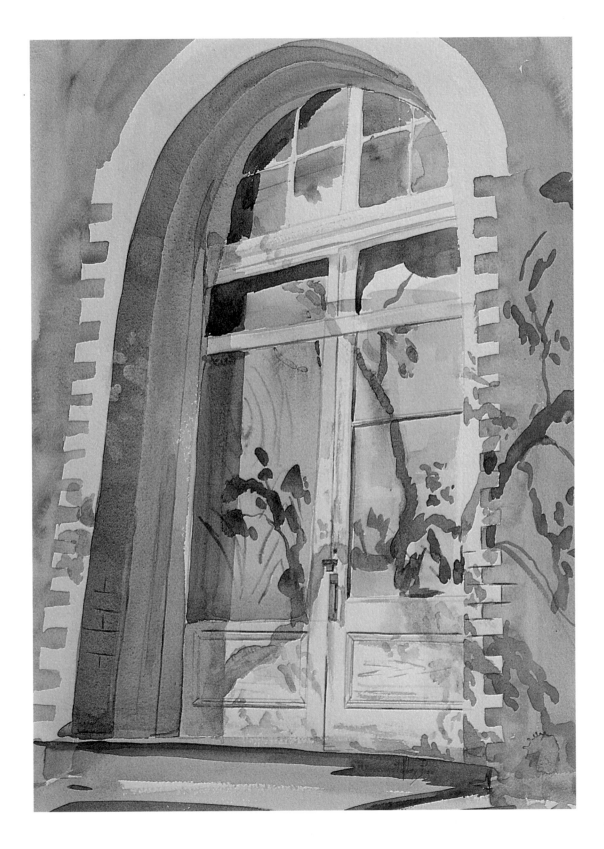

WATERCOLOR RIGHT FROM THE START

Progressive Lessons in Seeing and Painting

HILARY PAGE

WATSON-GUPTILL PUBLICATIONS/NEW YORK

Watercolor Right from the Start is dedicated to my students past, present, and future, for whom it is written and without whom it would not have been written.

ACKNOWLEDGMENTS

I gratefully acknowledge the following people, each of whom played an essential part in enabling me to create this book:

My mother for setting the painting example. Mrs. Drummond-Hay for her inspiring, encouraging teaching at Leelands Preparatory School in England. Bob Donahue at Advertiser's Studio in Indianapolis for getting me started. Artist-teacher Jose Perez for showing me a rational approach to drawing and painting and introducing me to the writing of Robert Beverly Hale.

Marilyn Wennermark for her professional advice and review of the text. Dr. Cynthia Young for her botanical expertise. Stephanie Spragins for her insightful, artistic perceptions.

The professional artists and students, both those whose work is included and those whose work could not be included because of space constraints, for their willingness to share their paintings.

M. Stephen Doherty, Editor-in-Chief of *American Artist* magazine. The staff at Watson-Guptill Publications, including Marian Appellof, Senior Editor; Areta Buk, Designer; Candace Raney, Senior Editor, for her expeditious decision and her enthusiasm and encouragement for the book; and Mary Suffudy, Executive Editor.

My husband, Norman, for his expert evaluation and advice on technical information, for his rational review of the text, and for his wonderful support and encouragement throughout the project.

Art on half-title page:
SHADOWED DOOR, 22 × 15" (55.9 × 38.1 cm), collection of Dianne and Matt Reiff.

Art on title page:
ROADSIDE SUNSHINE, 28 × 41" (71.1 × 104.1 cm).

First published in 1992 in the United States by Watson-Guptill Publications, a division of BPI Communications, Inc., 1515 Broadway, New York, New York 10036

Library of Congress Cataloging-in-Publication Data

Page, Hilary.
 Watercolor right from the start : progressive lessons in seeing and painting / Hilary Page.
 p. cm.
 Includes index.
 ISBN 0-8230-5688-0
 1. Watercolor painting—Technique. I. Title.
ND2420.P26 1992
751.42'2—dc20 92-17440
 CIP

Manufactured in Singapore

1 2 3 4 5 / 96 95 94 93 92

Contents

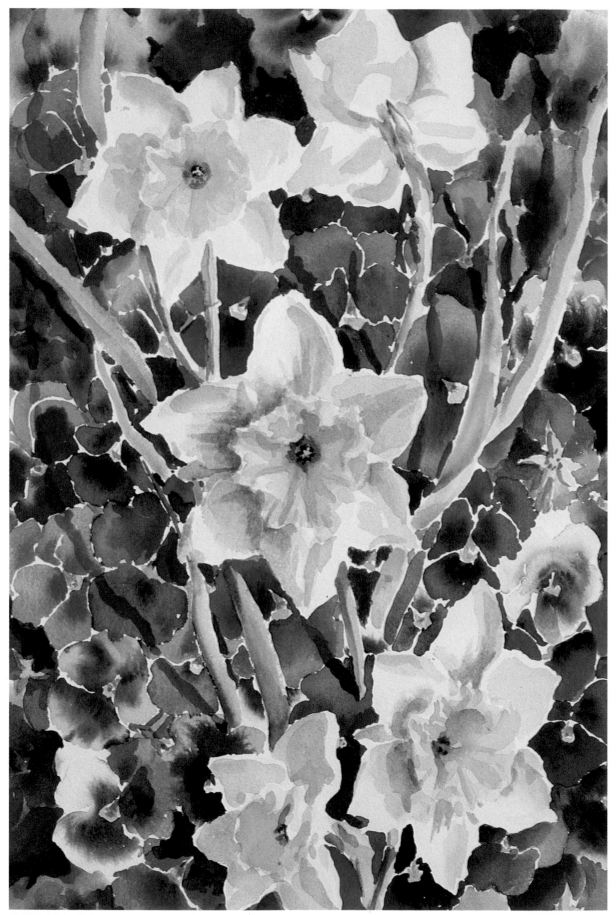

PANSIES AND DAFFODILS, 22 × 15" (55.9 × 38.1 cm).

Introduction

Watercolor Right from the Start is more than a book providing technical information about drawing and watercolor. It is an in-depth study of seeing, presented in a way that makes quite complex concepts easy to understand. As such it can be used as a reference for the experienced artist, as a manual for teachers, as a study program for the "rusty" painter, and as a complete course for beginners who want to learn drawing and watercolor and get it right—from the start.

The information presented is based on the belief that anyone who so desires can learn to paint in a unique way if provided with a well-rounded course of instruction that encompasses the following three aspects: learning how to see, to increase visual awareness of any subject whether it is recognizable or abstract; gaining hands-on practice with materials and techniques and thus developing necessary technical expertise and confidence with the medium; and understanding composition. It is assumed that, by definition, creativity cannot be taught.

Knowledge and skills, once acquired, practiced, and mastered, have to be laid aside and stored in the unconscious. Then the informed artist can be free to create truly original paintings. Just as a musician must first master the technical aspects of his instrument to be able to express the music's soul in performance, so, too, must a visual artist assimilate the technical knowledge that will allow him the freedom to conceptualize and interpret the spirit of his subject.

Beyond technical information is the spirit of painting, which enables the artist, both student and professional, to enter into the spatial and timeless aspects of his being and emerge from the experience feeling renewed and refreshed. Frequently students come to me and ask, "Do I have the talent to paint? Is it worth my while to continue?" To reply to such a question would be, I believe, presumptuous. Time and again I have observed that those who have the desire to find their unique form of artistic expression do so regardless of that ephemeral quality known as talent. If you have to paint, you have to paint. That is what makes art. That is what art is all about.

HOW THE BOOK IS ORGANIZED

Watercolor Right from the Start consists of nine chapters. The first two chapters acquaint the reader with the tools of the trade and basic watercolor techniques. The next six chapters explore how light, shadow, and color behave on the basic geometric forms from whose surfaces all three-dimensional subjects are derived. The basic forms are the sphere, the cylinder, and the cube; their derivatives are the ovoid, the cone, and the pyramid. Each of these chapters contains a series of lessons that instruct the reader in the characteristics of form while simultaneously presenting information on drawing, watercolor techniques, composition, and other aspects of the medium. Every lesson contains a practical application of that information in the form of a step-by-step demonstration. The final chapter focuses on composition and on how to utilize elements and principles of design to convey artistic ideas effectively.

HOW THE LESSONS ARE ORGANIZED

Lessons are arranged in carefully programmed series that start with relatively simple concepts and subjects and progress toward the more complex. A visual study of the geometric form is included in each lesson and is accompanied by diagrams and unusual photographs of models that clearly illustrate the concepts presented. In the demonstrations, observations of the geometric form are applied to man-made or natural subjects based on that form. Reference photographs of these subjects are provided for convenience, though it is it strongly recommended that readers work from their own material where possible.

Instructions are clearly presented so readers can easily draw and paint along with the demonstration, thus gaining experience. How to work with composition to make a dynamic statement is referred to in each lesson but is not the main focus.

HOW TO USE THE BOOK

Although it is preferable to work through the material in the sequence presented in the book, for the sake of variety, readers may choose their own progression, as long as it is systematic and takes into account the fact that the first lessons of a chapter are simpler than the latter ones. It is suggested that beginners start with some lessons on techniques before progressing to the lessons on form. Upon completion of all lessons, readers will have the essential background information necessary to compose their own truly creative watercolor paintings.

MATERIALS AND METHODOLOGY

We'll begin our venture into watercolor right from the start with a general survey of materials and basic information you will need to work through the book. Here you'll also find an overview of the watercolor process. Terminology will become clear as you progress.

First let's make sure you have the best and most cost-efficient materials for the projects at hand. I have found from experience that correct supplies forestall frustration; thus I am fairly specific in describing what you need. The lists of basic supplies for both drawing and watercolor are minimal. I list additional supplies because they are useful but not essential for completing the lessons.

DARTMOOR SPRING, 11 × 15" (27.9 × 38.1 cm).

Drawing Materials

The various kinds of drawing we shall cover include line drawing, creative and representational value sketches, and linear perspective. The materials listed here are limited to those needed for drawing as preparation for watercolor painting. All of the watercolor lessons require some drawing; a few additional lessons are on drawing alone. Drawing doesn't require much equipment. Here's what you will need:

- 11 × 14" spiral sketchbook
- 6B graphite sticks for value sketches
- 6B graphite pencil for details on value sketches
- 3B pencil for line drawings
- Nib or fountain pen with black ink for sketching
- Kneaded eraser
- Tissues to rest your hand on when making a value sketch
- Visualizing mats or mat corners to match the proportions of your painting area

In addition, you may wish to have on hand such extras as prepared acetate, a magnifying glass, and geometric forms (handmade or from an art supply store) of a sphere, cylinder, cube, ovoid, cone, and pyramid.

A visualizing mat, or viewing mat, is a mat with a small rectangular opening proportionate to your painting area. You use it as a frame through which to view your subject, and then visualize how the subject can appear on your paper. If, for example, you're working on watercolor paper that measures 22 × 30"—a standard full-size sheet—or on a quarter sheet (11 × 15"), your visualizing mat will ideally have an opening of 3 × 4". If you're working on a half (22 × 15")

or an eighth (11 × 7 ½") sheet of paper, your visualizing mat should have an opening of 4 × 2 ¾". The importance of the visualizing mat will become clear to you as you work through the drawing and painting lessons. You will need it with you at all times.

When you draw, hold your sketchbook upright. If you don't have an easel it works all right to rest your sketchbook on your lap with the back propped up against the table. Attempting to draw a subject with your sketchbook flat on the table results in distortion.

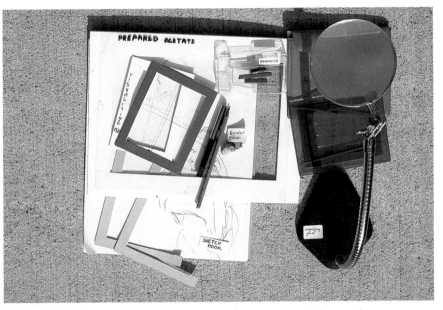

Drawing doesn't require a lot of equipment. Shown here are the basics plus a few extras.

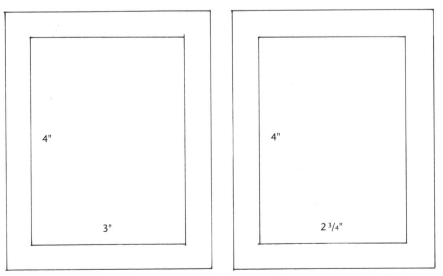

If you're working on a full or a quarter sheet of watercolor paper, use a visualizing mat with an opening that measures 3 × 4". For half or eighth sheets, the mat opening should measure 4 × 2 ¾".

Painting Materials

The watercolor materials listed are those you will need to complete the lessons. These include, naturally, paints, brushes, and paper, plus a few other essential implements. I recommend a minimal number of paint colors for beginning students and a broader list for students who want more options.

PAINTS

Watercolor paint as we know it today consists of pigment, a powdered substance that imparts a specific color, suspended in an aqueous vehicle, usually gum arabic, that binds it to the paper. To the pigment and gum arabic mixture are added preservative, wetting agent, and a moisturizer such as glycerin or honey.

Buying watercolor paints requires that you know the colors and their confusing and seemingly inconsistent nomenclature. No standardization exists; color names and handling qualities vary from manufacturer to manufacturer. For this reason, in some instances I specify paint brand or chemical composition. Pigments are selected for their suitability for the various watercolor procedures described in the book, and on the basis of these important characteristics:

- *Hue* is the color you see—red, blue, green, and so on—which is determined by the length of light waves a pigment reflects when applied to white paper.
- *Value range* means the range of light, irrespective of color, that a pigment can reflect off the paper surface. Value refers to relative lightness or darkness; on a scale ranging from zero to ten, zero is white and ten black. All watercolors can be diluted with water so that when applied to white paper they appear very light. However, when applied at full strength, some pigments, such as yellows, will always reflect a lot of light and can never be dark no matter how thickly you apply them. Thus yellows are said to have a limited value range. Prussian blue, on the other hand, has a wide value range, since it can also appear extremely dark when applied full strength. Understanding value range is important when it comes to choosing colors suited to specific subject matter.
- *Consistency* pertains to whether the pigment is transparent or opaque, smooth or sedimentary, or somewhere in between.
- *Working characteristics* refer to how the pigment acts when applied—whether it stains or lifts easily from the paper, and whether it spreads or sits still when applied to wet paper.

COLORS AND THE COLOR WHEEL

The color wheel is a circular arrangement of colors relative to their order in the spectrum and showing various relationships. The illustration below shows where the recommended colors described in the following pages are positioned on the wheel. Here, each color has been painted dark on the outside and light in the middle to indicate value range. Colors placed on the inside of the circle are more neutral (less bright) than those on the outside and/or have a wide value range, meaning that they can appear extremely dark. Black, which has the widest value range and is most neutral (reflects the least color), is placed in the center. Colors on the extreme outside have an especially light value range.

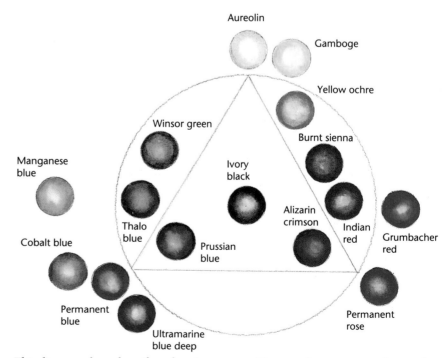

This diagram shows how the colors I recommend for use relate to one another on the color wheel. Their value range (lightness to darkness) is also indicated.

THE TWELVE-COLOR PALETTE

I recommend twelve basic professional-quality pigments. I do not specify brand when there is no particular difference between one and another.

- *Aureolin* (Winsor & Newton), or cobalt yellow, is a "balanced" yellow hue, meaning that when mixed with blues it will make bright greens and when mixed with rose pigments it will make bright reds. Aureolin is easy to use wet-on-wet because it does not spread uncontrollably. The pigment lifts readily when rewet and wiped off.

- *Gamboge* (arylide) is a less "red" yellow than most other synthetic gamboge hues on the market, and thus it mixes with rose to make reds and with blues to make naturalistic greens. It is a transparent staining pigment that will not lift when rewet, so it works well for glazing or layered washes.

- *Permanent blue* (Winsor & Newton) is actually a variety of ultramarine, though is less purple than other ultramarines and thus more "balanced," meaning that it mixes well with yellows to make bright greens as well as with rose pigments to make bright violets. It is slightly sedimentary, stains the paper, and spreads when applied wet-on-wet.

- *Prussian blue* is a very slightly neutral (not bright) and yellowish blue. It has a very wide value range (1–9.5), so if you need deep hues, Prussian blue is a good choice. It is smooth, staining, and will not lift when rewet. Phthalocyanine (phthalo) blue is similar, but Prussian blue is easier to handle, which is why I recommend it for beginning watercolorists.

- *Cobalt blue* is a luminous, transparent, light blue with a value range of 1–6. It contains some sediment, is manageable when used wet-on-wet, and once applied will not lift from the paper.

- *Manganese blue* is a transparent, turquoise blue, unique because of its highly granular consistency. Its value range is 1–6.

- *Winsor green* (Winsor & Newton) is a bluish green with a value range of 1–9. Unlike other phthalocyanine greens, it will lift from the paper when rewet, which makes it relatively easy to use.

- *Permanent rose* (Winsor & Newton) is an intense, "balanced" rose hue with a moderate value range of 1–6. It mixes with yellows to produce bright reds, and with blues to produce bright violets. The rose dye (quinacridone) is fixed, as is the case with all so-called dye pigments, to a transparent substrate. The inert pigment gives this paint an interesting and slightly granular effect. It works well when applied wet-on-wet. It will not lift.

- *Alizarin crimson* (dihydroxy-anthraquinone) is a transparent, slightly neutral, deep crimson with a value range of 1–9, making it invaluable for dark hues. To be totally lightfast, like many red synthetic organic "dye" pigments, it must be applied relatively thickly or mixed or glazed with other pigments. It stains the paper, and spreads wildly if used wet-on-wet. An alizarin crimson hue (quinacridone and napthol) is perfectly acceptable and is in fact more lightfast than regular alizarin crimson.

- *Grumbacher red* (Grumbacher) is a bright red staining pigment. If you want to economize, you can mix this hue from permanent rose and gamboge; just make sure you mix enough to cover the area you're painting, as it's very hard to get an exact match if you run out.

- *Burnt sienna* is a reddish-brown earth pigment that contains some sediment. It creeps when applied wet-on-wet, which can sometimes make interesting effects. Once applied, it will not lift.

- *Ivory black* as manufactured from charred bones is slightly granular and has a brownish cast. Though used infrequently, it is good for deepening night sky and land colors.

Additional Colors. The paints listed here are not essential for the lessons, but are interesting to try.

- *Ultramarine blue deep* (Holbein) is a purplish blue containing a great deal of sediment. This color can be most attractive when applied wet-on-wet.

- *Indian red* is a very deep, neutral, bluish-red pigment made of red iron oxide. It contains a great deal of sediment, which makes it ideal for portraying textured landscapes. Although the hue can be matched by mixing primary colors, the sedimentary quality cannot be duplicated.

- *Yellow ochre* is a sedimentary, neutral yellow earth pigment.

- *Thalo blue* (Grumbacher), a phthalocyanine blue, is an intense, transparent dye color resembling manganese blue but with a much wider value range (1–9). It is well balanced and will mix with yellows to make bright greens and with rose to make bright mauves. Thalo blue is so powerful that beginners may have problems handling it, but it is very versatile and useful to include in your palette.

PALETTE SYSTEM

Too often students come to me with a large palette whose wells are filled with messy, sometimes dried-out blobs of nameless paint. Probably a throwback to the oil-painting tradition of squeezing paints onto

For palettes I prefer using sealable, Tupperware-type round plastic containers with a plastic soda-bottle cap glued onto the back as shown.

the palette from tubes, this method is unsatisfactory with watercolor tube paints because they are not manufactured to work properly once they've dried out and have to be remoistened.

A more practical system is the one I use, consisting of sealable, round white plastic containers—Tupperware hamburger freezer containers are perfect—with a plastic bottle cap glued to the back of each near an edge, making it tilt to facilitate mixing. I use the caps from two-liter-size plastic soda bottles, attaching them with super glue. Each container, or "palette," contains either a single pigment or a specific mixture of pigments you need for a given painting; a painting may call for as few as one to as many as five or more such palettes. The size of these containers is adequate for most paint applications on a full sheet of watercolor paper.

WATERCOLOR PAPER

I recommend Arches 140-lb. cold-pressed or rough paper and, for one of the lessons, Arches 140-lb. hot-pressed (smooth) paper. Arches paper is 100 percent rag and pH neutral, meaning that it is of archival quality. It is manufactured with sizing—a type of glue—which controls absorbency and makes this paper particularly easy to use. Arches paper takes plenty of punishment such as scrubbing, scraping, and wiping, and neither masking fluid nor masking tape damages it.

A standard full-size sheet of Arches paper measures 22 × 30". To complete the lessons you will need to cut full sheets into halves, quarters, eighths, or whatever size is appropriate for your subject. I do not use "blocks" of watercolor paper because they are sealed at the edges, meaning that the paper will buckle when wet, since it cannot expand. For this same reason I don't recommend taping paper to your board.

There are many other fine papers on the market, and it is useful to experiment with them to see which ones best fit your style of painting. I sometimes use Arches 300-lb. rough paper, which makes washes lay on very smoothly. The 200-lb.-weight Waterford cold-pressed paper is

reasonably sturdy but does not allow you to lift paint from the surface. Whatman cold-pressed paper, which is very white and soft, is fine for a single wash and for wet-on-wet painting, but it does not take overlaying washes well. Hot-pressed illustration board allows a great deal of wiping off. Because this surface is rather slick, however, it takes practice to lay in a smooth wash.

BRUSHES

Like many artists hoping for astounding results, I have splurged and bought top-of-the-line kolinsky sable brushes. For most paint applications, though, a blend of synthetic and natural hairs is perfectly adequate. In fact, a less prestigious brush is more relaxing to work with, because you don't have to be so concerned about the cost of replacing it once the point wears down.

You will need variously sized flat and round brushes. Winsor & Newton's Sceptre series brushes, made from a blend of synthetic and natural hairs, have good working characteristics and are good value. There are many other fine synthetic-blend brushes on the market. Beginners and those working in a small format—1/4 sheet or less—can get along perfectly well with a minimal supply of brushes; most of the paintings in the demonstrations are done on paper this size. More experienced painters will need all the brushes listed.

For small paintings (less than 1/2-sheet size) you will need:
- 1" flat (synthetic-natural blend)
- #14 round (synthetic-natural blend)
- #8 round (synthetic-natural blend)
- #3 rigger (synthetic-natural blend)

- #1+ scrubber (synthetic; I recommend FolkArt)

For ½-sheet-size paintings you will need:
- #3 round (pure sable with fine point) or rigger
- 2" flat (bristle wash brush)
- 2" flat (nylon wash brush)
- #10 flat (sable; I recommend Raphael)

For full-sheet paintings you will need:
- 3" flat (white sable)
- 2"+ flat (squirrel hair; for blending colors on the paper)

ADDITIONAL MATERIALS AND EQUIPMENT

Beyond paints, palettes, paper, and brushes, you'll need a few other practical items. These are:

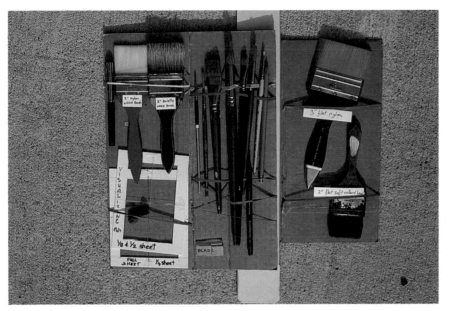

Here you see brushes and a few other pieces of painting equipment I recommend.

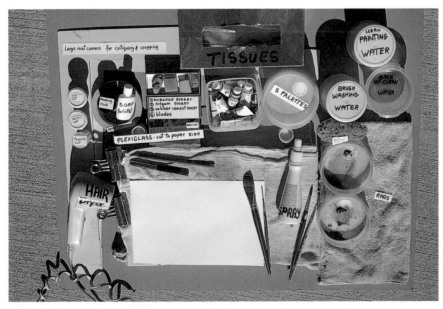

Additional equipment includes coarse salt, Plexiglas, clips, various kinds of erasers, hair dryer, spray bottle, water containers, tissues, rags, and sponges.

- ⅛"-thick Plexiglas board to place underneath paper. Boards should measure 12 × 16" for ¼-sheet or smaller paintings, 16 × 23" for ½-sheet paintings, 23 × 31" for full sheet. Ask for slightly damaged Plexiglas at your local frame shop for value.
- 3 water containers: one for painting, another for cleaning brushes, a third for backup. For large flat brushes, use a rectangular container so you can flatten the bristles on the sides as you squeeze out excess water.
- Rags for drying off your brush
- Cotton towels on which to lay wet watercolor paper
- Tissues for lifting paint off the paper
- Hair dryer to speed drying the paper between washes
- Wedges to tilt board when applying watercolor paint
- Natural sponge for wetting paper
- Spray mist bottle for rewetting paper
- Masking fluid, liquid (white) soap, and rubber cement eraser for preserving white paper
- Drafting tape for preserving white paper
- Art gum eraser for retrieving white paper
- Blades for scraping out and applying paint
- Margarita or fine rock salt for adding texture
- Clips to attach large paper to board
- Large mat corners to aid critiquing and cropping
- Pegboard painted with gesso for flattening completed work; 12 × 23", 16 × 23", and 23 × 31" sizes
- Weights, such as coffee cans filled with pennies, for flattening paintings
- Light table for transferring line drawings to watercolor paper

The Ten-Stage Painting Process

Each of the painting lessons in this book consists of several basic steps. Presented here is an overview of the process, from painting setup to signing the finished work.

Because many specific watercolor techniques, like the method for mixing colors or laying in a wash, are common to any number of paintings, I have chosen to describe such procedures in detail only where they first pertain rather than repeat them several times over throughout the book. These basic procedures appear in ruled boxes so that you can easily refer back to them should you need to refresh your memory. Additional technical information is given in all lessons. Every lesson but one calls for cold-pressed or rough paper.

1. PAINTING SETUP

For convenience arrange your water, palette, and rags on the right side of your board (left side if you're left-handed). The hair dryer can go on the opposite side. Brushes and extra paints also need to be so placed for easy access.

Place your work table near a window so your paper is lit by indirect, oblique light. For night work use a fluorescent or blue plant light rather than an incandescent lamp, which gives off a yellow light and thus distorts the way your colors appear. If you are able, it is preferable to stand while you paint so you have freedom of movement. If not, sit on a high chair so you can look down on your work. In many cases you can work at an upright easel, especially when you're painting on location. For more control it is best to lay your paper on a surface such as a Plexiglas board, tilting it slightly toward you.

Find a place where you can keep your painting paraphernalia out at all times. The kitchen table is usually not a good place because you constantly have to put everything away before you have finished. You might want to invest in an adjustable studio drawing table, but if you prefer not to, a card table is an inexpensive, easily stored alternative.

2. VALUE SKETCH

You have picked your subject and decided what appeals to you and what you want to convey in a painting; where do you go from here? The process starts as you jot down ideas in the form of a value sketch—a sketch in which you explore your subject in terms of its light and dark tones, and that you will use as a guide for your watercolor painting. A value sketch is usually executed in pencil or graphite. Future lessons will describe how to make "creative" and "representational" value sketches.

3. LINE DRAWING

The next stage is to make a line drawing, which can be a beautiful, expressive form of art in itself. For the purposes of this book, which is learning to draw as a precursor for watercolor painting, a line drawing is a light pencil outline of a subject to be portrayed. Until you become proficient enough to draw directly on the watercolor paper, you will need to make your line drawing on

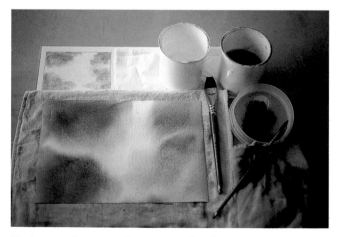

Basic setup for watercolor painting: brushes, water containers, palette, and rags to the right of your painting (to the left if you're left-handed), with your value sketch nearby for reference.

HOW TO TRANSFER A DRAWING

1. *Make your line drawing on sketchbook paper the same size as your watercolor paper and tape it to a window, light table, or improvised light table such as a lamp under a glass-top table.*
2. *Tape your watercolor paper on top of the line drawing; the lines will show through.*
3. *Lightly trace the lines onto your watercolor paper using a 3B pencil. If your painting is to be done in dark values in the wet-on-wet technique, or on hot-pressed paper in the wet-on-wet technique, you will need to make the lines relatively deep.*

sketchbook paper or, if your painting is to be large, on large-size tracing paper. This is to give you freedom to change your drawing as you develop it. You cannot erase a line from watercolor paper without damaging the surface. When the drawing is completed to your satisfaction you then transfer it to watercolor paper using the procedure described on page 14.

4. PRESERVE WHITES

You do not use white paint in transparent watercolor. Any white in a painting is the white of the paper. You have to make a decision not to paint those areas you wish to keep white—and must know exactly where they are to be before you start to paint. Besides just being careful there are two materials you can use to preserve and protect white paper. These are masking fluid (liquid latex) and drafting tape, both of which are applied to whatever parts of your image you do not want paint to cover. You can use regular masking tape, although it leaves a residue on your paper and thus must be removed very swiftly after application. For very thin lines you can use black line tape as used in commercial art. Your watercolor paper must be completely dry for you to apply any of these masking materials.

In the event that you paint over an area that you had wanted to keep white, you don't have to despair. There are ways of retrieving the white paper. One way is to use a hard scrubber brush to scrub paint off the paper. The other way is to use an art gum eraser to rub off paint. Both ways damage the surface of the paper, so make sure that you do not need to paint the area after all.

HOW TO PRESERVE WHITES WITH MASKING FLUID

1. *Before applying masking fluid, your paper must be totally dry.*
2. *Dip your brush (of the appropriate size for the area you have to cover) in liquid white soap, then wipe off excess soap.*
3. *Dip your brush in masking fluid and apply it to the paper in the designated areas.*
4. *Work for a short time, then wash your brush to prevent the masking fluid from hardening on it.*
5. *Repeat the brush-loading procedure and keep applying masking fluid until all areas you want masked are covered.*
6. *Throw out soapy water.*
7. *Proceed with the painting; you can paint directly over the mask.*
8. *Masking fluid can be removed when the paper is completely dry and when you don't need the white paper protected anymore. To remove, rub it with the pads of your fingers or use a rubber cement eraser.*

HOW TO PRESERVE WHITES WITH DRAFTING TAPE OR MASKING TAPE

1. *Apply drafting or masking tape to your watercolor paper over the area you want to keep white, overlapping edges of tape as little as possible so your pencil line drawing will still show through and so you won't have thick layers to cut through when you're done.*
2. *Use a sharp single-edge blade to cut the tape from around the area you are masking, guided by the lines of your pencil drawing. Carefully remove excess tape.*
3. *Press the tape down along all the edges of the area you have masked off so paint cannot seep through underneath.*
4. *Proceed with the painting.*
5. *Remove the drafting tape as soon as you don't need the area masked anymore.*

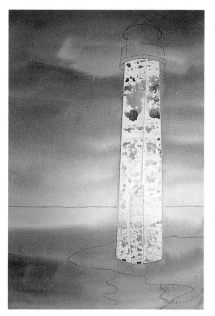

Drafting tape is used here to mask out the lighthouse to keep it white while the blue wash of the sky and water is laid in.

HOW TO RESTORE WHITES WITH AN ART GUM ERASER

1. *If you want a sharp edge to your white area, cut a very shallow line around it with a sharp blade.*
2. *On completely dry paper, "paint" with water the area you want lightened.*
3. *Wipe off surface water with a tissue.*
4. *Rub this area using your art gum eraser. This will lift off the paint.*

5. COLOR MIXING

Before you start to paint you need to mix your chosen colors. This sounds obvious, but you would be surprised at the number of painters who wet their paper in readiness for painting only to realize that they do not have their paints squeezed out, let alone mixed!

Difficulty with color mixing occurs when painters are unfamiliar with paints and do not know that each pigment has a different tinting strength—some are strong and deep, others are weak and light. This means that you need to squeeze out more of the weak pigments and less of the strong ones for an identical result. To help you master this, each lesson has an accompanying diagram to show you the proportions of each color you will need to make the correct mixtures for the painting in question. Usually you will have one palette for each color or mixture.

6. PAINT APPLICATION

The two principal methods of paint application in watercolor are to *lay in a wash* and *drop in paint*. In the context of watercolor a wash is a moving liquid carried along in a specific direction, like a wave washing to shore. A watercolor painting usually includes one or more washes. There are several types of watercolor washes, including wet-on-wet, wet-on-dry, flat (even-toned), and graded (dark to light or light to dark). To "lay in a wash" describes the action of applying a layer of watercolor on paper, covering either the entire surface or a predetermined section of the painting. To do this, you may need to agitate the brush a little to ensure that the paper is properly covered, using as few strokes as possible.

To "drop in paint" describes the action of touching prewet paper with a brush loaded with paint so the paper soaks it up. Again, you use as few brushstrokes as possible to transfer the paint to the paper.

7. DRY YOUR PAINTING

Many beginners ruin paintings because they continue to add paint to paper that is at the wrong state of dryness for the desired effect. Remember this rule: Once the shine has left the paper after the initial wash, do not add more paint or you will get watermarks or a muddy mess (unless you are deliberately attempting to make watermarks). You can add as many layers of paint as you want—but only so long as you lay them on dry paper. I have a catchy little rhyme that I say to my students: "When in doubt, dry it out." A hair dryer will greatly speed this process.

An essential component of watercolor painting is the ability to gauge whether or not your paper is

HOW TO MIX COLORS

1. Onto the higher section of your tilted palette, squeeze out the correct amount of each color needed as indicated in the palette diagram. If you work on larger paper (full or 1/2 sheets) you will need to squeeze out proportionately more of each pigment and mix with a greater amount of water.

2. Put about a teaspoonful of water (more for full- and 1/2-sheet-size paintings) in the lower part of the palette.

3. With your #8 brush drag the paint down into the water in the bottom of the palette and mix.

4. Leave some of the original blobs of paint unmixed.

5. If you are interrupted before you finish painting, seal the container to keep the paint fresh and moist.

6. When you have completed your painting, drain off unused mixed paint and clean off what remains of the original blob so it can be used again. Seal the palette if you want to save the paint.

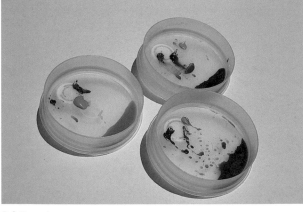

Palette system.

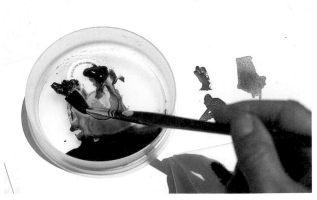

Method for mixing colors.

wet enough to continue laying in colors, or is dry enough to start laying in colors again. Here, at right, is a handy test.

8. CRITIQUE

When you decide you have finished your painting, especially before you share it with family and friends, you need to stand back from your work and look at it critically. One approach is to view your painting in a mirror so that the image is reversed, which makes you see it with fresh eyes so that anything that needs to be changed will be obvious to you. A second critiquing method is to surround your work with large mat corners. A large mat with an opening of 22 × 30" that has been cut into two equal sections can be adjusted to make mat openings of varying sizes, which you can place around your painting in various ways to see how well the image works within a frame. Often a composition is strengthened if you change the dimensions or crop a portion of it.

9. SIGN YOUR PAINTING

Sign your painting discreetly when you are satisfied that it is finished. I have seen paintings ruined by obtrusive signatures placed in the wrong position on the paper; thus, I describe at right an approach that will help you avoid this problem.

10. FLATTEN YOUR PAINTING

Your finished painting will probably be buckled and wavy. To improve its appearance and make it ready for matting and framing, you'll need to flatten it. Follow the simple method described here.

HOW TO TEST PAPER FOR DRYNESS

1. *Once the shine has gone from your paper, lay the back side (nail side) of your middle fingers on the area you are testing for dryness.*
2. *Decide whether the paper feels warm or cool. If the paper feels cool, it still contains some moisture and is not dry. Often the paper does not have to be completely dry for you to continue. If the paper feels warm (taking into account the fact that you may have just dried it with a hair dryer), then the paper is dry enough for you to rewet the surface and continue to lay in pigment.*

HOW TO SIGN YOUR PAINTING

1. *A usual place to sign is in the lower right-hand corner. Sometimes, however, the composition may determine that the left-hand corner would be a more appropriate spot.*
2. *Do not sign right at the edge of the watercolor paper; leave enough space to accommodate a mat.*
3. *Render your signature in paint applied with a very fine pointed brush. You do not want your name to be obtrusive. Practice signing your name on scrap watercolor paper. Use a pencil if you are not confident with a brush.*
4. *Some artists add the year and, for copyright protection, the copyright symbol © after their name. Dating a painting on the front gives it a vintage, which can be a problem if you are selling your work. Placing the date on the back instead will give you a record yet keep your paintings current.*

HOW TO FLATTEN A FINISHED PAINTING

1. *Lay your dry painting face down on an old towel.*
2. *Use a sponge or brush to lightly moisten the back of the painting all over.*
3. *Lay your painting, which will probably be curling because of the damp back, face down on clean white paper placed on a flat surface.*
4. *Lay a gessoed pegboard face down on top of the watercolor; it must be large enough to cover the whole painting. The holes in the pegboard allow the paper to dry out evenly.*
5. *Place heavy weights on the board. For a painting that measures 11 × 15" (¹/4 sheet of watercolor paper) I use four coffee cans filled with pennies; for larger paintings I use additional weights.*
6. *Let the paper dry under the weights for about thirty-six hours.*

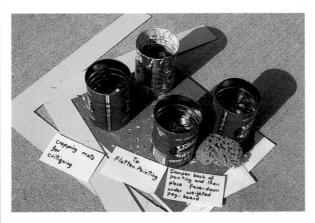

To flatten a finished painting you'll need a sponge, a gessoed pegboard, and weights such as coffee cans filled with pennies. Mat corners like the ones shown here are good critiquing aids.

BASIC PAINTING TECHNIQUES

In this chapter you will learn fundamental watercolor techniques and at the same time produce finished paintings. You will also learn about color as it pertains to the lesson at hand. The lessons are organized progressively, so that each new one builds on knowledge gained from those that came before. The subjects we'll learn from in this chapter include landscape, seascape, leaves, and flowers.

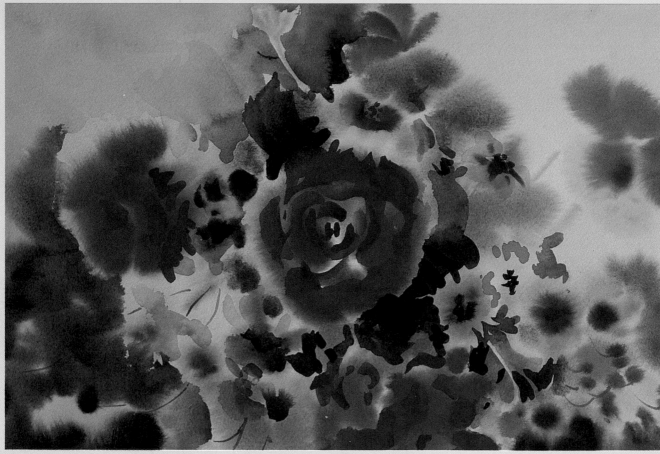

RED ROSES, WILD FLOWERS, 11 × 15" (28 × 38 cm), private collection.
Here is a good example of a painting executed in the wet-on-wet technique, which yields lovely soft explosions of color.

Learning About Washes and Drybrush

In this first lesson you will learn how to make a preliminary sketch to use as a guide for watercolor painting, and how to apply watercolor washes to paper.

CONCEPT: Depth and mystery in layered mountain scene

SEEING: How colors become lighter in the distance (atmospheric perspective); reflection

DRAWING: Making a preliminary sketch as a painting guide

PAINTING: Wet-on-wet; graded washes; hard and soft edges; drybrush; using the rigger brush

PAPER: 1/4 sheet (11 × 15") of 140-lb. Arches rough or cold-pressed

BRUSHES: 1" flat, #8 round, #3 rigger

COLORS: Permanent blue, burnt sienna

ALSO: Sketchbook and 6B graphite stick

SEEING

In most scenes distant objects usually appear lighter and bluer in hue, with less contrast between lights and darks. This phenomenon, known as atmospheric perspective, is caused by light on particles of mist or dust in the lower atmosphere. The closer mountains are to the viewer, the deeper, less blue, and warmer in tone they appear. By utilizing this observation you can create a feeling of depth in your mountain scene.

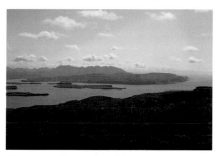

The more distant an object is in space, the bluer and paler it appears in relation to foreground objects.

Remember that water will reflect the sky. As with a mirror, an object's reflection will usually be slightly darker that the object itself—here, the sky and mountains.

DRAWING

Making a preliminary sketch of your subject in light and dark tones, known as values, helps to establish in your mind where you want to leave the paper white—an important consideration in transparent watercolor technique, in which white paint is seldom used. The stages of a value sketch approximate the layers of washes in a watercolor painting.

We will study two kinds of value sketches: representational and creative. A representational value sketch portrays an observable subject. A creative value sketch is culled from the imagination or visual memory. We will start with the creative value sketch.

HOW TO MAKE A CREATIVE VALUE SKETCH

1. *Draw a 5 × 7" rectangle using a 6B graphite stick or pencil. Depending on the subject, the rectangle can be either horizontal or vertical.*
2. *Use lines to indicate placement of your subject within the frame.*
3. *Shade everywhere except the whites. (In the "Misty Mountain" composition the whites appear in the sky and are reflected in the water.)*
4. *Shade the light middle tones, or values. (In "Misty Mountain" these are the light, distant mountains. It is particularly effective to place these mountains so that the lightest part of the sky is behind them.)*
5. *Shade the darker middle values (here, the middle-ground mountain range and some texture on the water).*
6. *Shade dark values (here, foreground rocks with grass and tree).*

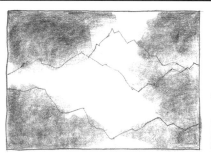
Lightest values

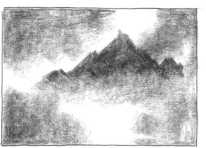
Light middle values

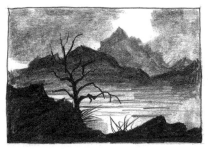
Darker middle values

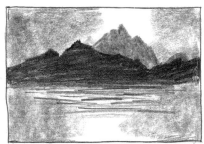
Darkest values

PAINTING

The diagrams accompanying each painting procedure show the relative proportions of each color needed for the lesson. For large paintings you will need proportionately more of each color. In any case, you probably will not use all the paint, but it is better to squeeze out too much rather than too little.

Mix your colors with about a teaspoonful of water as described in the previous chapter. For this painting you will use only one palette, which will include the colors permanent blue and burnt sienna. In this case, use about equal amounts of the two colors to make a dull gray. The pigments will separate, especially when applied to wet paper, resulting in a pleasing effect. Your paint will be progressively thicker (contain less water) as you lay in successive washes.

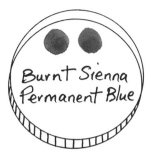

Burnt Sienna
Permanent Blue

STAGE 1: UNDERWASH

Before you begin to paint, have your colors mixed and your value sketch strategically placed for easy reference. You should know where you want to leave the paper white. You do not need pencil guidelines on your paper, since without them you have more freedom to change subsequent placement of mountains in case the paint does not rest exactly as you had anticipated.

Lay in pigment using the wet-on-wet technique as described below. Dry your painting once the shine has left the surface of your paper, using a blow-dryer held about 4" away.

WET-ON-WET TECHNIQUE

1. *Have all the paints you will need squeezed out, mixed with water, and ready to go.*
2. *Have handy your Plexiglas board, covered with tissues, paper towels, or a flat cotton rag to absorb excess moisture.*
3. *Know where you want to drop in paint and where you want to leave the paper white. Keep your value sketch in front of you for reference.*
4. *Take the phone off the hook. Now you can start!*
5. *Wet the paper with your 1" flat brush (larger brush for larger paper) first on the front side, next*
 on the back (to make the paper lie flat), and then on the front side again. Make sure that the edges are especially wet, since they will dry first. The paper should have an even shine on it.
6. *To avoid backruns, or watermarks, around the edges, lay your wet paper on tissues or flat cotton rags that have been placed on your Plexiglas board.*
7. *While the paper still has a shine on it, load your flat brush with paint and drop in color using the minimum amount of brushstrokes needed to cover the area. You'll need*
 to work fast. The most pleasing wet-on-wet effects occur when you lay in the pigment premier coup, or in one fell swoop. Do NOT add more pigment once the shine has gone, or you will get watermarks. Watermarks occur when your brush contains more water than the paper; when you apply the wet brush to the paper, pigment that has not yet dried is pushed aside by the excess moisture, forming rings.
8. *Once the shine has left the surface of your paper, you can dry your painting. A hair dryer will greatly speed the drying process.*

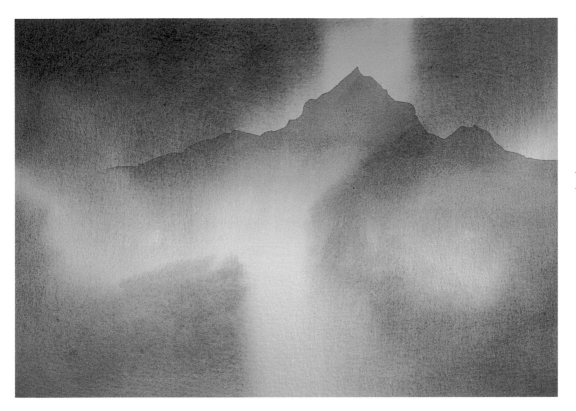

STAGE 2: BACKGROUND
Using fairly watery paint, lay in the distant mountain range using the wet-on-dry watercolor technique. Use your sketch to help you determine where to place the mountain. Notice how I have set it against the light sky for emphasis. Dry your painting.

WET-ON-DRY GRADED WASH; HARD AND SOFT EDGES

1. *If you have already laid in a wash, make sure your paper is completely dry. Mix enough paint with water to cover the specific area.*

2. *Tilt your board with at least a 2" wedge. A steeper tilt makes a more even wash, though the paint becomes harder to handle.*

3. *Using a 1" flat brush (larger for a larger area), lay in pigment on the paper according to your sketch. Painting on dry paper will produce a hard edge. Work your brush back and forth across the page horizontally and then downward. Keep a puddle of paint at the lower edge of the wash. Dilute paint with water as you progress downward to grade the tone.*

4. *Softening an edge. When you want to soften the edge of a painted area, such as the base of the mountain shown here, follow these steps:*

- *Wash out your brush in the "dirty" brush-cleaning water.*
- *Dry off excess water on a rag or tissue.*
- *Dip the tip of your brush in clean water.*
- *Shake off excess water.*
- *Hold your clean, wet brush vertical with the paper so its top corner touches the bottom edge of the puddle of paint, and work horizontally across the paper.*
- *Repeat this process until the pigment is merged with water and there is about 2" of clean water below the pigment level. Dry your painting.*

Note: As you work your way downward, do NOT go back into the paint you have already laid on the paper. If you really can't live with an irritating missed spot, dry your paper first to set the paint, and then repeat the wet-on-dry wash.

Note the puddle of paint that forms at the bottom of a wet-on-dry wash.

Softening the edge of a wash.

STAGE 3: MIDDLE MOUNTAIN RANGE AND WATER

Using slightly thicker and darker paint, lay in a wet-on-dry wash as in stage 2, only this time, instead of softening the lower edge, you will drybrush the lower edge to create the texture of moving water. For this procedure, described below, you can continue to use your 1" brush held vertically, or you can switch to your #8 round brush. When you are done, dry your painting.

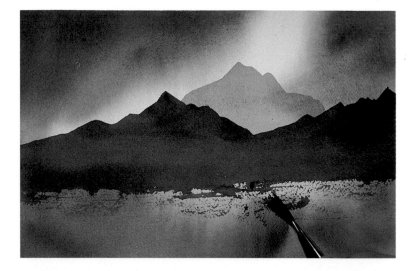

STAGE 4: FOREGROUND

Using thicker and darker pigment (color is not important here), lay in a wet-on-dry wash to make the foreground rock shapes.

While the paint is still wet, use your rigger brush to drag out pigment to indicate grass and a tree. A quick flick of the wrist, together with the long hairs of the rigger brush, will give movement to the grass. You may need to add pigment to paint the tree. Dry your painting.

Optional: Using deeper pigment, paint more foreground rocks.

DRYBRUSH TECHNIQUE

1. *Load your #8 round brush with reasonably dry pigment—i.e., without much water.*
2. *Bend the tip of the brush up and away from the paper; you get the drybrush effect with the heel.*
3. *Hold your brush horizontal to the paper; your thumb should be on top of the handle, as in the illustration.*
4. *Quickly drag the brush across the paper's surface. Practice on a scrap of discarded watercolor paper.*

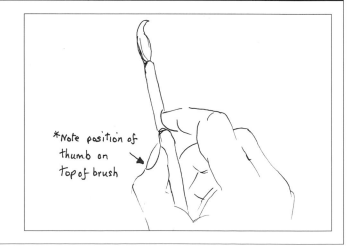

*Note position of thumb on top of brush

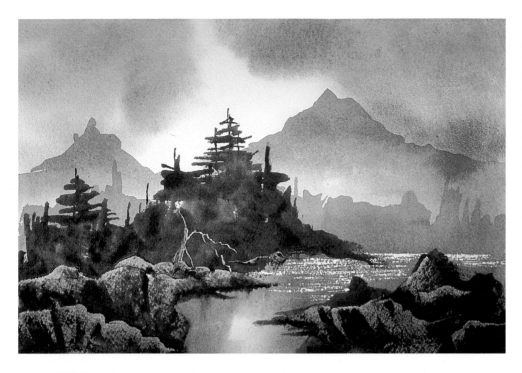

This variation on the featured painting required more complex color mixing. A subtle gray was achieved by mixing permanent rose, aureolin, and permanent blue in nearly equal amounts. Pine trees were painted in a zigzag pattern with the corner of a 1" flat brush. Rocks were scraped in with a blade as described on page 31.

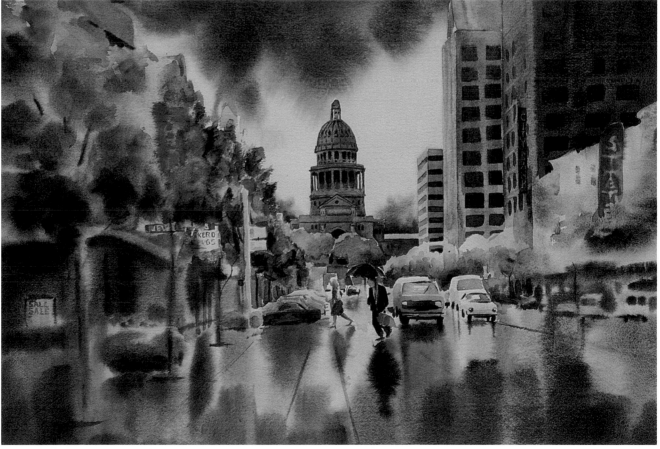

CONGRESS AVENUE, AUSTIN, 15 × 22" (38.1 × 55.9), private collection.

This painting illustrates the use of wet-on-wet and wet-on-dry techniques to achieve the atmosphere of a wet street and soft, fuzzy reflections contrasting with the hard-edged forms of the buildings.

LESSON 2 *Understanding the Color Wheel*

Introducing you to the color wheel and using a primary triad for a painting is the main purpose of this lesson, along with further watercolor techniques. You will mix bright secondary hues from three "balanced" primary colors and then neutralize them—make them less bright—by adding complements.

First, let's define some terms. Primary colors are the so-called three prime colors—yellow, blue, and red—which cannot be created from other colors. From them the so-called secondary colors—green, orange, and purple (or mauve, a light purple)—are mixed. You also need to know these terms:

Balanced primary colors. All pigmented colors consist of elements of the colors adjacent to them on the color wheel; for instance, a yellow pigment will contain some adjacent green and some adjacent orange. A "balanced" primary is one that

reflects equal amounts of adjacent hues. In the color wheel at left below, balanced primaries are arranged around the three points of an equilateral triangle, with aureolin, a particularly well balanced yellow, at the top. Sometimes called a "pure" primary, a balanced primary is one that will mix with the other two primary colors to produce bright secondary colors. An "unbalanced" primary is one that reflects more of one adjacent color than the other. An example of this is alizarin crimson, which is weighted toward blue and so will not mix well with yellow to make a bright orange secondary color.

Bright secondary colors. These are greens, oranges, and purples mixed from balanced primaries. The color wheel at left below illustrates a reasonably balanced primary triad of aureolin, permanent blue, and permanent rose, as indicated by the

solid-line triangle. The primary triad will be used for a number of lessons throughout the book. Mixed in pairs, the three colors produce green, orange, and purple—the secondary triad, indicated by the broken-line triangle.

Complements. These are colors that are placed opposite each other on the color wheel, indicated in the diagrams by dotted diameter lines. They are so named because when any two are combined, they complete the subtractive color mixing process of eliminating light to make black, which appears in the center of the wheel. Thus pigments of the lightest and darkest values, yellow and purple, are complements because together they make black, as do blue and orange, and red and green, which are about equal in value. The complement of a primary color consists of a mixture of the other two primaries. The

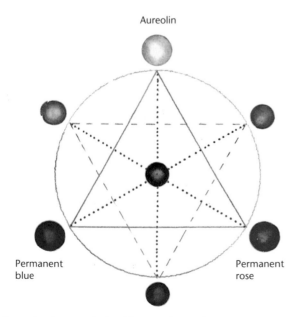

Balanced primary triad, with secondary mixtures.

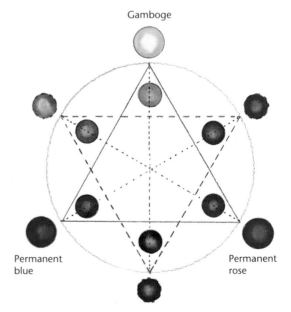

Neutral colors, shown on the inside of the wheel, are made by adding to a primary or secondary hue a touch of its complement, placed opposite to it.

complement of a secondary color is the (third) primary of which the secondary is not comprised.

Neutral colors. These are less bright, almost dull colors. Earth pigments such as yellow ochre and burnt sienna are neutral colors and do not reflect bright hues. A neutral color can be mixed—or, rather, a bright color made neutral—by adding to it a touch of its complement. Bright colors are neutral in the shade— in other words, when they do not receive direct light. The color wheel at right on page 24, whose primary triad consists of gamboge, permanent rose, and permanent blue, shows neutral colors inside the circle. These are made by mixing each primary or secondary color with a touch of its complement. Thus, to make gamboge less bright, you would add a touch of purple (blue and rose); to make orange (consisting of rose and yellow) less bright, you would add a touch of permanent blue to it. You can also make a color neutral by adding black or white to it (in watercolor, water constitutes white paint).

You will learn a great deal by making your own color wheel. First draw circles for each color in pencil, then paint in the primary colors. Next, mix secondary colors from the primaries. Then mix the neutrals as described. Finally, mix the three primaries together to make a black, placing it in the center of the wheel. Try different primary triads.

DEMONSTRATION
AUTUMN LEAVES

CONCEPT: Brightly colored, textured leaves

SEEING: Leaf shapes, vein structure, positive and negative shapes

DRAWING: Creating a pleasing design with a variety of cropped and overlapped shapes in an unusual format

PAINTING: Color mixing; limited wet-on-wet; softening edges; graded washes; texturing with salt and scraping

PAPER: 140-lb. Arches cold-pressed cut to a long, narrow format, either 15 × 5 1/2" (half of 1/4 sheet) or 22 × 7 1/2" (half of 1/2 sheet)

BRUSHES: 1" flat, # 8 round

COLORS: Permanent rose, gamboge, Prussian blue

ALSO: Margarita salt, 3B pencil

SEEING

Careful study is required whenever you portray recognizable subjects. As you look at leaves, ask yourself: Is the overall shape long, rounded, or divided into sections? Are the edges smooth or jagged? Is the vein structure palmate (several large veins branching from the leaf base to the blade), as in a maple, or pinnate (one large central vein with smaller branching veins), as in an oak?

DRAWING

Since the main object of this chapter is watercolor technique, this is the one time you can really cheat on your drawing and trace the outline shapes. Lay actual leaves on your watercolor paper so they make a pleasing design. Overlap some leaves, and have others going out over the edge of the paper. Make sure that the background, here meaning the negative spaces between the leaves, has interesting shapes. Trace the top leaves first, then around all the contours except where one leaf is underneath another. If you can't get leaves, sketch those shown here, cut them

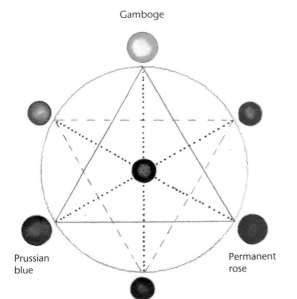

Gamboge

Prussian blue

Permanent rose

The primary triad for the painting Autumn Leaves *consists of gamboge, permanent rose, and Prussian blue. The solid-line triangle indicates primary colors, the broken-line triangle the secondary colors mixed from the primaries.*

The maple leaf (left) has a palmate vein structure; the oak leaf (right), a pinnate vein structure.

out, and follow the same procedure described. Since erasing damages watercolor paper, you may want to work out your design on sketchbook paper cut to the same size as your watercolor paper, then transfer your sketch to the watercolor paper as described on page 14. Your pencil lines need to be quite dark so they show through when you lay in a wet-on-wet wash.

PAINTING

Before you start any painting, you must always consider what colors are best suited to the concept you have in mind. Here, the concept of brightly colored leaves prompts me to choose bright staining colors that are reasonably balanced primaries that will mix with one another to produce bright secondary colors. Once dried, permanent rose, gamboge, and Prussian blue will not lift or disturb when you paint over them. They spread when applied wet-on-wet, which makes them ideal for this composition. The same pigments will be used repeatedly, so you will soon learn what each pigment will do.

Always have your colors mixed and ready to go prior to painting. In watercolor, once you have embarked on a wash you do not have time to then scurry around and squeeze out and mix more paints. You will need four palettes for this lesson. In palette 1, make a bright red by mixing a touch of gamboge with permanent rose. To make a reddish orange (a secondary color), add more gamboge. In palette 2, make a purple (secondary) by mixing some permanent rose and Prussian blue.

Your line drawing should look something like this, based on a pleasing arrangement of the leaves.

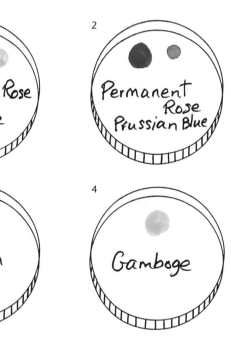

LIMITED WET-ON-WET TECHNIQUE

1. Make sure your board is flat.
2. Wet a limited area—one that is defined within boundaries created by lines or by the edges of the paper. For small areas use a small brush or the corner of a flat brush.
3. Avoid backruns around the edges of your paper by placing it on a paper towel or a rag laid flat.
4. Drop paint—the consistency should be about half pigment, half water—into the wetted area while the paper is shiny. It works well to drop in deeper pigment next to the line delineating the object.
5. When the shine has gone, dry your painting.

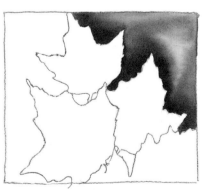

In this variation on the wet-on-wet technique, you apply paint only to a limited area you have selectively prewet. By taking the water and paint to the edge of the area, you create a hard-edged boundary.

STAGE 1: BASIC LEAF COLORS AND BACKGROUND

Before you start, look at your design and decide where you want the viewer's eyes to be drawn. Mentally make a note to leave the chosen area white. The eye is automatically attracted first to areas of obvious contrast—in color, value, or edge definition.

Wet your paper in preparation for applying paint wet-on-wet. While the paper has a shine on it, use your 1" brush (for small paper size) and lay in the pigment in this order, cleaning your brush between applications: yellow, red, orange, purple, and blue. The illustration is your guide for how bright the colors should be. The leaves will have more red and yellow in them than the background. Be sure to leave white areas strategically placed on your leaves. You will get watermarks if you continue to add paint or water once the shine has gone—though since leaves have so much texture anyway, a little more probably won't hurt in this instance.

Just as the shine is disappearing from your paper, drop in coarse salt to create texture. Make sure the paper isn't too wet, or the salt will dissolve. Different parts of the painting will dry at different rates, so you will have to watch and drop in salt where you want it at the appropriate time. The timing is tricky. Texture, like contrast, will attract the viewer's eye, so make sure the salt is strategically placed within your composition.

Also when the shine is just leaving your paper, scrape out some leaf veins with a blade or the chiseled handle end of your brush, or with a cut-up credit card. Dry your painting.

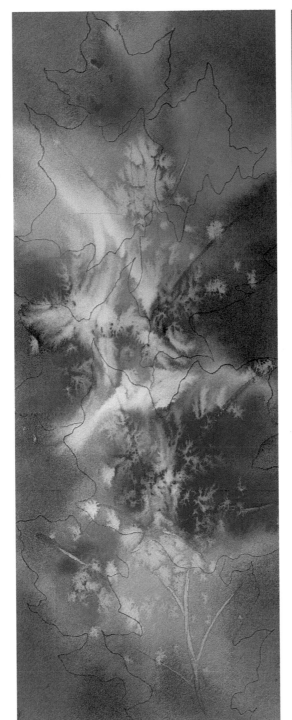

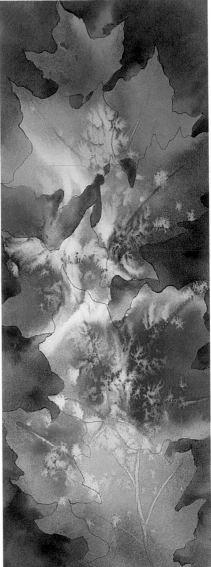

STAGE 2: BACKGROUND AND NEGATIVE-PAINTED LEAVES

Negative painting is a watercolor term you will hear often. It means to render an object not by painting the object itself—here, a leaf—but by painting around it to make it stand out. From the edge of leaves to the edge of your paper you will have small areas of "trapped" background—areas bounded by hard edges. Drop in deeper values of the colors you applied in these areas in the first wash, using the "limited area" wet-on-wet technique described on the left-hand page. Repeat the process for each trapped area in your painting.

STAGE 3: CREATING DEFINITION

Tilt your board toward you with about a 2" wedge. Turn your paper so that the area you work on is horizontal. Using your #8 brush, lay in a narrow band of moderately watery pigment to define a small shadow. This line can bleed beyond the leaf area. Now work very quickly and soften the edge using a separate wet brush or the process described in previous lesson: Wash out your brush; dry it on a rag; dip it in clean water; shake out excess water; then touch the lower edge of pigment so the paint runs into the water to make a soft edge. Repeat until the lower edge consists only of clear water. Dry each adjacent leaf before going to the next. You can use this technique to negative paint a vein if you like the effect.

You may need to accentuate some leaves by making them stand out from a darker background. Use the procedure described below to accomplish this. You can make the pigment slightly neutral for the darks and accents by adding a touch of the complement to the color. Have fun working on this. Now try a leaf painting using different colors.

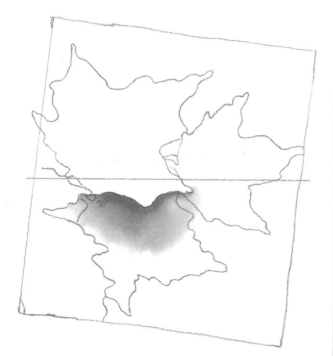

Darkening the margin between two leaves makes one stand out in front of the other, creating the illusion of depth.

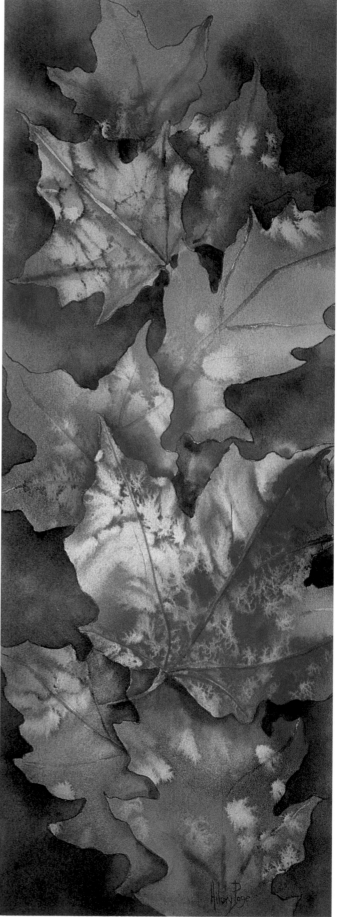

28

Value and Color Contrast

The eye is automatically drawn to areas in a painting where there is a marked contrast of color, value, or edge definition. In terms of value, you can create a center of interest in a composition by placing a darker subject right next to a light area. As an artist, you don't have to wait around for the perfect light to just happen; you can design lights and darks for yourself. Decide where you want the focal point to be—not in the center or at the edge of your paper— and place the greatest contrast there.

In the following demonstration you will learn to use more colors and painting techniques, as well as review techniques described previously.

DEMONSTRATION
SUNSET, MOUNTAINS, SEA, AND ROCKS

CONCEPT: Brightly colored mountain sunset scene

SEEING: Variations in sky tone; using value contrasts to direct the viewer's eye

DRAWING: Using a creative value sketch as guide for setting up effective contrasts

PAINTING: Wet-on-wet; soft, hard, and rough edges; overlaying washes; using a blade to create rock forms

PAPER: 1/8 or 1/4 sheet of 140-lb. Arches cold-pressed or rough

BRUSHES: 1" flat

COLORS: Aureolin, permanent rose, Prussian blue, permanent blue, burnt sienna, ivory black

ALSO: Mist spray bottle, 6B graphite

SEEING

Where in the photograph above is your eye drawn? Here, the scene is a combination of dark land forms already in shadow and a still-bright sky reflected in the water as a warm glow. This tone variation creates a

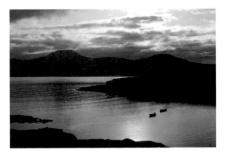

Mountains and sunset reflected in a serene body of water make an evocative subject for a painting.

feeling of depth, a phenomenon you can use in many compositions.

Whether you are portraying high, scattered cirrus clouds, dark gray nimbus rain clouds, or billowing cumulus thunder clouds, you need to shade the upper or lower side of the cloud depending on which is farther away from the light source. Clouds illuminated by a high midday sun will be dark on the underside and light on top. Clouds like the ones in this painting, which are illuminated by low sunlight, will be light on the underside and dark on top.

DRAWING

Following the procedure described at the beginning of this chapter, make a 5 × 7" creative value sketch in 6B graphite of sunset, mountain, sea, and rock forms. Values are grades of light and dark, regardless of color; a creative value sketch is one in which you create the placement of lights and darks from your imagination.

The stages of your sketch should approximate those of your watercolor washes. Remember, you start by shading everywhere except the areas you want to keep light. The viewer's eye will be drawn to the places where the contrast between light and dark is the greatest. Leave some white in the sky behind the

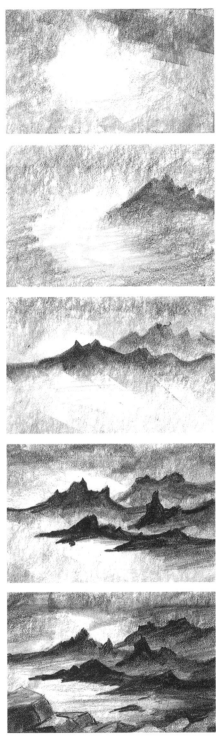

The stages of your value sketch should approximate those of watercolor washes.

prominent dark mountain shape. Vary your mountains in shape, size, and value for interest.

PAINTING

The hardest part about this painting is organizing and mixing your colors. Some, such as alizarin crimson and Prussian blue, have a much greater tinting strength than others, such as permanent rose and gamboge. Be sure to follow the palette diagrams for relative proportions of each pigment. Ivory black works well to give the impression of a dark evening sky. Adding black is another way to make a color neutral, though it tends to produce dull hues that are not as subtle as neutrals mixed from the primaries.

Here and elsewhere in the book, you may note minor variations in the artwork from one stage of the demonstration to the next. This is to show that it is not important to follow the original plan precisely. In watercolor you have to "go with the flow" and adapt to the appearance of the paint on your paper. Watercolor is most pleasing if it is not overworked to force a specific outcome.

In palette 1, mix an orange sunset color from aureolin and permanent rose. After you have applied orange to the sky, add more permanent rose to make a bright red. In palette 2, mix a blue sky color from Prussian blue and a touch of permanent blue. In palette 3, to be used for the darker sunset hues, leave burnt sienna and alizarin crimson unmixed. Palette 4 contains only ivory black, which you'll need for the evening sky color. In palette 5, mix a slightly pinkish, light gray for the mountains from alizarin crimson, Prussian blue, and gamboge. For the first, light mountain wash, draw down just a small amount of each pigment; with successive washes, add more pigment to make progressively darker grays.

1 Aureolin / Permanent Rose

2 Prussian Blue / Permanent Blue

3 Burnt Sienna / Alizarin Crimson

4 Ivory Black

5 Alizarin Crimson / Prussian Blue / Gamboge

STAGE 1: SKY AND SEA

Using the wet-on-wet technique, drop in colors in this order: yellow, orange, and red. Place them according to the illustration. Begin with the sky and follow, using the same colors, with the sea area, where the sky's reflection appears. Be sure to leave white as in your value sketch for the sky behind the mountain. Also leave some white areas where you can drop in Prussian blue. If the paper is still wet and shiny you can continue to drop in color, this time burnt sienna and Prussian blue, plus a hint of permanent blue; follow the illustration for placement. You can also drop in some ivory black at the top and bottom of the paper. If at any stage the shine has gone, dry your paper to set the paint, then rewet it using a soft brush or spray mist and continue dropping in paint where you left off. Remember to lay your paper on tissues or a flat cotton rag to avoid watermarks. Dry your painting.

STAGE 2: DISTANT MOUNTAINS
Following your value sketch, paint the distant mountain range, softening the lower edges according to the wet-on-dry technique described on page 21. Dry your painting.

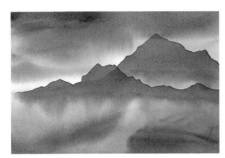

STAGE 3: MID-DISTANCE MOUNTAINS
Using the wet-on-dry technique, paint the middle mountain range in a gray deeper than what you used for the previous mountains, softening lower edges. Dry your painting. If a mountain you painted in the previous stage shows through one painted in this stage, just dry the paint and then add a small, limited wash to make the second wash more opaque.

STAGE 5: FOREGROUND ROCKS
You'll need thick, dark, neutral paint for the foreground rocks. So pick up with your brush—you'll have to dab into three separate palettes—some alizarin crimson, gamboge, and Prussian blue. Don't worry about muddying your palettes; this is the last paint application for this painting. Paint the overall shape of the rock form. Dry your painting.

When the paint is just losing its shine, hold a single-edge blade flat on the paper and scrape aside pigment to make individual rock forms. You have to press quite hard and put a little more pressure on one end of the blade than the other.

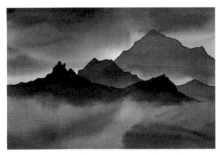

STAGE 4: NEAR-DISTANCE MOUNTAINS
Paint the foremost mountains and soften lower edges. Dry your painting.

STAGE 6: FINISH
Following the drybrush technique described on page 22, create the impression of some additional water movement in the foreground. To make the design more pleasing, you may need to darken the water at the sides. Add some dark accents. When the painting is dry, use a blade to scratch the paper's surface to portray light reflected in the water. Try a number of variations on this sunset theme to gain practice with the medium and to stimulate your imagination and creativity.

LESSON 4 *Studying Pigment Behavior*

You'll not only learn more color mixing in this lesson, but also you'll see how individual pigments act in unique ways when applied wet-on-wet.

DEMONSTRATION
PIED PANSIES

CONCEPT: Brightly colored pansies painted realistically from freshly cut flowers or from photographs

SEEING: Observing botanical characteristics

DRAWING: Direct drawing with a brush (no value sketch or line drawing)

PAINTING: Limited wet-on-wet; color mixing; using "spreading pigments" wet-on-wet to create a realistic effect

PAPER: 140-lb. Arches cold-pressed, any size

BRUSHES: #14 round

COLORS: Aureolin, gamboge, permanent rose, alizarin crimson, permanent blue

SEEING

If the time of year is right, try to find fresh pansies. If not, work from photographs. Since you will paint directly on your watercolor paper, with no pencil guide, you need to know your subject thoroughly and be able to answer these questions: How many petals does a pansy have? How many petals can you see? Looking straight on, what shape are they? What do you notice about the edges of the petals? How does the flower appear from the back and side? How are the sepals connected to the stem? Is the stem round or square? Whence do the leaves grow? What do the shapes and edges of the leaves look like?

You will be painting directly on the watercolor paper this time; there is no pencil drawing involved.

PAINTING

In this lesson you'll be painting pansies of different colors and at different angles without drawing them first in pencil. Use your #14 round brush throughout; its fine tip is good for fine work.

Squeeze out but do not mix your colors with water, since you will need only a small amount of paint for each application. In palette 2, permanent blue and permanent rose will give you a purple. In palette 3, permanent rose, alizarin crimson, and permanent blue with a touch of gamboge will give you a deep maroon. In palette 4, you will make an orange from permanent rose and a touch of aureolin. In palette 5, you will make a green from aureolin and permanent blue. Clean mixed paint off the palettes with a tissue after you finish each flower.

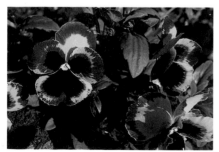

It's better—and more inspiring—to work from real flowers, but photographs can reveal enough information about the subject if you look carefully.

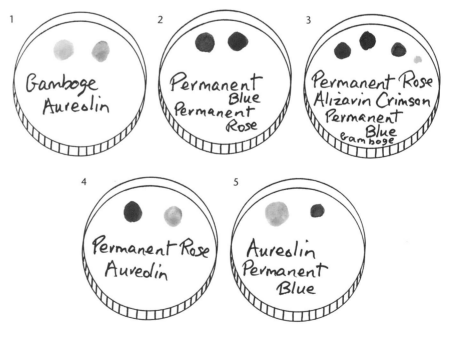

1 Gamboge Aureolin

2 Permanent Blue Permanent Rose

3 Permanent Rose Alizarin Crimson Permanent Blue Gamboge

4 Permanent Rose Aureolin

5 Aureolin Permanent Blue

BACK AND SIDE VIEWS

Using green paint mixed from aureolin with a touch of permanent blue, paint the five sepals and stem. Next paint the petals. From the side view you can see the square stem and how the sepals bunch backward as well as forward.

HEAD-ON VIEW, STAGE 1: FLOWER CENTER

Have your reference in front of you. Your board must be flat. We'll begin by painting pansies viewed straight on, using a yellow base color into which deep red alizarin crimson will be dropped. Mix gamboge with water as the base color.

Paint a small yellow triangle with the tip of your brush. This is

the center of the flower. For a tilted flower, place the triangle at an angle. When painting a second flower peeking out from the first, begin with its triangle, which will help you with the flower's position, even when there is only room for part of the flower to show. After painting the triangle, paint the amount of flower that shows through the space.

PANSIES WITH WHITE BASE COLOR

So that you can see the white petals' shapes, add a tinge of aureolin to water for their base color.

Drop in other colors appropriate for your composition. Try other combinations of pale base plus deep dropped-in color. Make a note of how your paints act when applied wet-on-wet.

STAGE 2: PETAL SHAPES

Using gamboge and a lot of water, paint the rough-edged petal shapes starting with the large one below the triangle, then the side ones,

then the top two. Leave a small white line between petals to keep them separate. You'll need to work quickly, because the paint must be wet and shiny for the next stage.

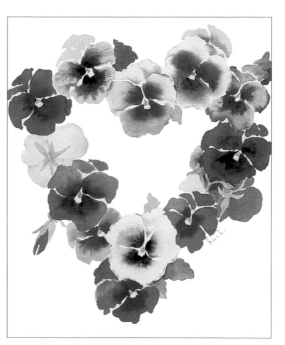

STAGES 3 AND 4: CENTER COLOR AND CENTER DETAIL

While the petals are still wet and shiny, drop in quite thick alizarin crimson. Start with the large bottom petal. Drop pigment next to the central triangle, then watch the color characteristically spread when applied wet-on-wet. Some pansies have a deeper outside edge. To achieve this, paint alizarin crimson just over the outside edge of the petal when it's still wet and let the color run into the yellow.

Dry your painting. For more control you can work each petal separately: Finish the yellow of one petal first, drop in the red, then paint the yellow of the next petal and add the red, and so on.

Painting the center detail is really a very short stage. In the center triangle, add yellow in the lower half. In the upper half make a green triangle with a touch of orange at the top. Study your pansy (or the photo) as you do this. Dry your painting.

For the pansy heart, I penciled in an incomplete heart shape very lightly so the lines wouldn't show through the paint, and then placed the pansy centers near the heart line. When painting multiple flowers, make sure adjacent ones are dry. Also, remember that pencil won't erase once it has been painted over, so use it sparingly.

THE SPHERE

We will begin our study of primary geometric forms with the sphere, which is the simplest because it is always represented by the same shape, a circle, no matter from what angle you view it. With careful observation you can recognize in any object the ideal primary form that underlies its structure, and therefore portray that object convincingly. White onions, for instance, are irregularly shaped spheres, which we will examine on a white ground. A study of red apples on white follows; red apples are more complex subjects than white onions, because their deep red local color makes it harder to gauge relative values. We will also study trees and roses, subjects in which the sphere is less obvious.

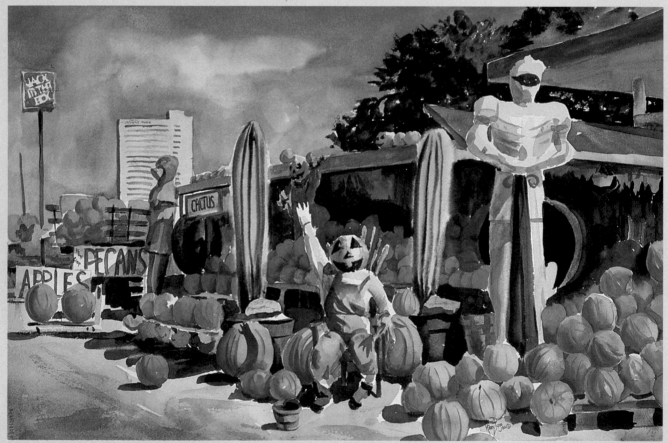

GUARDING THE PUMPKIN PATCH, 15 × 22" (38.1 × 55.9 cm), collection of Mr. and Mrs. Vaughn Scanland.

Spheres found in nature—in this case, bright orange pumpkins—can make for some colorful compositions.

LESSON 1 *The Value Sketch*

Learning to see with the eyes of an artist will forever change the way you look at the world. Learning to see can be quite simple; all you have to do is squint! As you do this, you study how light, shadows, and colors act with each of the primary forms—the sphere, cylinder, and cube, plus their derivatives, the ovoid, cone, and pyramid—from which everything around you is constructed.

As you learn to draw and paint, the way you see goes through three stages. At first you will put down what you think you see, namely, what seems obvious, but bereft of underlying relationships of value, color, and perspective. Art produced at this level of seeing is sometimes referred to as primitive; it is unsophisticated, ingenuous, and often thought of as creative because it is done without pretense. The second stage of seeing occurs when you have enough knowledge and skill to render subjects in a convincingly realistic manner. Reaching this stage takes training, observation, and practice. The third stage, one for which we are all striving, is akin to the first stage in inventiveness, but occurs when you selectively draw or paint, with knowledge, to express a creative idea. Mastering the second stage, the harbinger of artistic expression, is the focus of much of the material in the following chapters.

We will begin our approach to seeing by studying the sphere in terms of form shadow and cast shadow behavior and how value and color can vary from different viewpoints and under different lighting conditions. While immaterial themselves,

shadows help us define the three-dimensional form (volume) of objects on the flat, two-dimensional surface of our paper.

A major aspect of seeing is understanding values, the relative light and dark tones, independent of color, inherent in everything visible. A value can be judged light or dark only in relation to the values adjacent to it. In reality, lights are lighter and darks are darker than it is possible to portray on paper. Thus the problem the artist must solve is how to reduce what he or she actually sees into a narrower value range. This can be achieved in two ways: first, by combining two or more close values into a single one, and second, by employing an optical device known as simultaneous contrast, which we will explore in depth in subsequent chapters.

I've defined two types of value sketches: the creative, which you practiced in the previous chapter and which means you create tonal variations from your imagination and visual memory, and the representative, which is based on an accurate evaluation of tones seen.

The main purpose of a representative value sketch is to give you knowledge of your subject, while the creative value sketch is a way to manipulate actual values to make a visual statement. It is possible to creatively manipulate values only when you have gained a true understanding of actual values. Don't be tempted to skip over the value exercises. They are the stepping-stones to truly creative painting.

Many students are able to quote what values are—"lights and darks," they say. However, few are able to translate this information into an accurate appraisal of values. It takes understanding and practice to train the eye to gauge values of a total scene. Gaining such knowledge, an essential part of classical art training, is the focus of this lesson.

Since the sphere is the simplest form, and white is the simplest "color" with which to evaluate tone, we will start the value study by making a representative sketch of a white sphere on a white base. Before you begin, it is important that you understand basic drawing terms, as outlined below.

BASIC DRAWING TERMS

Form: A three-dimensional object

Ground: The ground, or base, on which the form rests

Local color: The intrinsic color of an object (red apple, green grass)

Form shadow: The shadow side of the form

Cast shadow: Shadow cast by the form onto another surface

Core shadow: The "core" of the form shadow, which on a curved form is a thin core of darker shadow between the form's light side and shadow side

Highlight: The lightest value on an object; a reflection of the primary light source

Reflected light: Light reflected from one surface onto another within a shadow area

CONCEPT: Learning to make a representative value sketch of a primary geometric form

SEEING: Accurately gauging values of form, core, and cast shadows of an obliquely lit sphere

DRAWING: Using a graphite stick; making a representative six-value sketch

PAPER: Sketchbook paper; sheet of any white paper to use as ground for sphere

DRAWING IMPLEMENTS: 6B graphite stick and 3B pencil

ALSO: Visualizing mat with opening of about 4 × 2 ³/₄", or same proportions as intended sketch; white sphere (Styrofoam ball or Christmas tree ornament painted white will do)

SEEING

If you don't have a sphere, study these photographs carefully. Taken from two different heights, they show the sphere lit by sunlight to provide the greatest value contrasts. The outstanding characteristic of the sphere is that its curved surface causes all light and shade likewise to be curved. Of significance in these images is that the object and the ground have the same local color—white. Remember: The ground is what the object is resting on; local color is the inherent color of an object or surface. Squint or look at your subject through almost closed eyelashes. This accomplishes the hard job of combining values into masses that you will then represent on paper.

Note these characteristics:

1. The light portion of the sphere is curved like the curved phases of the moon. On a shiny sphere you would be able to see a highlight, which would also be curved.
2. The total *form shadow* that's visible—the shaded side of the object—is lighter in value than the cast shadow because it receives reflected light from the ground.
3. The *cast shadow* is darker than the form shadow, due to the absence of reflected light. In color, out in the open, this cast shadow is tinted with neutral blue because it reflects blue from the sky.
4. The cast shadow is particularly dark directly under the curve of the sphere, where reflected light is completely absent.
5. The *core shadow*, the narrow band of dark between the light and shaded side of any curved form, is particularly apparent when the subject is lit by direct light.
6. In the photograph of the sphere taken from a low height, you can

see that the form shadow on the sphere is darkest where it faces the dark part of its cast shadow.

The spheres shown on this page are lit by direct sunlight to emphasize shadow characteristics. The light source for the sphere drawn on the opposite page is indirect because these conditions are usual for indoor drawing studies. Under indirect light, contrasts are less extreme and characteristics harder to identify. The core shadow is broader and the cast shadow has diffuse edges.

DRAWING

When you are drawing, you are portraying the illusion of form. Thus when you represent the object under indirect light, you can use your knowledge of how it would appear under direct light to emphasize characteristic features, such as the prominence of the core shadow and the contrast of values between the form and cast shadows, to enhance the essence of the form. Thus, even a representative value sketch can be somewhat creative.

You can adapt the procedure described here to whatever lighting situation or subject you are confronted with; it will be an invaluable aid as you work through the lessons.

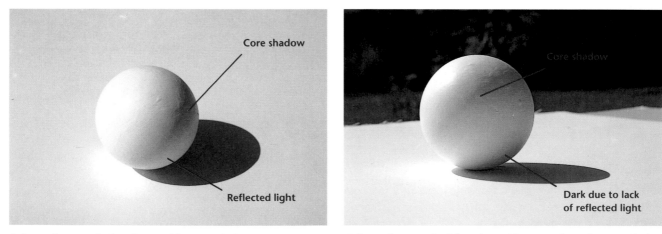

Sphere photographed in direct, oblique sunlight. *Sphere photographed from low, oblique angle in direct sunlight.*

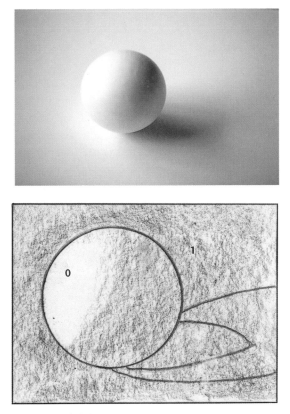

STAGE 1: LINE DRAWING

In this lesson, on a scale of 0-5, zero is white and five is the darkest value. Place your white sphere on a white base near a window so you have one indirect, oblique light source, as in the photograph. Indirect light modifies value variations.

Make an outline on your paper measuring about 5 × 7" to duplicate the proportions of your visualizing mat.

Look through the visualizing mat to set boundaries for the background around the sphere from which to gauge values.

Lightly line draw the form and its cast shadow within the frame. Sometimes when lit by an oblique light source the shadow will appear to split.

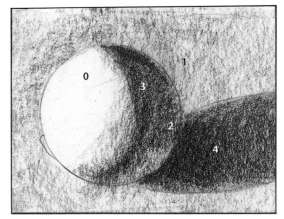

STAGE 2: VALUES 0 AND 1

Squint. Ask yourself as you view the form through the mat: "What is the lightest part I can see?" Lightly shade everywhere except the lightest area you have already identified. This means shading in the background too. The area you have shaded contains value 1, and the area you have left white is value 0. Note: Because it is not possible to portray on paper all the values you actually see, the highlight and lightest values are combined when the object has a white local color.

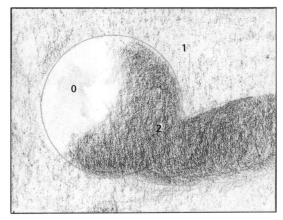

STAGE 3: VALUE 2

Squint. Identify the next lightest value, which is the combined shape of the form and cast shadows (on a sphere, sometimes this looks like the shape of a pair of bird's wings). Shade the combined shapes, which is value 2. Such combining of values is known as massing.

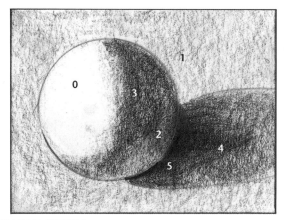

STAGE 4: VALUES 3 AND 4

Squint. Identify, then shade the core shadow (value 3). It is particularly easy to identify when the object is illuminated by direct light, especially sunlight. On objects lit by indirect light this area is broader.

Identify, then shade the mass of cast shadow (value 4). Ask yourself which is darker, the mass of the form shadow or the mass of the cast shadow? I hope your answer is the cast shadow!

STAGE 5: VALUE 5

Squint. Add a short, dark, fine band of cast shadow where the form rests on the base (value 5). This feature is more marked on curved surfaces than flat ones.

Look at the sphere and whole area through the visualizing mat and adjust values if necessary.

Now make a value sketch of the sphere lit by sunlight so you can compare it with the same subject in indirect light.

Rendering a Group of Spherical Objects

White onions are almost totally curved shapes that may be considered irregular spheres. They exhibit the characteristics of the perfect sphere, such as a curved highlight and core shadow. Portraying multiples of an object is a progression from the previous lesson, when you drew only a single sphere. I describe the value drawing procedure in detail so you can see the similarity between the instructions given for the simple sphere and a group of onions. You can then adapt the procedure as you practice representative value sketches of whatever subject you choose to study.

CONCEPT: Portray white onions in a loose, painterly style using pen and ink

SEEING: Learn to evaluate lights and darks in a group of almost-white objects, with one object in front of another

DRAWING: Line drawing; making a value sketch; combining values, or massing

PAINTING: Wet-on-wet; combining watercolor with pen-and-ink effects

PAPER: 11 × 14" sketchbook, ⅛ sheet of 140-lb. Arches cold-pressed

BRUSHES: 1" flat, #8 round, #3 rigger

COLORS: Aureolin, permanent rose, cobalt blue

ALSO: 3B pencil, 6B graphite stick, cartridge or nib pen, black ink

SEEING

Observe in the photograph above how similar the values of the sphere are to those of the onion. The onion's surface is somewhat shiny, resulting in a highlight not present on the sphere.

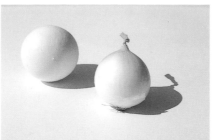

Compare shadow and light behavior on the sphere (left) with the onion (right).

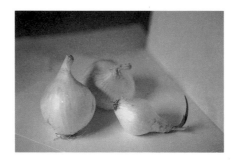

DRAWING

As in the previous lesson, you will make a value sketch. Then you will make a line drawing of your subject to scale and transfer it to watercolor paper in preparation for painting. Be sure to include the cast shadow shapes in the line drawing.

STAGE 1: SETUP

Arrange three onions on white paper. Have one oblique light source. Set up the onions so two overlap to make one shape.

Draw an outline on you sketchbook paper that duplicates the proportions of your visualizing mat.

Look at the setup through your visualizing mat to set boundaries.

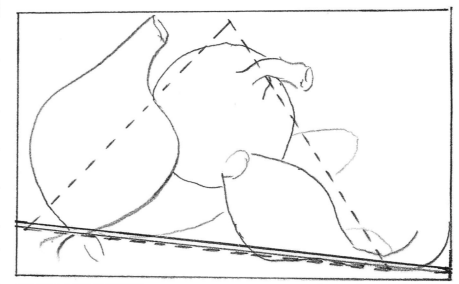

STAGE 2: LINE DRAWING

Using a 3B pencil, lightly sketch in the outline of your subject to scale. To gauge the relative positions and angles of the two front onions, draw a guide base line: As you view the subject through the mat, lay a pencil against the mat and, on your sketchbook paper, duplicate the angle of the pencil in relation to the side of the

viewing mat. After you have made the base line, it sometimes helps to imagine the objects within a shape, such as a triangle, to see them as a broad mass. Draw outlines for the objects and their shadows. In two-dimensional representation, shadows are as important in conveying volume as the objects themselves.

STAGE 3: VALUES 0 AND 1

Squint so you can't see details, just blurred abstract shapes. Squint until you see the lightest areas stand out. Using a soft-edged graphite stick, shade in everywhere except these lightest areas. The second drawing shows the abstract shapes with the absence of lines.

STAGE 4: VALUE 2

Squint so you can see, and then shade, the combined middle values. These "masses" are the hardest value shapes to see. You are not looking at objects. You are looking at joined shapes made by light and dark shading. You can see how shadow shapes become as important as the object. When designing more complex paintings pay particular attention to the shapes of masses made by combined middle values. Drawing isolates these combined shapes.

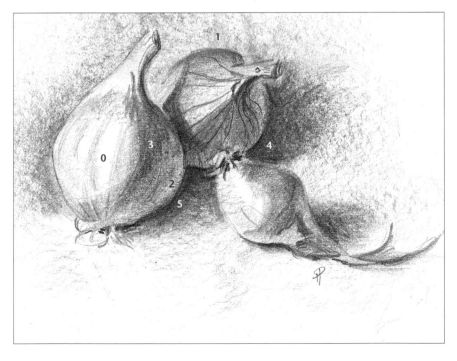

STAGE 5: VALUES 3, 4, AND 5

Squint so you can see, and then shade, the core shadow on the onions (value 3).

Shade the cast shadow (value 4), which will be darker than the form shadow.

Add dark accents (value 5), which occur where the onions rest on the white paper. There also may be dark accents within the roots and shoots.

PAINTING

Your line drawing of the onions should be on the watercolor paper. The colors chosen for this lesson, permanent rose, cobalt blue, and aureolin, are particularly well suited for the wet-on-wet technique, since they do not spread uncontrollably when applied this way. Also, the three colors are intrinsically light and have a limited value range, so they can never become too dark—an important consideration when rendering an almost-white subject.

This painting has only two stages. In the first you apply the paint wet-on-wet, then dry the painting; in the second you add pen-and-ink effects. The wet-on-wet technique requires that you work quickly so the paper doesn't dry before you want it to. Make sure you have everything before you start. Are your colors mixed? Do you have brushes, colors, water, rags, and tissues at hand? Is your value sketch placed where you can see it?

Mix your colors with about a teaspoonful of water. In palette 3, make a gray from permanent rose, aureolin, and cobalt blue.

STAGE 1: WET-ON-WET

Using the wet-on-wet procedure, lay in cobalt blue in the background areas and also in some shaded parts of the onions as per your value sketch. Be sure to leave plenty of white areas. Your paint will creep a little, so leave more white than you think you need. While the paper still has a shine, you can drop in more color. If the shine has gone, do not lay in paint or you will get watermarks, which will not work for this subject. Just dry your painting (with a hair dryer) to set the paint, then rewet it and continue to lay in color.

While your paper still has a shine on it, lay in yellow for the yellow and green parts of the onion.

Continuing on the shiny-wet paper, lay in some gray for the shadow areas. Remember that the cast shadow will be darker than the form shadow. Also remember that if one onion is in front of another, the back onion will be darker at the edge where they meet. When you paint wet-on-wet your colors will merge and you may feel out of control. Don't worry about this. You will clarify lines at the next stage when you use your pen. Dry your painting.

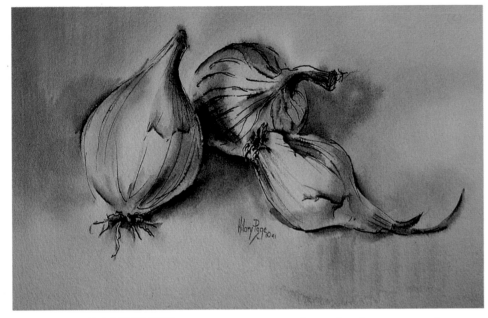

Drag your water-filled brush up to and along the ink line but not over it. The ink will merge with the water. Use enough water to soften the outer edges of the ink.

STAGE 2: PEN-AND-INK EFFECTS

Using a fountain or cartridge nib pen with black water-based ink, draw linear details on the onion. Add deeper shades of gray to your shadows by dragging the ink from the line with water using your #8 brush, as shown in the diagram above at right. Do not put water on both sides of the ink line to achieve this effect. Another way of merging ink is to put water on the paper at the desired area. Then use ink at an edge (not in the middle) of the water to get darks and accents. Once applied, pen lines are practically impossible to remove, so be sure you put them only where you want them. Dry your painting.

Sign your painting, then pencil in the completion date on the back so you can compare your progress with future paintings. Remember, the only way to measure your progress is against your own work, not that of your friends. However, sharing paintings after a "paint-together" session can be helpful. What you admire in others' work is what you may be striving for. Try to identify what you admire so you can emulate the effect.

Flatten your painting in readiness for matting.

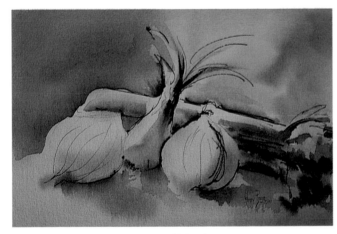

ONIONS WITH CELERY, 7 × 11" (17.8 × 27.9 cm).

I did this painting as a class demonstration. It is a good example of negative painting, for without the deep blue background, the onion on the left would be completely lost.

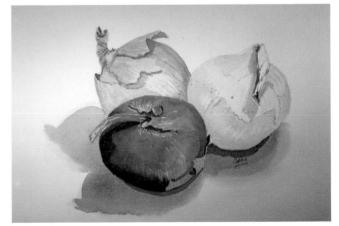

Cynthia Young, **THREE ONIONS**, 7 × 11" (17.8 × 27.9 cm).

The artist painted this study after class. Such studies are a fine way to teach yourself to see and paint. They also make delightful "kitchen" paintings.

LESSON 3 *Color, Value, and the Sphere*

Working with subjects of varied local colors, such as a red apple, means you have more complex value relationships to gauge. The top photograph shows a progression from a simple white sphere to a white apple—a more complex form, but still white—then a red apple, which has not only a more complex form, but color as well. It is harder to judge the value of a colored object than that of a white one.

This progression illustrates the basic procedure for analyzing how to portray a subject and is most important for you to understand. By understanding the simple white form, you can anticipate the tone variations of colored objects.

assume that the cast shadow will automatically be darker than the form shadow, as it is when object and ground are the same color. The problem here is to decide which shadow is lighter and which darker. You will have to squint at your apple to make this judgment. Notice how the highlight on the red apple is rounded, the characteristic shape of highlights on spherical objects. Highlights show up well against dark local colors, greatly enhancing the illusion of roundness.

The photograph of the white sphere on a colored striped ground shows how much illuminated color—color lit by direct light or sunlight—is reflected on less bright

surfaces. A color that is not directly illuminated cannot reflect more than a hint of itself onto another surface. Look back at the red apple in the first photograph and note that there is a hint of red in the part of the cast shadow closest to the apple.

DRAWING

It is always helpful to make a value sketch of your subject. First portray one apple, then gauge the values of form and cast shadows of two or three apples.

Since the shape of a single apple is simple and straightforward, you may want to dispense with the line drawing and paint directly on the watercolor paper as I did.

DEMONSTRATION
RED APPLES ON A WHITE GROUND

CONCEPT: Portray apples realistically

SEEING: Values of red local color

DRAWING: Line drawing or drawing directly with paint

PAINTING: Glazing technique with staining colors; limited wet-on-wet; soft and hard edges; optional use of salt

PAPER: 140-lb. Arches cold-pressed

BRUSHES: #14 round, #8 round

COLORS: Prussian blue, Grumbacher red, gamboge, alizarin crimson

ALSO: Sketchbook, visualizing mat, 6B graphite, 3B pencil

SEEING

I photographed the subjects in sunlight so you can see the greatest value contrasts. In indirect light, value differentials are less extreme.

When portraying a colored object on a white ground, you cannot

The white apple is just a step away from a perfect sphere form. From there we will make one more leap—to studying how local color, in this case, red, affects value.

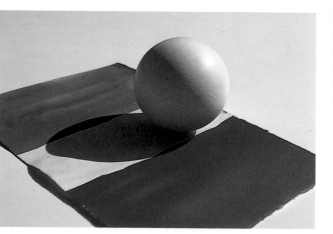

Note how much color from the striped ground reflects onto the surface of the sphere.

PAINTING

You will use the glazing technique, a traditional watercolor method of building up value and color by laying one single, unmixed color over another. The little swatches of color you see in the illustrations indicate the order of the colored glazes, or washes. The pigments chosen for this painting are especially well suited for the glazing technique because they do not disturb when rewet and painted over. Mix your colors with water, leaving some of the original blob of paint in each palette intact.

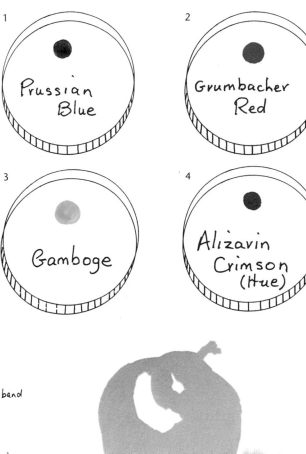

Use this procedure to lay in pigment in stages 1, 2, and 3. Prewet the total area within the broken line except the curved highlight. Thus you will wet the apple, the cast shadow, and an extra 1" band around the cast shadow This band of water is to ensure a soft edge around your cast shadow. Leave a hairline strip of dry paper between apple and cast shadow as shown in the diagram. Lay in paint in the prewet area. Don't paint over the highlight. Don't add pigment in the band of water around the cast shadow. Dry your painting.

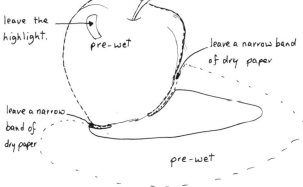

STAGE 1: YELLOW UNDERWASH, APPLE AND CAST SHADOW

Following the procedure for laying in paint described at left, apply gamboge with your #14 round brush. Be sure to leave the highlight unpainted.

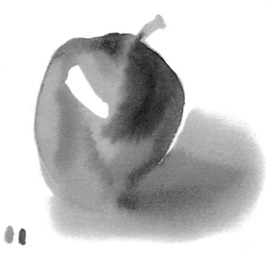

STAGE 2: UNDERPAINTING FORM AND CAST SHADOWS

Use Prussian blue to model the darks in the form shadow. Apply water and pigment according to the instructions described for the diagram. Leave areas unpainted where you want the red on the apple to be particularly bright. Dry your painting.

STAGE 3: RED-GRAY UNDERWASH

Rewet the apple and cast shadow and then drop in Grumbacher red. The overall hue should be light red, with a reddish-gray cast shadow. Dry your painting.

STAGE 4: RED WASH; BLUE HINTS IN CAST SHADOW

Lay in a wash of Grumbacher red and alizarin crimson over the apple. Be sure to keep the light areas light. Dry your painting.

Use Margarita salt at this stage if you want texture; apply it just as the shine is leaving the paper. Dry your painting.

Lay in a hint of blue in the cast shadow, but keep a reddish glow directly under the apple.

Use Margarita salt if you want to add texture.

The edge of the front apple is lighter where it appears to touch the apple behind it. Note the slightly hard edges caused by the apples' shiny surfaces.

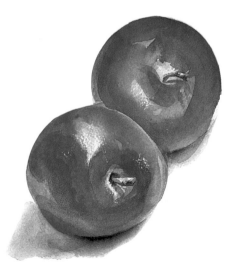

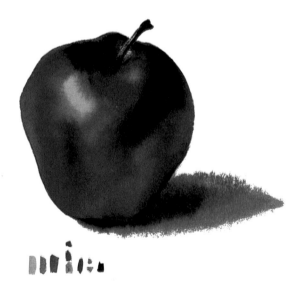

STAGE 5: MODELING AND ACCENTS

Squint again to rejudge values, then drop in Prussian blue or alizarin crimson according to the hue of the apple you're working from. Color and value changes within the form are usually soft-edged on smooth curved surfaces. However, if the apple is very shiny, there may be some hard edges.

Add dark accents under the apple and at the stem. Use a blade to scratch out highlights if you painted over them in error. I lifted off some of my shadow with an art gum eraser using the procedure described on page 15.

Leo Smith, **APPLE TIME,** 22 × 30" (55.9 × 76.2 cm).

Knowledge attained while studying individual fruits can be used when you are ready to paint a full-scale still life. Here, Leo Smith uses apples to convey the rich atmosphere of the harvest season.

Recognizing Spheres in the Landscape

The subject of this lesson, green trees in a field with blue flowers, is an example of middle-valued, colored spheres whose geometric form is disguised. Unless carefully topiaried, few trees are perfectly rounded. I will admit that I searched quite hard to find a perfectly spherical tree such as the one in the photograph at left below.

DEMONSTRATION
GREEN TREES AS
MODIFIED SPHERES

CONCEPT: Brightly colored trees in a field of blue flowers

SEEING: Conceiving a complex natural subject as a simple geometric form

DRAWING: Value and placement sketch to make a pleasing underlying design

PAINTING: Direct painting method adaptable to working on location; laying in washes on wet and dry paper; mixing greens and neutral grays; drybrush

PAPER: 1/8, 1/4, or 1/2 sheet of 140-lb. Arches cold-pressed

BRUSHES: #14 and #8 round, 1" flat for 1/4 sheet; use larger size for larger paper

COLORS: Aureolin, permanent blue, permanent rose, alizarin crimson, Prussian blue, Winsor green, burnt sienna

ALSO: Art gum eraser, 3B pencil

SEEING

The tree in its simplest mass is a single sphere. Leaf-covered branches growing out from a tapered trunk can be seen as a series of small spheres comprising a larger whole, as the photograph of the model at far right shows. Note also in the photo how much red and blue color from the striped ground is reflected in the shadow areas of the cotton-ball "branches." From this you can deduce that a tree growing in a field of green grass will appear significantly greener than one growing in the middle of barren brown soil or a city parking lot.

Since the local color of tree and grass are about the same value, you can expect the cast shadow to be darker than the form shadow, as it is with white objects on a white ground. Shadow colors are less bright and more neutral than colors lit by bright sunshine. To make a color neutral, you will remember from the leaf lesson, you add a touch of its complement.

If you are viewing your tree from ground level, perspective will make the cast shadow appear flat, as in photograph A on the facing page. From middle height—say if you are on a hill looking down at a tree—the cast shadow shape is elliptical, as in photograph B. Many students give a round shadow to a tree viewed from ground level, but photograph C illustrates that the cast shadow is circular only if viewed from above. Also because of the effects of perspective, the first in a row of trees of equal size will appear largest, and the others will appear progressively smaller the farther back they are from the viewer, as shown in photograph D. In a pair or group of objects, often the background object appears darker than the one in front of it at the edges where they meet. But that's not always the case, as photograph D also shows. It all depends on the position of the light source.

DRAWING

Start with a graphite or pencil value sketch of your trees. Always be mindful of your light source and the broad underlying sphere form. Then you can break the tree into branches with leaves comprised of smaller spheres. Understanding the basic structure makes it easy for you to create your own tree forms.

It is very easy to use a pencil drawing as a crutch, so for this lesson try to paint directly. If you really feel you have to have a pencil guide, make your line drawing to scale on sketchbook paper and transfer it to your watercolor paper.

A tree like this one can be seen as a modified sphere.

In this model, spherical cotton-ball "branches" combine to form the larger sphere of the whole tree. Note how color from the striped ground reflects up into the shadowed areas of the "branches."

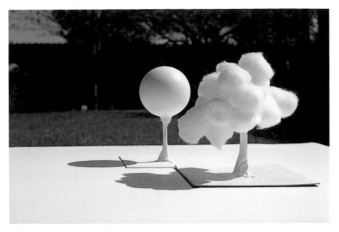

A.

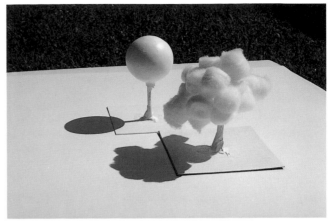

B.

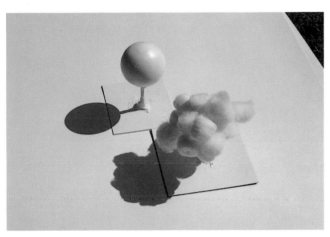

C.

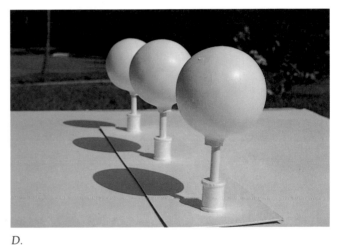

D.

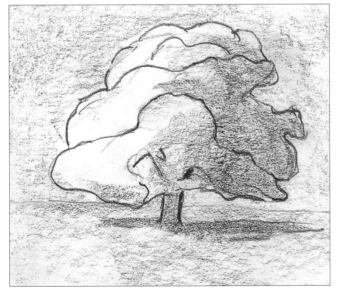

Values 1, 2, and 3.

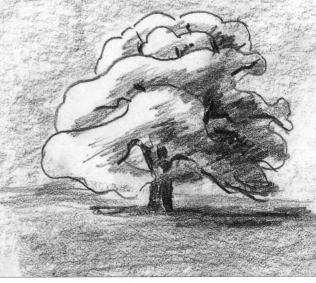

With values 4 and 5 added.

PAINTING

Mix your colors with water. In palette 1, to make a leaf green, mix aureolin with a small amount of Winsor green, Prussian blue, and a touch of permanent rose to neutralize the color if it is too bright. In palette 2, mix a sky blue color from permanent blue and Prussian blue. In palette 3, for the bluebonnet flowers, combine permanent blue with a touch of permanent rose and permanent blue. In palette 4, mix a gray for the tree trunks from burnt sienna and permanent blue. In palette 5, mix a pinkish orange from aureolin and permanent rose. As you become experienced you will learn how to combine some palettes rather than using one palette per color.

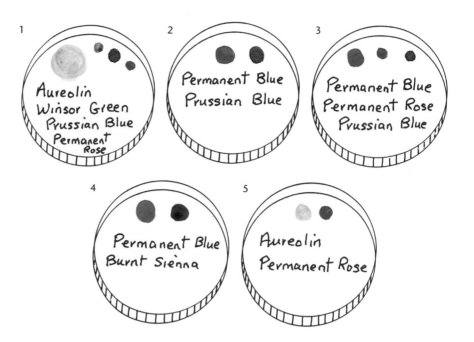

1. Aureolin / Winsor Green / Prussian Blue / Permanent Rose
2. Permanent Blue / Prussian Blue
3. Permanent Blue / Permanent Rose / Prussian Blue
4. Permanent Blue / Burnt Sienna
5. Aureolin / Permanent Rose

STAGE 1: FLOWERS AND FIRST TREE WASH

On dry paper, direct paint individual and masses of blue flowers using a #8 round brush. In transparent watercolor you will not be able to paint flowers over green grass. Add orange flowers—the complement of blue—to make the blue seem brighter.

With your #14 round brush, paint the overall tree shape in varied greens of quite light value. A small amount of burnt sienna dropped into the green is often attractive. You may want to leave some light areas within the body of the tree to represent the sky seen through the leaves, or you can lift out these lights later. Drybrush the tree edges by dragging the corner of your almost-dry brush along them, as shown on page 22.

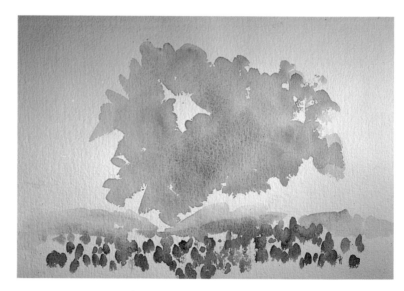

STAGE 2: GRASS, SKY, SECOND WASH ON TREES

Using the same light green you used for the tree in stage 1, paint between the flowers. Distant greens will be bluer, so just add a little blue to your green for these. Dry your painting.

Lay in the sky. Using your 1" flat brush, wet the sky areas before you drop in the paint. Leave white for the clouds; drop in blue and pinkish orange on the underside of the cloud. Drybrush the sky into the tree using the "heel" of your brush to make a jagged edge. Dry your painting.

Mix darker green for the trees by using the same colors as before only with more Prussian blue and permanent blue and less water. Paint the dark shadows on the trees and a dark cast shadow under them. Drybrush jagged edges. Dry your painting.

STAGE 3: MIDDLE TREE VALUES, TRUNK, CAST SHADOWS

Lay in the middle values between the light and dark sides of your trees in warm, yellowish greens. Dry your painting.

Have you ever seen a brown tree trunk? Not many around. Paint a gray tree trunk and branches, which will be variegated because of shadows and light filtering through the leaves. Branches usually can only be seen appearing through the dark areas of the leaves you have painted. Check this out yourself.

Negative paint a few flower leaves and blades of grass. This means that, as one student put it, "You paint where it ain't." In other words, you don't paint the leaves and grass themselves but paint the shapes between them. Positive paint other leaves and grass. Dry your painting.

The trees' cast shadow seen from ground level will be a narrow ellipse. Darken all colors within the shadow area on the ground, working each color separately.

Use a blade to scratch out some lights if necessary on the bluebonnets, grass, and tree next to the branches. You can also lighten areas by using a scrubber brush or an art gum eraser.

Critique your painting. Stand back from it, look at it in a mirror, and surround it with adjustable mat corners to make sure you have the best dimensions for the composition.

Closeup photograph showing leaves to be negative painted.

Three stages of negative painting.

LESSON 5 *Interpreting Flowers as Spherical Forms*

Carefully study a rose in full bloom. Note how en masse, the delicate individual petals form what is essentially a spherical blossom. As you look at any complex form made up of many parts, try to see it as a simple mass. This will make the task of interpreting the subject in paint much more manageable, and will result in a more unified image.

DEMONSTRATION
CORAL PINK ROSES

CONCEPT: Realistic, botanical-type rendering of roses

SEEING: Studying flower and leaf formation in detail

DRAWING: Value sketch (optional)

PAINTING: Direct painting wet-on-dry (no pencil guidelines)

PAPER: ⅛, ¼, or ½ sheet of 140-lb. Arches cold-pressed

BRUSHES: #14, #8, and #3 round

COLORS: Aureolin, permanent rose, permanent blue

SEEING

Compare in the photograph the values on the sphere with those on the white rose and the full-blown pink roses. These values will be present whether the rose is a deep color or a light one. Value relationships are easier to gauge on light-colored flowers because the value range is broader.

Study individual petals and ask yourself what shape they are. How do they fold over one another? How do the sepals appear? What is the color, shape, and edge surface of each of the compound leaves? Which direction do the thorns face? The leaves on roses are compound—one leaf is actually comprised of several leaves—and have a pinnate vein

structure. The green leaves have a pinkish cast. What colors do you notice in the leaves of your roses? These are questions you need to answer before you start to draw or paint.

DRAWING

To help you visualize how to portray the way the petals fold over and how leaves look when foreshortened, you may find it useful to trace over a rose in a magazine, just to see how the shapes will translate onto a two-

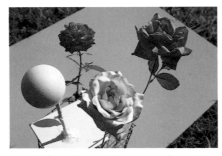

Study the value gradations on the perfect sphere, the rose painted white, and the various pink roses shown here. Note the structural details of the rose—the shape of the petals, and the shape and color of the leaves.

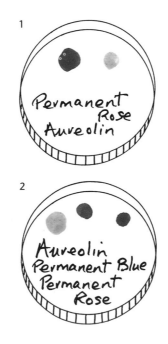

dimensional surface. (We will study foreshortening at length in the next chapter.) You do not need a line drawing as guide for this painting.

PAINTING

Squeeze out your colors and mix them with water. Remember, the blobs of paint belong in the higher part of the palette. In palette 1, mix a coral pink color from aureolin and permanent rose. In palette 2, for the leaves, mix aureolin with permanent blue and a touch of permanent rose.

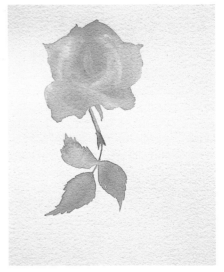

STAGE 1: UNDERPAINTING
Study, memorize, then paint the shape of the rose in a light pink using a #14 round brush. Use a #3 brush to make the little arrow shape of the petal's center edge; be sure the paper stays shiny so you don't get watermarks. Clean and dry the #14 brush, then use it to lift out the tips of the lightest petals. Dry your painting.

With your pointed #8 round, using a light-valued mixture of yellow, red, and blue, paint unevenly shaped leaves with jagged edges. You might want to use your #3 brush for this. Add the stem where it appears from behind the leaves. Notice, too, the shape resembling a Celtic harp where the leaf attaches to the stem. Make sure your thorns are pointing downward. Dry your painting.

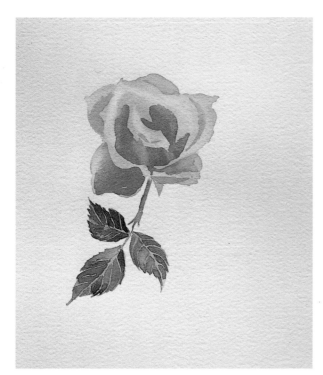

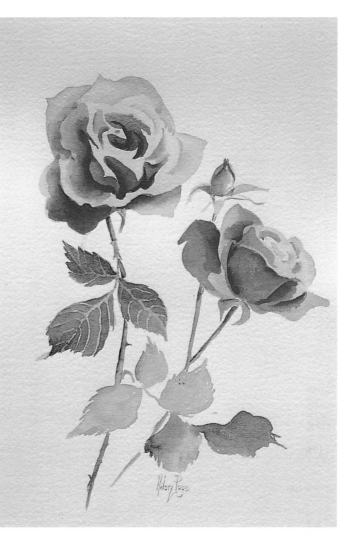

STAGE 2: MIDDLE VALUES OF ROSE; VEINS ON LEAVES

Squint at your rose so you can see large masses of medium and deep color. You are not looking at individual petals; you are looking at general areas of deeper color. Paint the middle value area with your #8 round. Use your #14 brush to soften edges where necessary.

Using your #3 brush, with a darker shade of green, negative paint the leaf veins—in other words, don't paint the veins themselves but paint around them as you render the leaves. Dry your painting.

STAGE 3: DETAILS

Using your #3 brush and a darker value of coral pink, paint the small dark values in your rose within the larger areas of medium value. Make sure your rose has the characteristic coil shape, with one petal wrapped around the next. Soften edges with your #8 round brush.

Paint the rest of the stem. Drop in a small amount of dark green on the shaded side of the stem while it is still wet. Also paint any thorns.

Check your values. You may want to put a light pink glaze over part of a couple of leaves; just make sure the paper is dry before doing this.

VICTORIAN BOUQUET, 26 × 22" (66 × 55.9 cm).

In this painting of roses, begun as a class demonstration and finished two years later, I introduced a series of oval grids as a way of further studying the compositional and design possibilities of my subject.

THE CYLINDER

The cylinder, more complex than the sphere, is composed of two equal round flat surfaces and of a curved surface comprised of straight vertical parallel line systems. The subjects chosen for our study of the cylinder are a lighthouse, white birch trees, bananas, and a glass filled with water. We will also study perspective as it relates to the cylinder; the phenomenon of foreshortening; and the optical problems involved in painting a transparent, water-filled glass.

GLASS JUG WITH CUT GLASS ON LACE AND STRIPED FABRIC, 11 × 7" (27.9 × 17.8 cm).

The cylinder abounds in everyday objects. This study of a cylindrical clear-glass jug is very detailed and took considerable patience to paint, but it shows particularly clearly how convex glass magnifies and reverses objects reflected in it.

Analyzing the Cylinder

An upright cylinder is called a "right" cylinder. In any other position, the cylinder is "oblique." Whether the cylinder is upright or prone, the height line systems are straight and the horizontal ones are curved.

Two distinguishing characteristics of an obliquely lit cylinder are the shapes of the core shadow and the highlight. Unlike the curved core shadow on the sphere, the core shadow on the cylinder is a thin, straight band of dark between light and shade, in accordance with the straight height plane. The highlight on the cylinder, also following the straight height plane, is long, thin, and straight, unlike the rounded shape of the sphere's highlight. Both the core shadow and the highlight are horizontal when the cylinder is lying down, as you see in the photograph at center right. For descriptive purposes the verticals of the cylinder are always referred to as the height lines even when the cylinder is horizontal—just as in figure drawing, height always refers to the height of the model whether he is standing or lying down.

A striped lighthouse is the perfect subject for studying the cylinder, because the stripes—here, white and red—make it possible to observe how the form's core shadow and highlight behave with both light and dark color values. The background in the painting that follows involves a creative approach to rendering rock forms using a blade.

DEMONSTRATION
STRIPED LIGHTHOUSE

CONCEPT: Stark, cylindrical lighthouse

SEEING: Straight core shadow and highlight on striped cylinder

DRAWING: Achieving symmetry in line drawing of a regular cylindrical form; studying the ellipse

PAINTING: Graded washes; layered washes; using blade

PAPER: $^1/_8$ or $^1/_4$ sheet of 140-lb. Arches cold-pressed

BRUSHES: 1" flat, #8 round, #3 round or rigger

COLORS: Cobalt blue, permanent blue, aureolin, Grumbacher red

ALSO: Drafting tape, art gum eraser, single-edge blade, 3B pencil

SEEING

Because the range of values that can be portrayed on paper is relatively narrow, you need both light- and dark-valued subjects to illustrate the specific characteristics of any given form. The straight core shadow is apparent and easily portrayed on an obliquely lit white cylinder, while the straight highlight is clearly seen and portrayed on a colored surface. The striped lighthouse shown here, with its inherently light, white values and inherently dark, red values, lets you observe both of these characteristics on a single form.

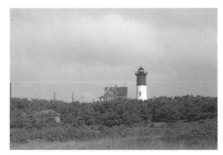

Photo by Tom McTaggart.
A red-and-white-striped lighthouse is an excellent subject for studying highlights, light, and shadows on the cylinder.

DRAWING

For this painting you will need to do a careful line drawing. It is harder than you might think to draw a symmetrical lighthouse, yet it is important to draw it correctly. A lopsided lighthouse can be most disturbing to the viewer. I have an astigmatism in one eye, so it is just about impossible for me to judge whether or not a line is vertical. You may have a similar dysfunction. Lots of artists do. Having a mirror handy in which you can constantly view your work ameliorates a problem such as this.

Here's a procedure to help you draw a balanced lighthouse. Check the diagram below as you work through the directions.

On sketch paper lightly draw a tall, narrow rectangle, in which you will draw your lighthouse. Measuring down from the top, draw two small divisions for the peak of the tower and the body of the tower. To find a center point, join diagonals, then lightly draw a vertical line passing through the point where they intersect. Extend this line to indicate the tower's vertex. The broken lines in the drawing represent construction lines.

Because of the effects of perspective, and for esthetic reasons, you will need to taper the lighthouse. To achieve this, mark two points inward on the top line of the rectangle. These are indicated by large dots on the line drawing. Draw lines from these points to the base corners of the rectangle to make the tapered "sides" of the lighthouse.

A good description of an ellipse is a squashed circle. Because of perspective, the horizontals on a cylinder, which in the lighthouse are the peak of the tower, the balcony, and the stripes, appear as partial ellipses. When you are looking up at the visible part of the ellipse, the front part will curve downward from the center, forming a "sad face" arc. When you are looking down at the visible part of the ellipse, it will curve upward from the center, forming a "happy face" arc. At eye level, the horizontal divisions appear as a straight line. Armed with this information, you can now complete the elliptically shaped peak of the tower, the balcony, and the stripes.

After having drawn the lighthouse, add the general land shape and reflection shape, which will be in the water directly below the lighthouse. The horizon line that divides ocean from sky needs to be parallel to the base of the lighthouse—a sloping ocean is visually disturbing, akin to a tilted picture you can't help but want to straighten!

Transfer your completed line drawing to watercolor paper.

PAINTING

Mix your colors with water. Remember to squeeze the paint onto the upper part of the palette, and leave some of these blobs intact. In palette 2, for the sky and ocean, make a light neutral blue with cobalt blue, aureolin, and Grumbacher red. In palette 4, make a dark gray for the tower and a red-gray for the rocks with permanent blue, aureolin, and Grumbacher red.

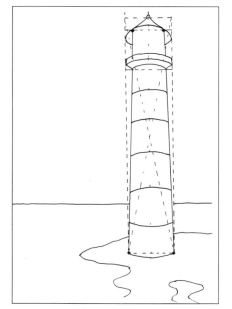

Be sure your drawing of the lighthouse is symmetrical.

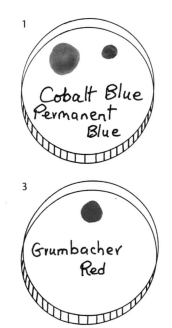

1

Cobalt Blue
Permanent Blue

2

Cobalt Blue
Aureolin

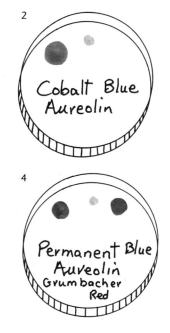

3

Grumbacher Red

4

Permanent Blue
Aureolin
Grumbacher Red

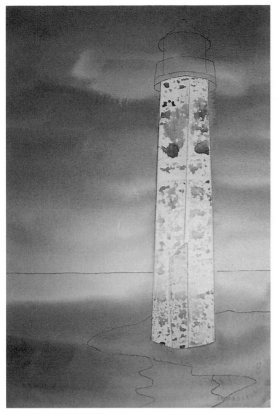

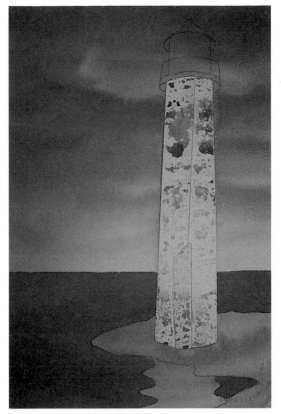

STAGE 2: OCEAN

Tilt your board toward you, and then, with your 1" flat brush, lay in a wash over the ocean area using the same color as in the previous stage but of a thicker consistency (in other words, use less water so you get a deeper value). Dry your painting.

Soften the horizon line. If the edge has already dried, follow the procedure outlined below.

STAGE 1: SKY

To preserve whites, mask out the "belly" of the lighthouse with drafting tape. Cut around the shape with a single-edge blade, as described on page 15. Be sure to press down the edges of the tape so water cannot creep under it.

Wet your paper all over. With your board slightly tilted, starting at the top of the paper, use your 1" flat brush to lay in deep blue paint (the color you mixed in palette 1). Gradually lighten the color as you work toward the horizon. Darken the blue at the base of your paper. I know from experience that the wash won't be exactly as you want it. I also know from experience that you won't make it any better by fussing with it, so dry your painting immediately.

HOW TO SOFTEN A HARD EDGE THAT HAS DRIED

1. Test your paper for dryness. If it feels cool to the back of your fingers, it is not perfectly dry.
2. Using clean water, "paint" a thin line along the edge you want to soften.
3. With a dry tissue, press quite hard and wipe off the loosened paint with a swift action.

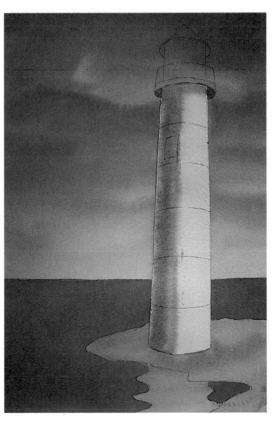

STAGE 3: FORM AND CORE SHADOW ON LIGHTHOUSE

Turn your paper sideways so the light side of the lighthouse is at the top. Using your 1" flat brush, wet the total lighthouse area.

Using your #8 round, lay in a blue-gray form shadow in the lower two-thirds of the lighthouse.

While the wash is still wet and shiny, use your #3 round brush to lay in a deeper blue, thin, straight line for the core shadow. This takes practice! Dry your painting.

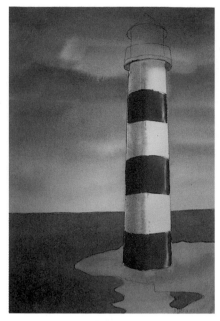

STAGE 4: STRIPES WITH HIGHLIGHT

Return your paper to its vertical position. With your 1" flat brush, sparingly wet one stripe.

While the paper has a shine, lay in red paint holding your brush vertically and starting on the shaded side. Leave a white strip for the highlight.

Complete all the stripes in the same way. Dry your painting.

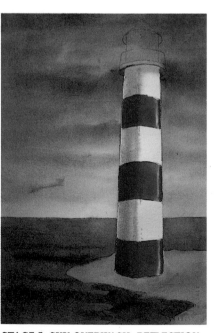

STAGE 5: SKY OVERWASH; REFLECTION

Rewet your paper except for the red-and-white striped part of the lighthouse.

Drop in weak red in the sky, and in the ocean to make waves. Dry your painting.

Lay in the reflection of the red stripes in the water. Dry your painting.

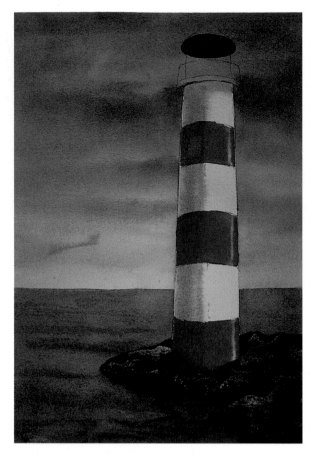

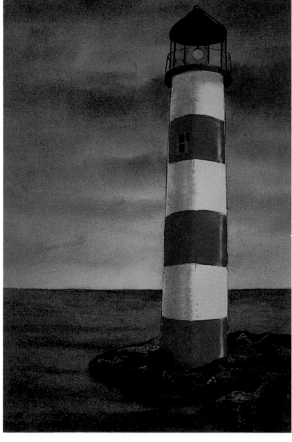

STAGE 6: TURRET, WINDOW, ROCKS, REFLECTIONS

Lay in a dark gray for the underside of the turret.

Wet the place where the window facing the light is to be, then wipe the area with a swift action, lifting pigment.

Using thick, dark red-gray paint, on dry paper lay in a wash over the rock area. Just as the shine is leaving, use a blade to scrape out rocks. Rewet the water area below the rocks.

Draw down paint into the water to make reflections. Make a dark line as rocks touch the water.

STAGE 7: TURRET AND DETAILS

In a very dark gray, paint the turret. Make sure you leave the highlights unpainted.

Paint three of the four windowpanes on the side of the lighthouse dark gray.

Darken the ocean with blue on either side of the lighthouse to make the structure stand out.

Using your #8 round brush, paint a blue-gray cast shadow under the turret as shown in the illustration at left.

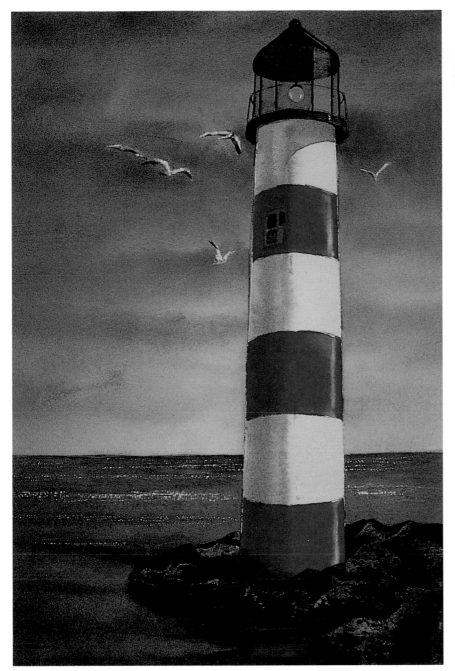

Harold Phenix, **BOLIVAR POINT LIGHTHOUSE,**
24 × 20" (61.0 × 50.8 cm).

*This painting is included in T. Lindsay
Baker's* Lighthouses of Texas *(Texas
A&M Press). Harold Phenix is a
well-known artist whose work has a
wonderful loose quality about it. Such
seeming ease comes with experience.*

STAGE 8: FINISH

*Refer to photographs of seagulls before you paint the shapes of the birds. You should
assemble a picture reference file for use with future paintings; old calendars and your
own photos provide great reference material.*

*When your paper is completely dry, you can "paint" the bird shapes with water and
an art gum eraser using the procedure described on page 15.*

*Scrape out waves with your blade; your paper should be dry. Because of
perspective, distant waves will be close together. Near waves will be broader and
farther apart.*

*In the turret, lift out the pane of glass that is facing the light, as well as highlights
on the beacon; do this by painting a thin line of water and then quickly wiping the
area to remove pigment. Restate values where necessary.*

LESSON 2 *Leafless Trees as Cylindrical Forms*

In the previous chapter we studied trees that had the characteristics of spheres. In this lesson we'll study trees again, this time a grove of bare birches whose trunks and branches are almost perfect cylinders. This is a good opportunity to observe more shadow phenomena as well, particularly shadow behavior in the landscape.

DEMONSTRATION
BIRCHES IN THE SNOW

CONCEPT: Create a feeling of mystery, depth, and coldness

SEEING: Light, shadows, and perspective with a white-on-white cylinder

DRAWING: Creative value sketches; arranging objects within a picture frame; directing the viewer's eye through value contrast

PAINTING: Graded washes; layered washes; negative painting; drybrush; special blade technique

PAPER: ⅛ or ¼ sheet of 140-lb. Arches cold-pressed

BRUSHES: 1" flat, #3 rigger, #8 round (use larger brush for larger paper)

COLORS: Prussian blue, permanent rose, aureolin, cobalt blue

ALSO: Single-edge blade, 3B pencil

Trees or lines touching the image area "frame" at base and top appear to come forward. The shadows cast by trees viewed from the front appear to converge as they recede backward.

SEEING

Study the photographs and diagrams shown on this page and on the next and observe the phenomena of form, perspective, and shadow they illustrate. Remember from previous lessons that when the local color of an object and the ground on which it rests is the same, the cast shadow will be darker than the form shadow. This is an important, basic rule.

As illustrated by the photograph at left below, trees that touch the top and bottom of an image area appear to come forward.

Trees or lines that touch the top but not the bottom of the frame appear to come forward, but not as much as in the illustration at left.

Trees, lines, or objects that are thin and do not touch the image frame at either the top or the base create the sense of great distance between the object and the viewer.

Areas of high contrast—the juxtaposition of, for example, extreme light and extreme dark—appear to come forward and draw the viewer's eye.

As you look upward (i.e., above your eye line) at a tree trunk, horizontal lines, or partial ellipses, appear as downturned arcs. When you look downward (below your eye line) at the trunk, these lines appear as upturned arcs. When you look at the trunk at eye level, there is no apparent arc, simply a straight line.

Because of the effects of perspective, tree trunks appear to get narrower as you look upward at them.

As you saw in the photograph on the facing page at bottom left, shadows cast by a stand of trees viewed from head on appear to recede into the background, the spaces between them diminishing and the shadows appearing to slant inward so that, if extended, they would eventually converge at a single point. When, however, your viewpoint is from the shadow side of the trees, as here, with the light source directly behind them and in front of you, the trees' cast shadows appear to move farther apart, making a fan shape.

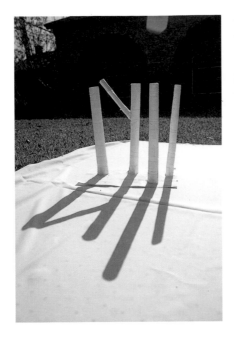

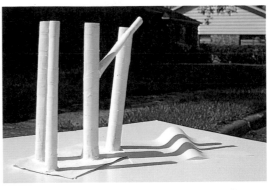

Cast shadows appear to vary in thickness as they follow inclines and contours of the land. The variation helps describe the ground's undulations.

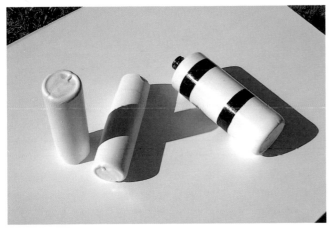

The strength and darkness of the cast shadow is obliterated by the superior power of reflected light in the form shadow.

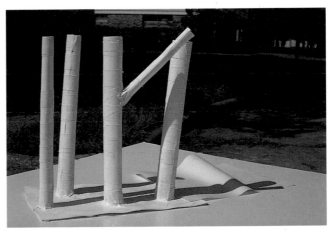

Shadows cast from one tree onto another are arc-shaped.

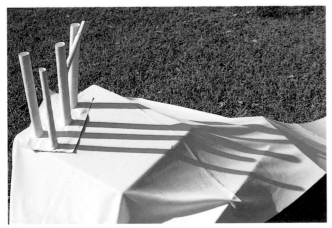

Shadows that angle downhill will be long.

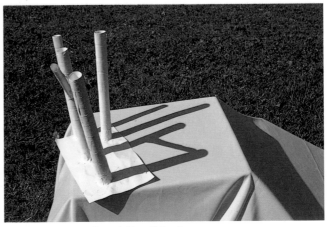

Shadows that angle uphill will be short.

DRAWING

Draw two horizontal and two vertical rectangles that each measure 5 × 7" and make a series of creative value sketches within them using information from the preceding photographs and diagrams. Remember, a creative value sketch is done from a combination of your imagination about a subject and your knowledge of how light, shadow, and value would function in the scene if it were based on reality. Put an arrow at the top of the paper to indicate which direction the light comes from. You should be able to identify six values in your sketch, as the watercolor stages will approximate these layers of value.

Choose your favorite design and make a line drawing of the trees to scale on tracing paper. Then trace onto your watercolor paper only the lines of the three lightest trees. You will trace more trees onto the painting surface as values progressively deepen in the watercolor stages.

PAINTING

A student new to watercolor, on hearing that the painting to illustrate the lesson was to be a snow scene, disconcertedly said, "But I don't have white paint!" One of the charms of transparent watercolor is the radiant effect of the white of the paper shining through the layers of color. You don't need white paint, you just need to preserve the white of the paper.

In palette 1, mix a neutral blue from Prussian blue with touches of permanent rose and aureolin. In palette 4, for the tree bark, mix Prussian blue with permanent rose and a touch of aureolin. In each of your palettes, leave some of the original blobs of paint unmixed.

Creative value sketch for painting.

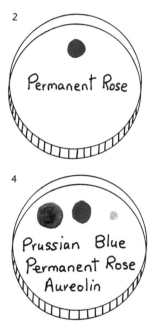

1 Prussian Blue Permanent Rose Aureolin

2 Permanent Rose

3 Cobalt Blue

4 Prussian Blue Permanent Rose Aureolin

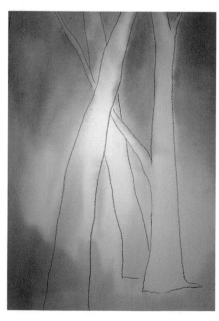

STAGE 1: GENERAL UNDERWASH AND FOREGROUND TREES

Wet your paper. With the three lightest-valued trees—those in the foreground—traced onto your watercolor paper, lay in a neutral blue at the top and base of the painting using the wet-on-wet procedure. Drop in some permanent rose next to it. Do not paint the trees. The paint will create soft edges in the water, so paint a little away from the edges of the trees. Leave a white, unpainted oval in the center of the painting. Dry your painting.

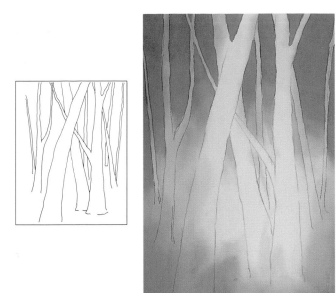

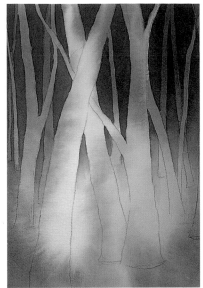

STAGE 2: NEGATIVE PAINT MID-DISTANCE TREES

When your paper is dry, pencil in the medium-distance trees.

Starting on the left-hand side of your paper (or right-hand side if you are left-handed), wet a section between two trees.

With your #14 round brush, lay in a deeper blue wash between the trees starting at the top of the paper, using a limited wet-on-wet process. Soften the lower edges where applicable with your 1" flat brush. Paint between the remaining trees, including the original ones. Dry your painting.

STAGE 3: DISTANT TREES

Repeat the last stage, penciling in more trees when the paper is dry. Then negative paint them.

STAGE 4: FORM AND CORE SHADOWS ON TREES; DISTANT HILLS

Work each tree individually. Lightly wet one whole tree. With your #14 round brush, lay in the form shadow in neutral blue, just as you did when painting the lighthouse in the previous lesson. Remember which direction your light is coming from. Lay pigment on less than half the shadow side of the tree, since the paint will creep. While the paint is still wet, add a touch of cobalt blue to your neutral blue and drop in the line of core shadow with your #8 brush. Cobalt blue does not spread when applied wet-on-wet and so is easy to use in this instance. Dry your painting. Repeat this procedure for all the trees in the foreground. You may want to put shadows on some distant trees. Dry your painting.

When your paper is completely dry, pencil in the line of the background hills.

Negative paint the hills using a dark shade of blue behind them. The hard-edged dark hill line will draw the eye especially if you make it low where the nearby snow is very light. You can soften this hard edge just as you softened the horizon line in the previous lesson.

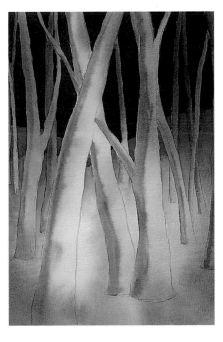

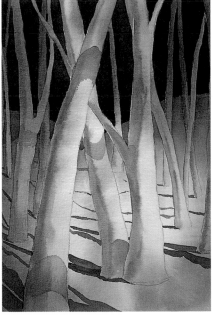

STAGE 5: CAST SHADOWS ON GROUND

Cast shadows will appear and disappear and look thicker or thinner according to the contours of the land and the angles of incline. Paint the cast shadows in a fairly dark shade of blue, making sure to connect them with the trees that cast them. They will be harder-edged near the trees and softer farther away from them.

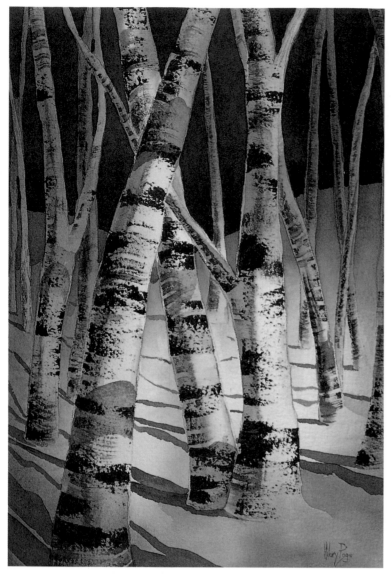

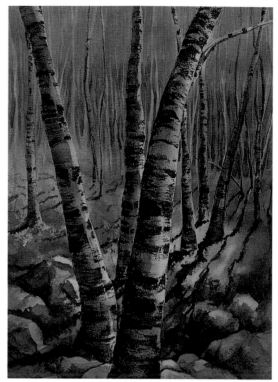

FALL BIRCHES, 28 × 22" (71.2 × 55.9 cm).

This painting shows a similar scene imagined in the fall. Try one yourself following the stages described in this lesson but using the appropriate colors.

STAGE 6: BARK TEXTURE; CAST SHADOWS ON TREES

To make the characteristic splits and imperfections in the birches' bark, dip your blade into a thick blob of Prussian blue, permanent rose, and a touch of aureolin. Don't worry if you contaminate each successive blob. Smear the paint along the edge of the blade. The paint on the blade should be of a width that is the same size as the bark markings are to be, which must be in appropriate proportion to the size of your tree. Drag your paint-laden blade from the shadow side of the tree around to the lighter side, and from the other side back to the center. The gap in the middle is the highlight. The bark markings should be downward-curving arcs as you look up the tree, upward-curving arcs as you look downward, and straight lines where your view is at eye level.

Shadows cast from one tree to another will curve according to the light source, the angle of the branch that is casting the shadow, and the angle of the branch that receives it. Refer to the photographs on page 59. Decide where these cast shadows belong according to the requirements of your particular trees.

Squint at your painting to see if the underlying abstract shapes and lines make a pleasing design. Scrutinize your painting in a mirror. If necessary, add glazing washes of permanent rose to deepen values. Dry your painting.

LESSON 3 *The Behavior of Light and Shadows*

Sometimes a subject sits before you that makes you want to dispense with preparation and just take off and paint. That was how I was feeling as I studied a bunch of sunlit bananas. I was particularly excited about the interesting shadows one banana cast onto another and onto the ground. Knowing the transient nature of shadows, I quickly grabbed the nearest pencil—a #2 office pencil—and made an annotated value sketch.

I had a short time to paint not only because of the sun but also because it was dinnertime and my family was as usual waiting for dinner to appear on the table. I dispensed with drawing and painted directly on the paper. Why don't you try this approach too? It will sharpen your powers of observation immeasurably. My painting turned out fresh, and when I came to do a more studied version, I tried to emulate what I had captured in my first, spontaneous effort.

DEMONSTRATION
BANANAS

CONCEPT: Study of light and shadows on a bunch of sunlit bananas

SEEING: Values of light, reflected light, and cast shadows; reflected color in shadows of light-colored subject on white ground

DRAWING: Value sketch; line drawing on prepared acetate

PAINTING: Direct painting; glazing; using neutral colors

PAPER: 8 1/2 × 11" sheet of 140-lb. Arches cold-pressed

BRUSHES: 1" flat, #14 round, #8 round, #3 round or rigger, scrubber brush

COLORS: Gamboge, permanent rose, permanent blue

ALSO: Sketchbook, mat with opening the same size as your watercolor paper, prepared acetate, water-based felt-tip pen, 6B graphite, 3B pencil

SEEING

By studying the progression from the sunlit white cylinder to the white banana to the yellow banana, you will know what values to expect when you start your painting. When the local colors of subject and ground are different, as they are here, then you have to take into account how those colors affect shadow behavior. You must judge the relative values of form and cast shadows by their actual appearance; you cannot simply assume that the cast shadow will be darker than the form shadow.

Study the photo of the striped cylinder on a white ground, which shows how colors become more neutral when in shadow. In sunlight, the yellow, red, and blue local colors are bright. The form shadow of each is reasonably neutral. The core shadow, the darkest in value, is very neutral and dull. You will remember from the "Autumn Leaves" lesson that you make a color neutral by adding to it a touch of its complement. To neutralize and darken a color further, you add progressively more of the complement.

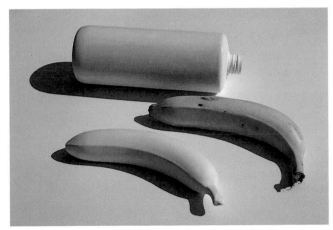

Compare the behavior of light and shadows on the plain white cylinder, the white banana, and the yellow banana.

Note how color reflects from the stripes on the cylinder into its cast shadow, and how the colors become more neutral as they receive less light.

Now look at the photo of the sunlit bunch of bananas and answer these questions. What colors do you see reflected in the cast shadow? Where do you see light reflected in the form shadows? Finally, pick up a bunch of bananas and compare and contrast them. How many flat sides does each banana have? Are the sides even and always constructed in the same way? Where do color changes take place? Where is the banana green? Where do the brown areas occur? The artist has to know the answers to these visual questions to be able to paint. The artist is the eyes for the layman.

Observe these characteristics of a white or colored horizontal cylinder on a white ground:

1. The cast shadow is very dark directly below the curved part of the cylinder because there is little light to be reflected there.
2. Some neutral color is reflected from the object into the cast shadow.
3. Much light and color are reflected from one surface onto another as the cylinder curves to face the light.
4. On the banana, the core shadow is a dark, neutral yellow band between light and shade.
5. The highlight is a light, straight, horizontal band.

DRAWING

Arrange your subject in a pleasing configuration of interesting positive and negative shapes, taking into consideration the drama of light and shade. You are in effect designing your composition. Your viewer's attention will be drawn to the areas of greatest value contrast, so carefully consider how the light falls on your subject. You might try setting your subject in sunlight. This will make you work quickly, because shadows will change before your eyes. Alternatively, set your bananas under artificial blue plant light so you get strong shadows. Think about the total composition. A bunch of bananas set in the middle of white paper is not as interesting as having one or two separate bananas set at interesting angles on or near the rest, and with some cropped as they bleed off the paper.

If a banana is placed so you are looking at it from any position other than a straight-on, horizontal viewpoint, the drawing will require some foreshortening. Drawing foreshortened objects is hard, but prepared acetate is a great help. Make yourself a transparent drawing surface by taping a sheet of prepared acetate to your clear Plexiglas board or to a mat that has an opening the

same size as your watercolor paper. View your subject through the acetate, holding it straight in front of you and close to your subject so the subject is the size you want it to appear on your paper. Close one eye, and then, with a water-based felt-tip marker or a brushful of dark-valued paint (permanent blue is fine), trace around the banana shapes and shadows on the acetate. You'll be surprised at the strange shapes foreshortened bananas make—I had one that looked like a tadpole! Thinking in terms of such shape comparisons will help you draw foreshortened objects in the future. You can wipe the acetate clean and use it again for another composition.

Using a light table or window, transfer your line drawing to watercolor paper. If you drew your subject on the acetate too small, enlarge the drawing on a photocopier; alternatively, make a grid over the image and another on your watercolor paper, then copy the lines of the original image in correct position and size following the grid on your watercolor paper.

It's always helpful to make a value sketch before you start to paint. Be sure to assess values in the overall composition, not just in isolated areas. A visualizing mat will help you with this.

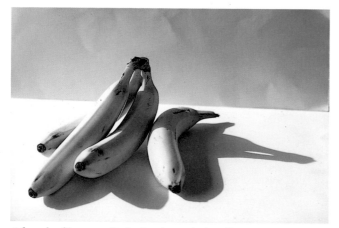

A bunch of bananas lit by bright sunlight offers interesting shadow shapes for a painting.

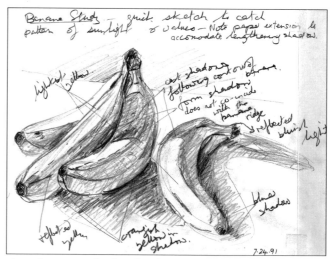

A quick annotated value sketch is a good way to assess values. For this sketch I used just a regular #2 office pencil.

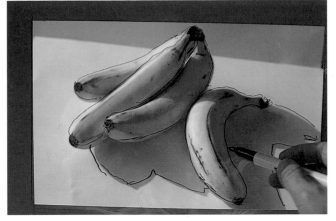

Making a drawing on prepared acetate is helpful when you're trying to render the shapes of objects that are foreshortened.

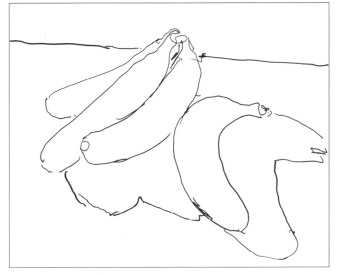

Line drawing made on acetate.

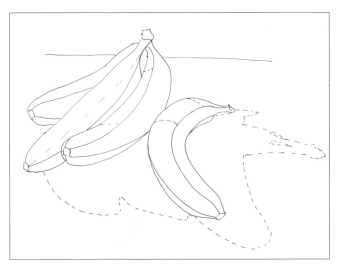

Line drawing showing cast shadow outlines.

UNDERSTANDING FORESHORTENING

Foreshortening refers to the apparent shortening of an object due to visual perspective.

To observe foreshortening in cylindrical forms, study the photographs shown here, in which I used three pens of equal size as examples for comparison. The first example shows the three pens held in different positions, all horizontal to the viewer. The second example shows the three pens held in different positions at an angle to the viewer. In both instances the cylindrical forms appear progressively shorter when viewed from near-frontal to frontal positions. Because of the effects of perspective, they also appear to narrow as they recede in space. These observations will be very useful to you when drawing many foreshortened cylindrical forms, including arms and legs on the human form.

To study foreshortening, hold one or more pens or other small cylindrical objects in your hand and angle them in various ways. With one eye closed, observe how the forms seem to shorten as you rotate them. Memorize the foreshortened shapes.

PAINTING

You will need two palettes for this painting. In palette 1, by mixing gamboge, permanent rose, and permanent blue with water, you'll create a neutral, mustard yellow for the yellow form shadows and reflected yellow in the cast shadows. In palette 2, mix a mauve-blue for the cast shadows and background from permanent rose, permanent blue, and a touch of gamboge.

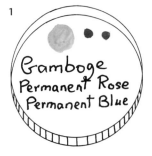

1

Gamboge
Permanent Rose
Permanent Blue

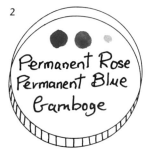

2

Permanent Rose
Permanent Blue
Gamboge

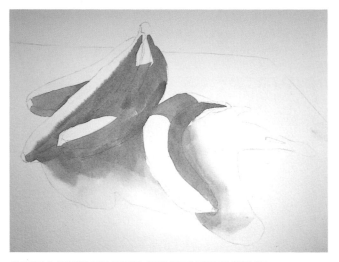

STAGE 1: FORM SHADOWS AND REFLECTED COLOR

Start with dry paper. Using your 1" brush, pick up your slightly neutral, mustard-yellow color to paint yellow form shadows and reflected yellow in the cast shadows directly under the bananas. Soften edges in the cast shadow with the corner of your 1" brush as you did in the "Misty Mountain" lesson in the basic techniques chapter. Dry your painting.

STAGE 2: CAST SHADOWS ON GROUND

Load your #8 round brush with deep yellow and your 1" flat with mauve-blue. With your #14 round, gently rewet the total shadow cast on the ground; then quickly drop in mauve-blue on the shadow edges (which in sunlight will be hard-edged), and yellow pigment where yellow is reflected from the sunlit part of the bananas into the shadow. Soften the outside edge if necessary with a semimoist clean brush. Dry your painting.

STAGE 3: CAST SHADOWS ON BANANAS

Study hues in the shadow cast by one banana onto another banana. They will be deeper and more neutral than those of the form shadow, so add a touch more blue and rose to your yellow palette to mix this color. Make sure you paint the shadows so they follow the contour of the banana.

STAGE 4: LIGHT SIDES OF BANANAS; DETAILS

Working one banana at a time, wet the light side of the banana and then drop in pale yellow pigment. Make sure you leave the highlight. While the area is wet, drop in a darker core shadow in a deeper, more neutral yellow where the light side of the banana meets the shadow side—if this occurs at a point other than one of the ridges.

Add some blue to the remaining yellow to make a green and, using a small brush, paint greens as they occur at the tails and stems of the bananas.

Mix a light brown by adding a touch of permanent rose and gamboge to your green, perhaps with a touch of blue if needed. Use this color for details of the bananas' tails and stems. Also with this color, drybrush some typical brown imperfections at the ridges. You may wish to use a very light spatter of brown to create some characteristic spots. Cover any areas you do not want spattered. Dry your painting.

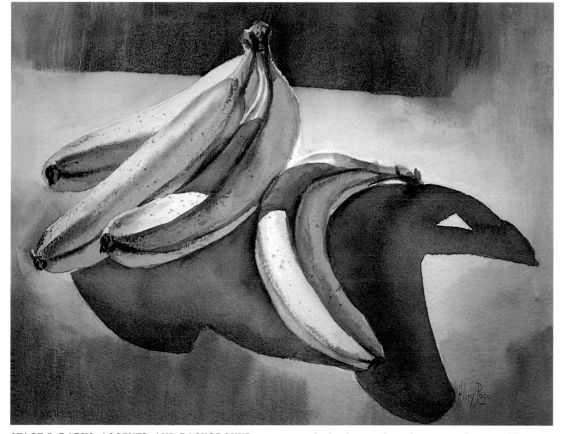

STAGE 5: DARKS, ACCENTS, AND BACKGROUND

Do not rewet the bananas. Dark browns are made by adding more pigments to your light brown; use them to add details to the stem and tail.

Paint a thin, dark blue band where the banana rests on the ground. Restate other values if necessary. Dry your painting.

In a lighter mauve, negative paint around the light front edges of the bananas. Not only does this emphasize lightness, but also it draws the viewer to the interesting shapes of the cast and form shadows. Drybrush or soften these edges as you move away from the banana.

The background can be a neutral mauve-blue color, which complements and thus emphasizes the yellow bananas. It must not be too intense or it will compete with the yellow color of your subject for the viewer's attention. The vertical back plane can be darker where it touches the bananas to draw the viewer to the lighter forms. Wet the area and drop in paint using the limited wet-on-wet technique.

If by mistake you've lost some whites, a scrubber brush is a helpful tool for retrieving them. It's also useful for softening edges. You scrub the offending area with it and wipe off the disturbed paint with a tissue. Dry your painting.

If you like a challenge, then painting a transparent glass is for you. A water-filled glass causes an object seen through it to appear magnified and distorted. This is because the shape and density of the glass and water make the vessel act as a lens.

Study the behavior of distortions and reflections by observing various setups. Start with a very simple arrangement, eliminating distractions by placing black mat board or fabric behind and below your glass, as in the photograph at left below, so you can see subtle light reflected off the surface of the glass. Next, place your glass on fabric and slide a piece of white mat board behind it, as in the center photo. Because of the white background, you can see that the colored cloth on which the glass rests is reflected in the water's surface.

DEMONSTRATION
GLEAMING GLASS
STUDY

CONCEPT: Realistic study of a water-filled glass with flower against a patterned background

SEEING: Understanding reflections, highlights, and distortions made by water in a glass cylinder

DRAWING: Line drawing of an even-sided curved object showing ellipses; "values" of transparent glass

PAINTING: Wet-on-wet; direct washes; softening hard edges; using masking fluid

PAPER: 1/8 or 1/4 sheet of 140-lb. Arches cold-pressed or rough

BRUSHES: 1" flat, #14 and #8 round, and #3 round or rigger

COLORS: Permanent blue, permanent rose, gamboge, Winsor green

ALSO: Sketchbook, tracing paper, 6B graphite, 3B pencil

SEEING

For your painting setup, try to get a balance between interesting detail and strong composition. For the featured study, I placed a striped fabric behind and under my glass. I then slid a piece of white mat board at an angle and halfway behind the glass, not only because it makes an interesting shape division in the composition but also because it clearly shows how the cloth on the left side of the background is reflected in the right side of the glass.

Here are some observations of the featured setup:
1. Images in the glass generally appear hard-edged.
2. The background image is seen in reverse, reflected in the opposite side of the glass.
3. The ground on which the glass rests is reflected on the surface of the water.

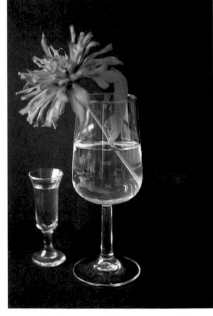

To study the optical phenomena of glass and water, start with a simple setup like this one, set against black to eliminate distracting detail.

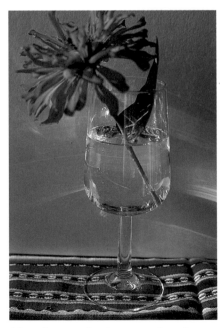

Now observe what happens when the background is light and you place a brightly striped piece of cloth underneath the glass. Note how the cloth reflects in the water's surface.

Setup for the painting. Note how the cloth at left in the background reflects in the right side of the glass.

4. The flower stem appears to deflect at the water's surface.
5. The stem appears to deflect a second time at the front ellipse of the water's surface.
6. The stem appears magnified when viewed through the glass's "belly."
7. Within the glass, light becomes magnified and extremely bright in highlights, often haloed by a thin, dark band of spectrum colors.
8. The area where you would expect a dark cast shadow is light because light is magnified as it passes through the water.
9. Highlights reflected on the outside of the glass are sometimes quite subtle and are not as bright as the intensified highlights that appear inside the glass.
10. Glass will appear lighter than any dark background it is set against.
11. Glass will appear to be about the same value as any light background it is set against, but the sides, rim, and base will appear darker.

DRAWING

An easy way to make a glass symmetrical is to lightly sketch it on drawing paper in the position and size you want it to be in the painting. Then on a sheet of tracing paper just a little larger than the glass, trace over your outline. Fold the tracing in two and, with a sharpened 3B pencil, even out the sides of the glass. Next, lay the tracing face down on your original drawing. Trace over your penciled lines on the backside so the graphite on the front transfers to your drawing paper. Then transfer the completed line drawing to your watercolor paper. The dark areas on my line drawing indicate where to place masking fluid to preserve white highlights in the painting.

An ellipse is a squashed circle. In a transparent cylinder, such as a glass, you can see a series of ellipses whose shapes vary according to your

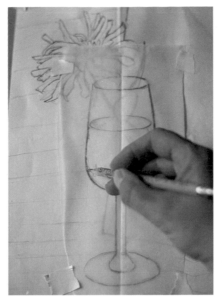

Tracing paper can help you achieve symmetry in your drawing of the glass.

Rings painted around a transparent cylinder become ellipses as you look throught the object. Seen from straight on, the ellipse becomes a straight line.

viewpoint. In a water-filled glass they appear at the top, water level, and base, and must be rendered in correct perspective. Study the photograph of the transparent cylinder around which I've painted five rings, pink on the outside and white on the inside. When you look straight down into the cylinder, you see a circle; at eye level you see a straight line. Otherwise, these rings

In the line drawing, dark areas indicate where to apply masking fluid to preserve white paper for highlights on the glass.

This is an illustration of how not to draw ellipses—with pointed, arrow-shaped ends.

appear as ellipses. Ellipses become progressively rounder as you look up or down at the cylinder. The outside ring goes downward at each edge when you are looking up at it. The outside ring appears to turn upward when you are looking down at it. Remember, though, that an ellipse is a curved form, not a pointed one; beginners often make the edges of an ellipse look like arrows.

The chief difficulty of making a value sketch of glass, especially of glass against a white background, is that the subject itself is intrinsically light in value, yet the magnified, focused highlights, which are a chief characteristic of a water-filled glass vessel, are much lighter than the white of your paper. You thus have to trick the viewer into perceiving these highlights to be lighter than they really are. You can achieve this optical illusion through simultaneous value contrast, whose principles are explained in the box at right below. To make your value sketch of the glass, follow these steps:

1. View the glass through a visualizing mat and identify the lights and magnified highlights.
2. On your drawing paper, lightly shade in the image with graphite except where the highlights occur. You will need to place a tissue on your work after this stage so you don't smudge it thereafter.
3. Surround highlights with a thin, dark, hard-edged ring so they will appear lighter than they really are.

4. Continue combining "masses" of values and working from light to dark as you would for any representational value sketch.

PAINTING

When working with a multicolored subject such as this one, you will need to adjust and combine some palettes. Remember to squeeze the paint onto the upper part of the palette. Use your #8 brush to mix the paint with water, and leave some of the original blobs intact. In palette 1,

mix a neutral gray from gamboge, permanent rose, and permanent blue. In palette 2, mix a green for the leaf and stem of the flower from gamboge and permanent blue. After you have painted the leaf and stem, wipe off the mixed paint and add Winsor green. In palette 3, mix an orange for the flower and fabric from gamboge and permanent rose. In palette 4, mix permanent blue with water for the blue part of the fabric. In palette 5, mix permanent rose with water for the pink part of the fabric.

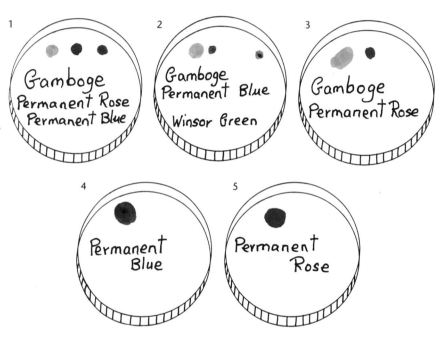

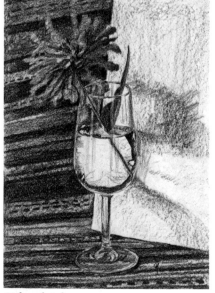

Value sketch.

SIMULTANEOUS ACHROMATIC VALUE CONTRAST

1. *Hard-edged areas appear to have high value contrast.*
2. *Soft-edged areas appear to have less value contrast.*
3. *A white area surrounded by hard-edged dark appears to expand.*
4. *A hard-edged dark area surrounded by white appears to contract.*
5. *Adjacent grays seem darker as a darker hard edge meets a lighter one.*
6. *To make a light area appear lighter, surround it with a hard-edged dark.*
7. *To make a light area appear darker, surround it with a hard-edged light.*
8. *To make a dark area appear darker, surround it with a hard-edged light.*
9. *To make a dark area appear lighter, surround it with an even darker dark.*
10. *To modify a value contrast, i.e., make a dark appear less dark, soften the edge.*

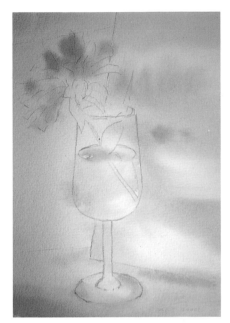

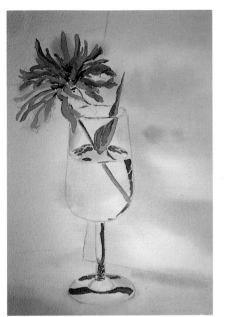

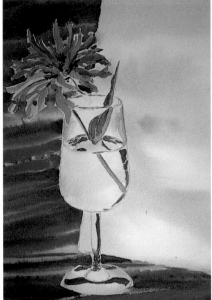

STAGE 1: SHADOWS ON WHITE BACKGROUND

On dry paper, apply masking fluid to mask out magnified highlights.

In preparation for the wet-on-wet technique, wet your paper and lay it on tissues on a flat board. Lay in a very light neutral gray wash to tone your paper so the highlights show up. Drop in shadows according to your value sketch. Tint your shadows so they reflect or lean toward colors near them, such as orange from the flower. Dry your painting.

STAGE 2: LEAF, STEM, FLOWER, AND GLASS

Paint the first light green wash on the leaf and stem, faithfully recording how the stem deflects as it crosses the water's surface. Drop in the stem's darker form shadow while the first wash is still wet.

Lay in the flower's first light orange wash. Return to the leaf and lay in a second wash of darker green. Return to the flower and lay in deeper orange hues.

Lay in bright, individual colored shapes of the fabric reflected in the glass. You'll need to use a small brush.

STAGE 3: FABRIC BACKGROUND

Thoroughly wet the fabric area, even that seen through the glass above the water level (but not the fabric reflected in the water). Be careful as you paint water around the flower. Keep wetting this area for about ten minutes so the paper is thoroughly soaked but not swimming in surface water. Lay your paper on tissues to avoid backruns.

Lay in fabric colors. Edges will merge. Note that the fabric seen through the glass above the water level is lighter, so paint it that way. Dry your painting.

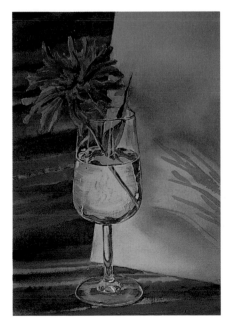

STAGE 4: GLASS SURFACE AND REFLECTIONS

Add gray tone at either side of the glass (apparent because of the thickness of the glass).

Drybrush neutral gray onto the glass surface at the edges and some in the center to indicate the ever-moving, magnified background seen through the glass of water. It's hard to take a photograph of a water-filled glass because it is almost impossible to keep the image still. Look at fabric through a glass of water and you will see what I mean.

Hold your damp 1" brush vertically and agitate it to create straight lines indicating reflections on the surface of the glass, then lift off pigment. Restate

values if necessary. Add dark accents around the rim and where the glass rests on the fabric.

If you need to deepen shadows, rewet the area before you drop in pigment. Emphasize the glass by deepening dark hues adjacent to it. As I worked, the sun's position changed, causing the flower to cast unusual-looking shadows on the background. On impulse I abandoned my preliminary value sketch and laid in these shadows. Such impulsive painting can dilute the impact of your original intent. However, a student pointed out to me that the shadows echo stripes in the fabric and as such are in character. Because they are transient, they also add interest and a feeling for the passage of time.

THE CUBE

Our study of the cube includes learning about linear perspective and its practical applications to drawing and painting buildings, the main theme of this chapter. You will learn how to manipulate perspective to create specific effects such as adding drama or a feeling of flatness to a scene. Although our focus is on buildings, the cube has other artistic applications.

The watercolor demonstrations in this chapter are a painting of a plowed field to illustrate one-point perspective; a painting of an old post office to illustrate two-point perspective; and a painting of a country store to illustrate the use of three-point perspective. The lessons further explore phenomena of light, shadows, and color as they occur on exterior and interior surfaces of the cube form.

OLD VON MINDEN HOTEL SCHULENBURG, 22 × 30" (55.9 × 76.20 cm).

Three-point perspective is utilized in this painting to convey the feeling of the height and size of the building.

The Cube and Linear Perspective

The geometric cube is a solid form bounded by six equal squares. The rectangular solid is a modification of the cube, with outer surfaces consisting of three pairs of different rectangles. Take a minute to count the six surfaces of this book to envisage these three pairs of parallel surfaces. Other modified cube forms are boxes, benches, and gasoline pumps. In various photographs throughout this chapter, the models used to illustrate perspective have been color-coded with blue lines to indicate height (surfaces, planes, or edges), red lines to indicate length, and green lines to indicate depth.

Linear perspective provides a system that enables you to portray a solid, three-dimensional form such as a book on a flat surface such as your drawing or watercolor paper.

How does linear perspective work? Imagine standing in the center of railroad tracks and looking along the tracks straight ahead of you through a sheet of glass. You know that the ties are of equal size and are positioned at equal intervals along the track. You know that the tracks are parallel and will never meet. Yet as you look into the distance, the ties appear to become smaller in size and positioned closer together, and the parallel tracks appear to meet at a point on the horizon, where they vanish. Still imagining that you're viewing this scene through a sheet of glass, imagine tracing onto its surface with a black marker the railroad tracks and the horizon line—which is level with your eyes—just as they appear. You would trace the tracks not as parallel lines, even though you know that they are indeed parallel and

therefore can never intersect, but as lines that converge at a point on the horizon line, the eye line.

When drawing a cube, you are representing not just one of the surfaces, but all three of the form's parallel systems—height (coded blue), length (coded red), and depth (coded green)—all of which, like the railroad tracks drawn in perspective, meet at three separate "vanishing points" on the eye lines. How these sets of lines appear in perspective, and how many vanishing points you'll need to draw the object—one, two, or three—depends on the angle at which the cube

or any object is placed and the angle at which you view it.

If you are to understand perspective you must become conversant with its concepts and terminology. You will probably not master all the concepts at once, but if you persevere, you will learn at least enough to help you draw and paint buildings successfully. For most such work you really need to master only one- and two-point perspective. Once you've done that, three-point perspective will be relatively easy to understand. It is useful when you want to add drama and interest to your work.

A perfect geometric cube, like the one in the foreground, is a solid form comprised of three identical pairs of square sides.

The rectangular block is a modification of the cube. Its outer surfaces consist of three pairs of different rectangles.

Railroad tracks seen in perspective. The rails are parallel, but seen in perspective, they appear to meet at a single vanishing point on the eye line.

From the side, you can see that the rails are parallel lines and the ties are the same size and equidistant.

73

Point: Dot marking a position in space

Parallel lines: Lines on a plane that when extended in either direction will never meet

Right angle: 90-degree angle at the intersection of a vertical and horizontal line

Diagonal: Straight line joining opposite angles of a rectilinear form

Geometric cube: Solid form comprised of three identical pairs of square sides that relate to the three systems of parallel planes: height, length, and depth

Rectangular block: Solid form consisting of three pairs of different rectangles that relate to the three systems of parallel planes: height, length, and depth

Picture plane: Imaginary plane that lies between you and the object you are viewing. It extends to the edges of your peripheral vision and will always be at right angles to your direction of vision line. A visualizing mat through which you view a subject provides a frame for this imaginary plane and becomes synonymous with it.

Direction of vision point: Point marking the exact direction of vision

Direction of vision line: Imaginary line joining the viewer's eyes and the exact point on the object being viewed

Horizontal eye line: In one- and two-point perspective, a horizontal line that passes through the direction of vision point; symbol for an imaginary plane level with the viewer's eyes and synonymous with the horizon in the viewer's field of vision. The vanishing points of objects drawn in one- and two-point perspective are located on the horizontal eye line.

Vertical eye line: In three-point perspective, a vertical line that passes through the direction of vision point; symbol for an imaginary vertical plane level with the viewer's eyes. The third vanishing point of an object drawn in three-point perspective is located on this line.

Vanishing points: Points located on the eye lines where each of the three systems of parallel lines of the cube meet. In one- and two-point perspective, vanishing points for the length and depth systems are located on the horizontal eye line; in three-point perspective, the vanishing point for the height system of parallel lines is on the vertical eye line.

Parallel lines

Right angle

Diagonal

This diagram shows the position of the viewer—his direction of vision point and his picture plane/frame—relative to the object in, at left, a two-point perspective viewpoint and, at right, a one-point perspective viewpoint.

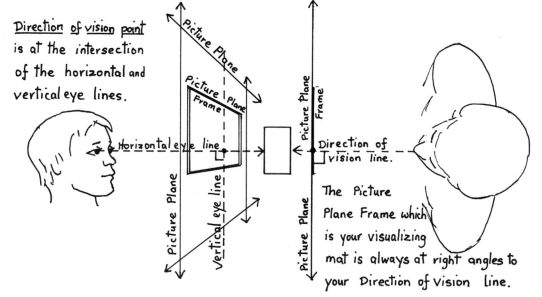

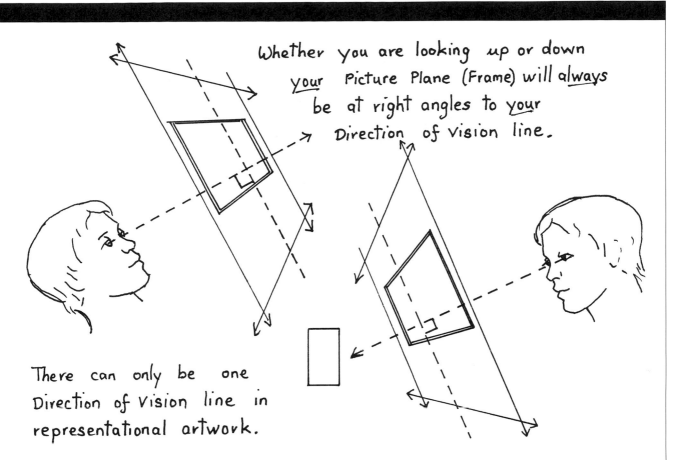

Whether you are looking up or down your Picture Plane (Frame) will always be at right angles to your Direction of vision line.

There can only be one Direction of Vision line in representational artwork.

This diagram shows the position of the viewer—his direction of vision point and his picture plane/frame—relative to the object in three-point perspective viewpoints.

Height lines are BLUE. LENGTH LINES are RED

Vanishing Point
LENGTH

DEPTH LINES are GREEN

VANISHING POINT
DEPTH

BUILDING WITH BACK PORCH

Height lines are blue, length lines red, depth lines green. The broken line is the eye line. This building is drawn in two-point perspective: Two of its three systems of parallel lines—length and depth—are not parallel to the picture plane. When extended they meet at two separate vanishing points.

The following definitions of one-, two-, and three-point perspective apply to buildings or blocks resting on a flat surface and viewed through a visualizing mat. They also apply to the photographs of the models shown here.

ONE-POINT PERSPECTIVE

A building portrayed in one-point perspective has one system of parallel lines, the depth lines, that are not parallel to the picture plane frame. These lines meet on the horizontal eye line at one vanishing point. To draw a building in one-point perspective, look straight on at the building placed squarely in front of you.

TWO-POINT PERSPECTIVE

A building portrayed in two-point perspective has two systems of parallel lines, the depth and length lines, that are not parallel to the picture plane frame. These lines, if extended, would meet on the horizontal eye line at two separate vanishing points. All height lines will be both vertical and parallel to the picture plane frame. To draw a building in two-point perspective, look straight on at the building as it faces you at an angle.

THREE-POINT PERSPECTIVE

A building portrayed in three-point perspective has none of the three parallel systems of the cube—depth, length, and height—parallel to the picture plane frame. If extended, these lines would meet respectively at three separate vanishing points on the horizontal and vertical eye lines. To draw a building in three-point perspective, look up or down at the building as it faces you at an angle in a closeup view.

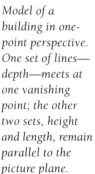

Model of a building in one-point perspective. One set of lines—depth—meets at one vanishing point; the other two sets, height and length, remain parallel to the picture plane.

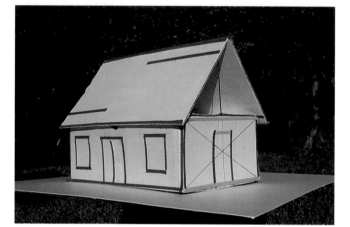

Model in two-point perspective. Two sets of lines—length and depth—meet at two vanishing points; the other set of lines, height, remains parallel to the picture plane.

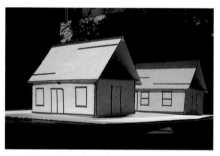

Buildings that face the same direction have the same length and depth vanishing points on the eye line.

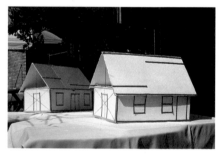

Buildings that face in different directions have different length and depth vanishing points on the same eye line.

Model in three-point perspective. All three sets of lines meet at three different vanishing points; none of the sets of lines is parallel to the picture plane.

Understanding Two-Point Perspective

Many buildings you'll come across when on location can be drawn in two-point perspective, which is simple to understand if you work through the following procedure. Once you have worked through the exercise and seen how to draw buildings in perspective, then you can dispense with the rules. You will know what to anticipate when faced with a building and will be able to judge angles as accurately as needed for painterly interpretations.

The featured building is a block with a slanted roof. The upward-slanting surface has a separate vanishing point not mapped in the demonstration.

DEMONSTRATION
DRAWING A BUILDING IN TWO-POINT PERSPECTIVE

CONCEPT: Line drawing of a simple building showing construction lines for two-point perspective

SEEING: Angle of length and depth lines

DRAWING: Using a visualizing mat to help gauge angles; optional use of colored markers to distinguish length, depth, and height lines

PAPER: 11 × 14" sketchbook

ALSO: Visualizing mat, 3B pencil, eraser; red, blue, and green fine-point colored markers (optional)

SEEING

If you are working on location, set yourself back a little from the building you are drawing and view it from an angle.

DRAWING

Make sure your building is small and that you have plenty of space on your paper for the construction lines. When you come to gauge the angle of the length and depth lines, view the building through your visualizing mat. Lay your pencil against the mat in alignment with the building's length line (which could be the gutter) and depth line when you are trying to estimate an angle. You will then replicate the angle of the length and depth lines, and extend them to establish the two vanishing points. Remember that in two-point perspective, all height lines are verticals.

1. Draw a small picture plane frame in your sketchbook. If working from a photograph, make a frame of similar size around the building. If working on location, view your subject through a visualizing mat.

2. Gauge general proportions and lightly sketch a small building within the picture plane frame. You will then redraw the building in perspective in a darker shade on top of this guide drawing as you work through the procedure.

3. Draw the vertical line to represent the corner of the building that is nearest to you. Put a point on the vertical to indicate your eye level—a plane level with your eyes. If you are sitting on the ground, the point will be low on the vertical. If you are sitting on a ladder, the point will be high on the vertical.

4. Lightly draw a horizontal eye line that passes through the eye level point.

eye line

5. Eyeball (guess) the angle of the top (not roof) length line. Extend the length line at an angle downward to cross the eye line at **vanishing point length**.

VANISHING POINT
LENGTH

6. Draw the lower length line from the base of the vertical upward to **vanishing point length**. Note the cone shape these lines make.

VPL

7. Eyeball and then draw the farthest vertical to make a quadrilateral shape for the "length" side of the building. Your original light drawing will probably help you place this line. Note that in two-point perspective all height lines are vertical.

8. Eyeball and then draw the depth line, which angles downward from the other side of the nearest vertical. Extend the line downward to cross the eye line at **vanishing point depth**.

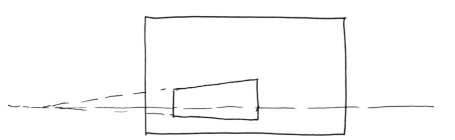

VANISHING
POINT DEPTH

9. Draw the lower depth line from the base of the vertical upward to **vanishing point depth**. Do you see the double cone shapes these lines make?

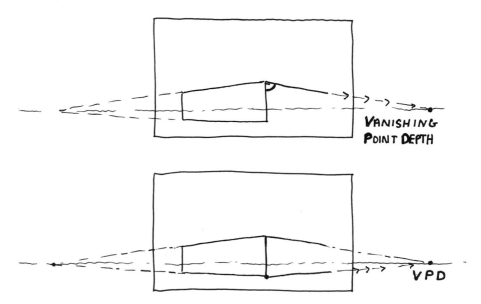

VPD

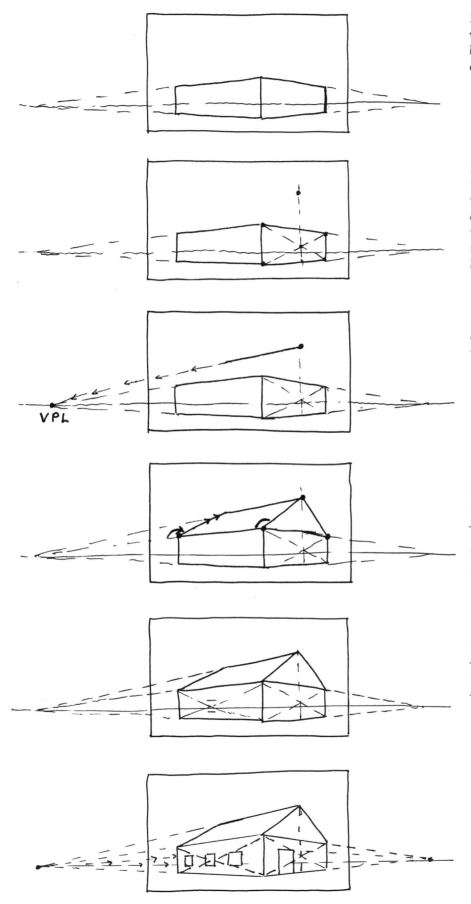

10. Eyeball and then draw the farthest vertical to form the "depth" side of the house. Maybe you judged this correctly on your original sketch.

11. For the roof, join diagonals on the "depth" side of the building. Draw a vertical through the point where the diagonals meet. Eyeball a point on this vertical to indicate the top corner of the roof. Again, your original sketch will help you gauge this.

12. Draw the top roof line from the point on the vertical going downward to **vanishing point length**.

13. For the near side of the roof, draw a line from the top of the vertical to touch the top of the roof line. The slant on the far side must make a flatter angle (where indicated) than the one on the near side. Continue this line until it meets the top roof line.

14. To add windows and doors, join diagonals on the front of the building to find the center point. Lightly plot the top and bottom of the center window on the front side. All window and door lines on the same side of a building, apart from the verticals, slant downward to either a length or depth vanishing point.

15. Lightly draw construction lines from **vanishing point length** through the top and bottom of the window. Eyeball the size of the windows. Draw verticals for windows. Can you see the fan shape made by construction lines from both vanishing points? Top and base lines make imaginary cone shapes from the tallest corner vertical nearest to you.

VPL

Whether you are painting landscapes or buildings, you will need to go out in the field to do so. So, let's go on a short side trip to get you started painting on location. No art education is complete unless you study light, shade, color, and form "en plein air," as the French impressionists called it. This is the only way you will see the subtle range of light and colors photographs simply can't convey. Here are some tips:

- **Basics.** You will need your basic drawing and painting equipment, including a visualizing mat. In addition, you'll need a bottle of water; an umbrella (for sun or rain); a folding chair or stool; a portable easel (if you have one); refreshments; and, depending on climate, blankets, sunscreen, and insect repellent.

- **Paper.** I precut watercolor paper to the desired size, though occasionally I use a full sheet. Sometimes I use a pad of hot-pressed drawing paper, which works well for loose watercolor washes and pen and ink. Occasionally I precut little acid-free mat boards to paint on.

- **Paints.** You need only a minimum. For most on-location subjects I use permanent rose, aureolin, and permanent blue, with the addition of alizarin crimson and Prussian blue for dark values. I often have the paint squeezed out before I arrive at my destination.

- **Watercolor pencils.** These are easy to handle when sketching on location and they enable you to record color. However, you still must gauge values. You can wet the paper and then draw the color into the water, or draw and then selectively blend colors with a dampened brush.

- **Cameras.** A Polaroid camera is useful for catching fleeting, interesting shadow patterns, though I tend to be a purist; photographs can take the edge off the experience to the detriment of the painting. A regular camera is useful for recording information if you don't have time to finish your painting on site, but don't overuse it. The camera gives a cozy feeling that you can "always work from a photograph."

- **Position.** Sitting so the sun is to one side of you gives you the best light to portray form. Sitting with the sun directly in front of you can be interesting but is extremely hard on the eyes. The sun directly behind you will flatten your subject because there will be no shade to imply form, as when you use a flash in photography. I use an adjustable

sun umbrella attached to a pole that can be driven into the ground. It is invaluable for providing shade on sunny days and shelter from rain!

- **Comfort.** Rarely are conditions perfect, which is one of the challenges of painting on location. Dress appropriately and have either a hot or cold drink handy. I usually either sit on the ground and spread my equipment comfortably around me, or I stand at my portable easel.

- **Safety.** In remote places it's a good idea to paint with a friend. I've never had any problems painting by myself in areas where there are people around.

- **Painting with an audience.** Typically, people will stand bang in front of you, between you and your subject, so it's impossible to continue. They then ask you what you are painting! Don't be intimidated by people watching you. Most wish they were sitting there enjoying themselves too.

- **Subject matter.** Although you may start by painting simple landscapes, inevitably you will find yourself wanting to paint buildings—requiring some understanding of perspective.

- **Use the visualizing mat.** To limit the wealth of subject matter you will be faced with, frame your subject with your visualizing mat. Inexperienced painters will try to include everything they see, while the informed see broad masses and limit details.

- **Start with a line drawing.** Although I often paint direct (without pencil lines) when on location, most people feel more comfortable if they draw first. So make a simple, light line drawing of your subject to get the general placement, then come in with heavier lines.

- **Study shading.** Squint and observe your subject through closed eyelashes so all detail is obliterated and broad masses of light and dark areas become apparent. Too often the overall effect of a painting or drawing is weakened because it contains no middle values.

- **Remember negative and positive.** Inexperienced artists draw everything they see as "positive," as a dark subject on a light background. A "negative" subject is one that is light against a dark background. Check your subject and ask yourself, "Which is lighter, the subject or the background?"

THE ALAMO, 15 × 22" (38.1 × 55.9 cm), private collection.

Painting on location has been a main source of inspiration for me.

Composing in One-Point Perspective

One-point perspective is the simplest to portray, so we will start with a scene that visually is like many parallel railroad tracks laid side by side. The inspiration for this painting came to me as images of plowed fields and farms repeatedly flashed past me while I was driving through the Texas Panhandle. I made a mental note that such a scene would make an interesting composition. Knowing that it would be an unpopular request to ask my husband to stop the car, I thus imprinted the images in my memory. Much later, I turned them into *Plowed Field with Distant Farm*. You, too, can use memorable images culled from similarly unpromising situations as a springboard for inspiration.

DEMONSTRATION
PLOWED FIELD WITH
DISTANT FARM

CONCEPT: Create a feeling of space

SEEING: Observe how one-point perspective works in the landscape

DRAWING: One-point perspective; eye line; vanishing point

PAINTING: Wet-on-wet; graded washes in color sequence

PAPER: 1/8 to 1/4 sheet of 140-lb. Arches cold-pressed

BRUSHES: 1" flat, rigger, #8 round

COLORS: Burnt sienna, permanent blue, gamboge, alizarin crimson

ALSO: 3B pencil, sketchbook, 6B graphite, spray bottle

SEEING

When you face the direction of the light source to look at the furrows, they will appear dark, because you are seeing their shadow side. When you do not face the light source, the furrows will appear light, because you are seeing their illuminated side.

DRAWING

Start with a line drawing of the furrows in one-point perspective. Make a 5 × 7" frame in your sketchbook. Draw a horizontal line a little under a third of the way across your paper. This is your eye line. About a third of the way along it, mark a spot indicating your exact direction of vision. This will be the one vanishing point for the furrows. Draw furrow lines from the point to the edge of the paper. Drawn in perspective, these lines will make a fan shape. The plowed field is in one-point perspective because only one system of parallel lines, the depth lines, are not parallel to the picture plane. Since the field is flat it does not have height lines.

Now make a value sketch using the line drawing as a guide. To help you maintain consistent light and shadow, draw an arrow just outside the frame to indicate an oblique light source. My light source is from the east (top right). Using graphite or a 3B pencil, shade in values in the same stages you will use for succeeding watercolor washes. The direction in which the furrows lead the eye is so powerful that you will need to place the farmhouse at the vanishing point.

On your watercolor paper you need to draw only the horizon line. The furrow lines and building are not necessary at this stage.

The lines representing the furrows in the field all converge at a single vanishing point on the horizon line, which is synonymous with the eye line.

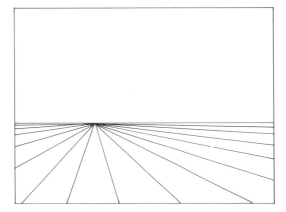

Value sketch, with arrow to show direction of light source.

PAINTING

For this painting you will need five palettes. Mix your colors with water using your #8 brush and about a teaspoonful of water in each palette.

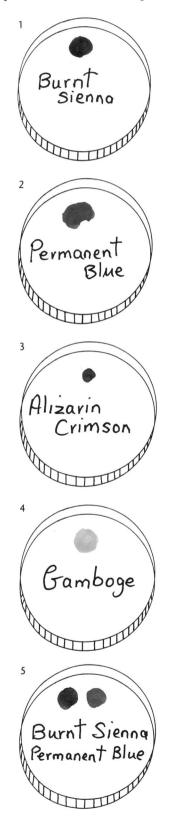

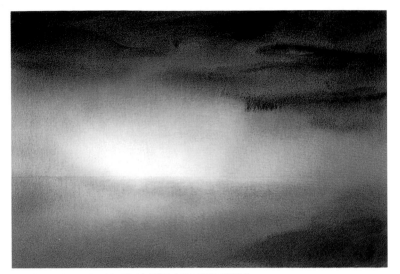

STAGE 1: UNDERPAINTING FOR SKY AND FIELD

Have your value sketch handy. With your 1" flat brush, lightly wet your paper front and back to keep it flat, then lay it on a slightly tilted board on top of a rag, paper towel, or tissues.

With your 1" flat brush, using a small amount of gamboge, paint a doughnut shape, leaving the center white where the house will be. Next, pick up a touch of alizarin crimson and paint another larger, uneven circle that overlaps the yellow. Alizarin crimson is a powerful pigment and will spread and dominate your whole paper unless you are careful. Third, make a ring of burnt sienna. The top, deeper part of the sky can be permanent blue followed by a mixture of permanent blue and burnt sienna. This deep hue will be echoed in the lower part of the plowed field at a later stage.

Once the shine has left your paper, do NOT add more pigment or you will get watermarks, which are not appropriate for a calm sky. If you have to go back in, let your painting dry, and then rewet it with a mist sprayer. Only when it is shiny can you add more pigment. Dry your painting.

STAGE 2: FIELD

Using burnt sienna, lay in the field, making it darker by adding permanent blue toward the base and on the side from which the sun is shining. Do not paint the furrows yet, but while the paint is still wet, wipe off a light area where the tree trunk is to be. Dry your painting.

Soften the horizon by painting a thin line of water along the hard edge. Then wipe off the water, making one strong movement across the paper.

STAGE 3: HOUSE, DISTANT TREES, AND FURROWS

In a light spot on the horizon, lightly pencil in the building. This will be the approximate position of your vanishing point. The building can be drawn as if you were facing it from straight on or sideways.

Negative paint the house by painting trees in burnt sienna and permanent blue around it. The shaded side of the white house will be lighter than the background trees. Sensitively add windows and doors (they look more artistic if not placed symmetrically).

At the furrows' vanishing point, which will be just in front of the house, start a furrow using your pointed #8 or rigger brush. Press lightly at first and gradually increase pressure to make the furrow wider as you progress downward. The furrows will make a fan formation from the vanishing point.

With your clean, damp 1" brush held flush with the light side of the furrows, wet the area and agitate the pigment a little, then, with a bold action, swipe the paint off with a tissue.

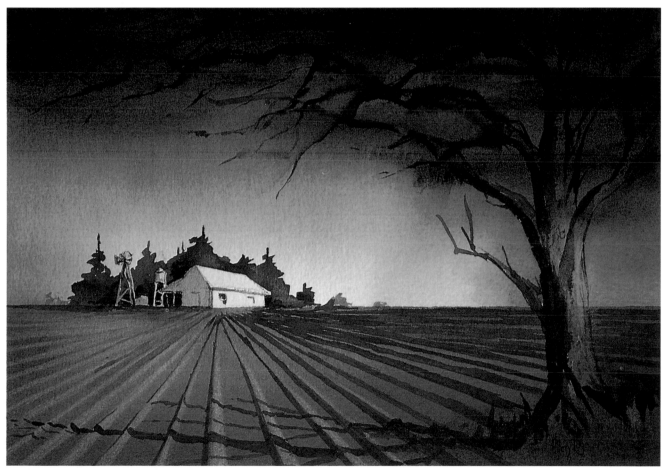

STAGE 4: FOREGROUND TREE AND SHADOWS

Paint the foreground tree using a dark mix of permanent blue and burnt sienna. You can make interesting painterly branches by streaking the sky with water and then using your rigger to paint branches into the dampened area. Branches will be hard-edged wherever the paper is dry and diffused wherever it is wet. Dry your painting.

To make the tree stand out more, you may need to lift off some pigment from the light side of the trunk or darken a small area of sky adjacent to the light.

Paint the dark tree shadows, making them jump over the furrows to create a magical effect and help define their angles. Add darks and accents, and adjust values where necessary.

Composing in Two-Point Perspective

This lesson provides the opportunity to portray a building in two-point perspective and to study light and shadows on a gray subject, Clodine Post Office. Because this is a typical country store, you can adapt the lesson to any similar building.

Legend has it that "Clodine" was named for Claudine, a child who lived here at the turn of the century. Owners of the horse and buggy who would give the ever-late little girl a ride to school would shout, "Claudine! Claudine!" If you sit around painting, you'll be given a wealth of details about your subject.

you need to consider how one color continually affects the appearance of another. The photographs of folded, striped colored paper shown here illustrate the effect of green and of white on neutral colors typical of most buildings. Remember that only colors in direct light or light colors can influence colors in shade. In the photograph at bottom left, sunlit green and white are reflected onto colors that are in shadow, just as green grass might reflect on a house. You can see how much the local colors are influenced by the green reflected light and white reflected light when you compare the little

patches of sunlit color in the foreground with the same colors in shadow. The order is reversed in the photograph at bottom right, in which the sunlit colors influence the green and white stripes, which this time are in shade. Such color influence occurs when a colored building in sunlight reflects its color into a green area of foliage or grass that is in shade.

DRAWING

Make a line drawing of Clodine Post Office (or a similar store) in two-point perspective, adapting the procedure described in lesson 1. The building is easy to draw, since it is a

CONCEPT: Realistic, nostalgic painting of an old country post office

SEEING: Gauging form and cast shadow values on a gray subject

DRAWING: Line drawing in perspective; shade and shadows; simplifying and combining masses

PAINTING: Direct washes; wet-on-wet; drybrush; using masking fluid

PAPER: 1/4 or 1/2 sheet of 140-lb. Arches cold-pressed or rough

BRUSHES: 1" flat, rigger, #8 round (1/4", 1/2", and 2" flats are useful if you have them)

COLORS: Burnt sienna, permanent blue, gamboge, Prussian blue, permanent rose, alizarin crimson

ALSO: Masking fluid, 6B graphite

Clodine Post Office.

Local colors in shade are influenced by sunlit green and white reflected onto them. The little patches show the same local colors in sunlight.

Note the difference between the value range of the white cube and that of the gray cube in sunlit and shadow areas.

Green and white in shade are influenced by local colors reflected onto them. The green stripe in the foreground is the same local color as the green stripes that are in shadow.

SEEING

When the local color of a building is not white, such as Clodine Post Office, the contrast between light and dark values will not be quite so marked, as illustrated by the comparison of white and gray cubes.

Since many buildings are surrounded by green grass and trees,

simple cube form with the front extended and with a little triangle placed on top in the center. Remember, you start off by drawing the tallest vertical that is closest to you. If you are on location, look at your subject through a visualizing mat to frame your composition.

It is always worth your while to make a value study. I have one student who does not have the patience to make a graphite value sketch, but give her gray paint and she makes a fine study in five minutes. I have another student who will spend the whole three-hour class making a detailed value study. You have to go with your own personality.

PAINTING

In palette 1, mix a watery gray from permanent blue and burnt sienna for the building's first wash; for a darker gray, add more permanent blue. In palette 2, mix a light yellowish green for the trees from gamboge, permanent blue, and Prussian blue with a hint of permanent rose; for a deeper green, which can have a thicker consistency, add more of the blues. Add a touch of alizarin crimson for an even darker green. In palette 3, mix a light blue for the sky from permanent blue and Prussian blue. In palette 4, mix an orange from permanent rose and gamboge; for a deeper orange, add burnt sienna.

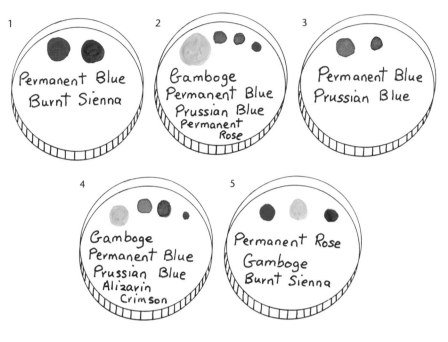

Line drawing of Clodine Post Office. Heavier black areas indicate where masking fluid is to be applied.

Value sketch.

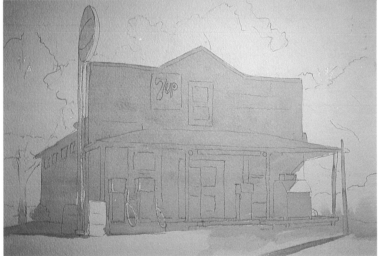

STAGE 1: MASKING AND FIRST WASH

Apply liquid mask to areas indicated by heavy blacks in the line drawing: hoses on the gas pumps, the light side of the signpost, the light part of the building by the ice chest, the sky seen through the branches near the center of the trees, and any other areas you wish to keep light.

On dry watercolor paper, with your board slightly tilted, use your 1" flat brush to lay in an even, light gray wash over the whole building including the shadow side of the Gulf sign. Add streaks of brown for the rust patches on the top part of the building. Continue the wash into the building's cast shadow, but don't paint the orange barrel. Dry your painting.

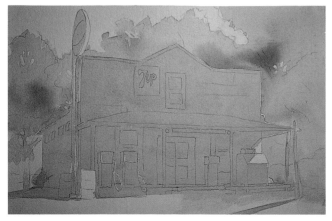

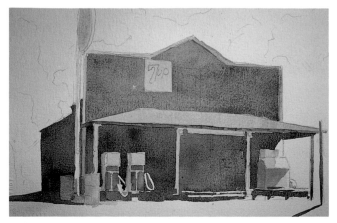

STAGE 2: TREES

Using your 1" brush, sparingly spread clear water over the tree area. Lay in a varied, yellowish-green and gold wash over the total tree area. Drybrush the tree edges next to the sky by laying your brush horizontally and lightly stroking paint into the paper. Dry your painting.

STAGE 3: BUILDING

Using a slightly deeper blue-gray color, lay in a wash on the top part of the building, but do not paint the top edge of the building, the 7UP sign, or the porch roof. Also with blue-gray, paint the side of the building and the cast shadows of building and pole. (To focus the instructions, this stage is a re-creation, which is why the trees do not appear here.)

Using a slightly browner gray, paint inside the porch, the T design of the gas pump, and the rust on the ice chest. Don't paint the pillars and the orange barrel. Dry your painting.

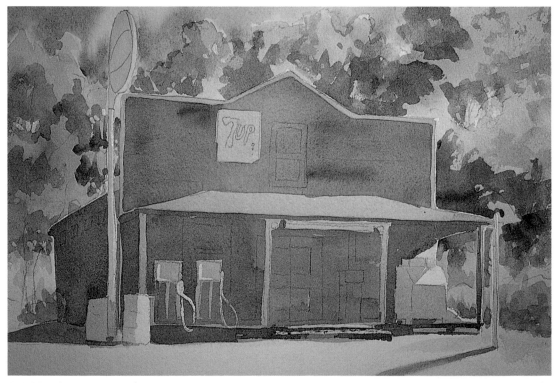

STAGE 4: SKY AND TREES

Wet the sky area. Drop in blue for the sky, but leave a white cloud behind the Gulf sign. Drybrush edges next to the trees. Optional: Drop in burnt sienna and permanent blue (your building color) for the underside of the cloud.

In a deeper green of thicker consistency, drybrush the form shadow areas of the trees. The edges should be particularly jagged where the light meets the

form shadow. Often students leave a gap between the building and the tree when the tree is growing from behind the building. Be sure to paint darker green right up to the edge of the building. While the paint is still wet but not shiny, scrape out branches in the dark areas above the building. Dry your painting.

When your painting is completely dry, rub off all masking fluid with a rubber cement eraser or with the pad of your index finger.

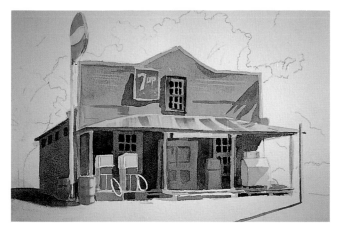

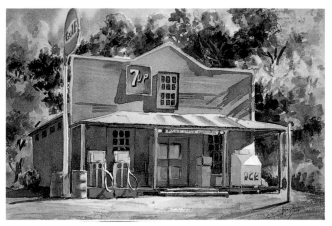

STAGE 5: BUILDING

(Re-creation) Using a deeper blue-gray, paint the shadows cast by the top window, the 7UP sign, and the trees. Lift out some of the "corrugated" lines if necessary by agitating your damp 1" brush held horizontally.

Paint the inside walls of the porch an even darker, warm gray that reflects the gravel. Negative paint the window and door areas by painting around them.

Darken the building's cast shadow and the pole's cast shadow.

In a slightly darker gray, paint the dark windowpanes. The easiest way to do this is to make one stroke using a small flat brush the same length (or width) of the pane. If you do not have a brush this size, use your #8 round brush. Paint the rectangular outline of each pane and fill in the center. Make some panes darker than others to add variety.

Using orange, negative paint the 7UP, the darker side of the barrels, and the orange part of the Gulf sign.

Add burnt sienna to orange and then drybrush rust on the porch roof. A small flat brush—1/4" or 1/2"—works well for this. If you don't have one, use your #8 brush with the hairs splayed. Add rust to the Gulf sign.

STAGE 6: TREES, SKY, SHADOWS, DETAILS, FOREGROUND

Add a touch of alizarin crimson and Prussian blue to your green to make a thick, dark green. Drybrush the dark accents.

Use a gray to positive paint the tree trunk and some branches.

Using a fine brush, paint all the lettering—Gulf, Post Office Clodine, Ice, and the dark part of the 7UP sign.

Add dark accents. A building or barrels or anything resting on a surface needs to be "anchored" to the ground. A dark line often accomplishes this. Add a wavy line for the corrugated edge of the porch roof and the shadow sides of the pump hoses.

Lay in light orange near the building and blue in the foreground. A slightly deeper value at the top and bottom of your painting will help lead the viewer's eye to the subject. Make shadows as per your value sketch to break the horizontal foreground. They will be greenish near the trees. If you want some texture for the dirt road, cover your painting except there and spatter the area.

LETTERING

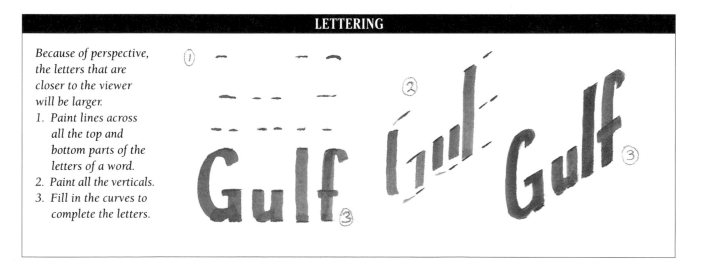

Because of perspective, the letters that are closer to the viewer will be larger.
1. Paint lines across all the top and bottom parts of the letters of a word.
2. Paint all the verticals.
3. Fill in the curves to complete the letters.

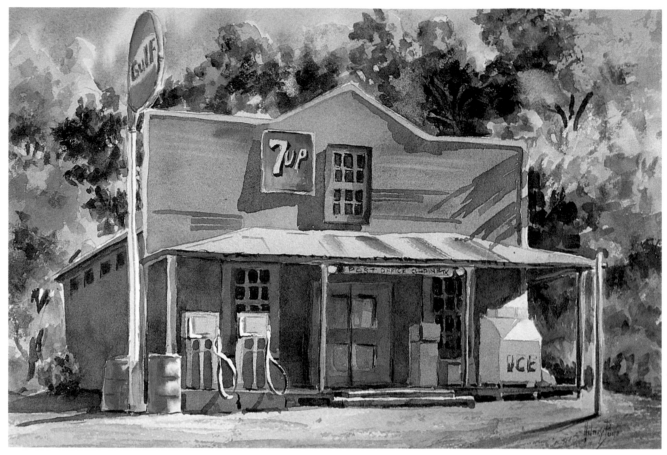

STAGE 7: ADJUSTING VALUES

Some values, notably those of the pillars, top window frame, sides of the ice chest, and pumps, may need darkening.

CLODINE MIST, 15 × 22"
(38.1 × 55.9 cm),
collection of Homco
International.

*I painted this scene
as a demonstration
from under my
umbrella one wet,
cold February day. I
thought the weather
added atmosphere.
Many participants,
not so enthusiastic,
painted from inside
their cars. One
member kept such a
cramped position to
avoid the rain that
she injured her back.
Such is the way of
painting on location!*

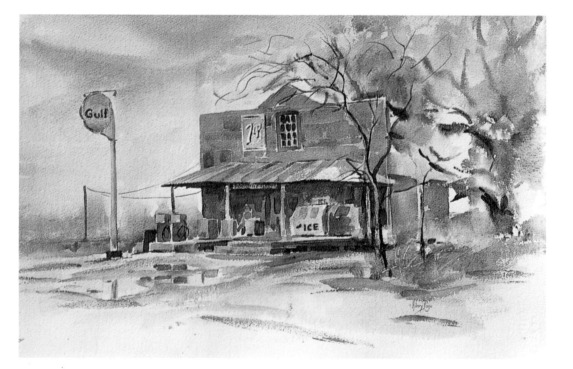

Composing in Three-Point Perspective

Portraying a subject in three-point perspective can be a challenge, but your grasp of one- and two-point perspective should serve you well.

Before you begin to paint this next subject, a white building with a porch, it will be useful to study the behavior of shadow, light, and reflected color on the basic geometric forms of which it is constructed. The implications of the ways one color influences another are far-reaching. After you have looked closely at the sequence of photographs shown here, it will not be possible to take the "coloring book" approach to painting—coloring objects in a composition individually.

This folded, randomly striped sheet of paper gives you some indication of the extent to which one color influences another. This example shows you local colors illuminated by direct sunlight and in shade.

The white cube on a white ground in sunlight has a form shadow—the shadow side of the form, which is lighter than the cast shadow.

Above and top: Because of the phenomenon of reflected light, the form shadow under the eaves and porch is lighter than the cast shadow, as both the model and an actual building shown here illustrate. This is particularly evident on sunny days, though it is subtly apparent when the sky is overcast.

Here you see the same piece of paper as in the example above but illuminated so that the stripes in direct light reflect their light and color onto the stripes in shadow, influencing those hues accordingly. Observe the color of the yellow stripe when influenced by blue reflected light.

Note how the colors of the striped ground reflect color into the form shadow, enabling you to pinpoint the source of reflected light. Notice the considerable value variations within the form and cast shadows. The variation is always dependent on the colors and values of adjacent objects.

A shadowed porch model is interesting to study, for in it appears a veritable rainbow of colors reflected from adjacent, lighter colored objects.

This time the stripes are illuminated from the opposite direction. Note how much the yellow in shade is influenced by the red reflected light. The yellow is no longer recognizable.

CONCEPT: Convey the quaintness of an old store from an interesting viewpoint

SEEING: Shadows and reflected colors

DRAWING: Draw a building in three-point perspective; consolidate individual objects into large masses

PAINTING: Wet-on-wet; wet-on-dry; mixing neutral shadow colors; adding calligraphy for details

PAPER: 11 × 14" sketchbook; 140-lb. Arches cold-pressed

BRUSHES: 1" and 2" flats; #8 round; #3 round or rigger

COLORS: Aureolin, permanent rose, Prussian blue

ALSO: 3B pencil, 6B graphite

SEEING

Most people assume that the sky is the lightest part of a scene. The photograph of Juergen's store, below, graphically shows that this is not the case. Shadows throughout are highly influenced by the solid blue sky and are thus blue in tone. As an artist, you have the option of deemphasizing the blue "coolness." Inside the porch there will be much greater variation in reflected color. This lesson is a practical application of the knowledge you gained from studying the preceding photographs.

DRAWING

It is not necessary to do an architectural rendering in perfect perspective every time you draw a building. Just use your knowledge of perspective to attain a desired effect. One-point perspective creates a flat appearance; two-point perspective is representative; three-point perspective creates drama. Three-point perspective, traditionally used to portray high-rise buildings, can be used to make a mundane subject more interesting, as it has been used here in the close, upward-looking viewpoint chosen for the painting of Juergen's store.

You are probably saying to yourself, "How on earth can I manage three-point perspective?" Easy. It's only one step beyond two-point perspective. You know that when portraying a building in two-point perspective, all height lines are parallel verticals. Well, in three-point perspective, the outside height lines bend inward a little toward a vertical line, which is in fact your vertical eye line. So when portraying a building in three-point perspective, all you have to think about beyond two-point perspective are the slightly inclined height lines.

Make your line drawing of the building to scale on sketch paper and then transfer it to watercolor paper. I added the old man sitting on the bench because you'll always find local residents "passing the time 'o day" on such a porch. Actually, "George" happened to be the model at our weekly figure-painting session, and I saw that he would be perfect for the painting.

Study the photograph and decide where you want your center of interest to be. Then make a 5 × 7" value sketch in which you use value contrast—the juxtaposition of hard-edged lights and darks—to draw the viewer's eye to the spot you have chosen. The diagrams showing stages for the watercolor washes can be used for the stages of your value sketch.

PAINTING

Mix all your colors with water. In palette 4, first you'll mix a light green from aureolin with touches of Prussian blue and permanent rose, then, for a darker green, you'll add more Prussian blue and permanent rose. After the initial stages you will be dabbing into all the palettes.

Study the phenomena of shadows and reflected color and light on this white building, which I photographed from a three-point perspective viewpoint using a wide-angle lens.

Line drawing of Juergen's store.

Simplified line drawing showing how none of the edges of the building is parallel to the picture plane. Arrows and color-coded dots indicate the direction of the three vanishing points for height, length, and depth systems of parallel edges or surfaces.

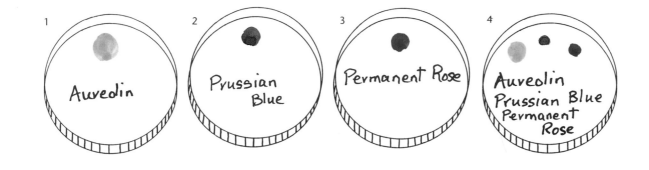

1 Auveolin

2 Prussian Blue

3 Permanent Rose

4 Auveolin
Prussian Blue
Permanent Rose

STAGE 1: UNDERPAINTING FOR REFLECTED LIGHT

Bearing in mind the information you have just studied regarding the amount of illuminated color that bounces from one form to another, use the wet-on-wet technique to lay in underlying reflected colors. Lay in the colors separately, working from light to dark (yellow to blue), and let them mix on the paper. Leave an oval of white as you see here. Indicate green in the tree areas. The black-and-white diagram shows the amount of paper to cover with paint. Dry your painting.

STAGE 2: REFLECTED COLOR IN FORM AND CAST SHADOWS

On dry paper, with your board tilted, lay in the same individual colors in slightly deeper and warmer tones on the front of the building next to the porch roof (reflected color), and in the porch area. Make cast shadows on the ground darker than the form shadows. Dry your painting.

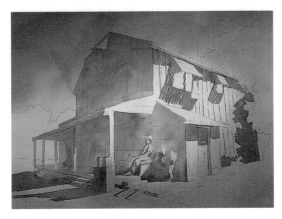

STAGE 3: CAST SHADOWS ON SUNNY SIDE OF BUILDING

In darker hues with more blue and green, lay in shadows cast by the eaves, windows, and trees. Dry your painting.

STAGE 4: SECOND WASH ON TREES; CAST SHADOWS ON GRASS

Drybrush a middle-valued green into the light green of the trees. Leave some light green showing at the edges.

Wet the grass area, then drop in darker, dull green, soft-edged cast shadows. Dry your painting.

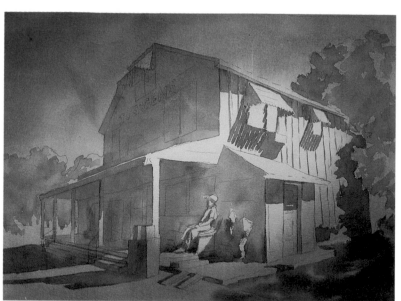

STAGE 5: INSIDE PORCH; UNDERPAINTING FOR WINDOWS

Paint a wash in warm (yellow and rose) neutrals and cool (blue) neutrals as indicated over the total interior area of the porch. Dry your painting.

Underpaint the windows in a neutral gray mixed from the same three colors.

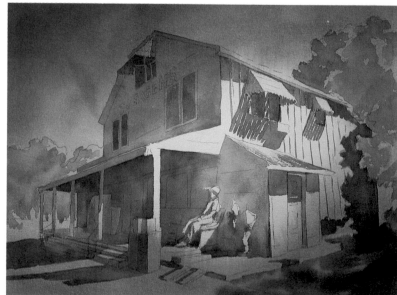

STAGE 6: DARK TREE AREAS; LOWER INNER PORCH AREAS

Drybrush dark greens into the trees.

Paint the lower portion of the porch and negative paint the icebox and other objects in neutral gray. With each additional wash, you deepen the values. Dry your painting.

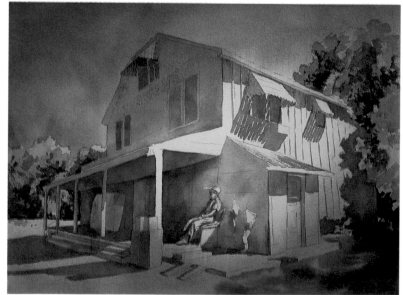

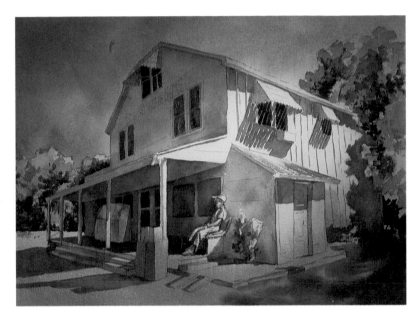

STAGE 7: DARKS IN WINDOWS; READJUST VALUES

You can mix very dark hues by adding permanent rose and a touch of aureolin to Prussian blue, and then modify the color and make it lean toward green, red, or blue by adding more of the appropriate color. Lay in dark hues on the windows.

Emphasize form by darkening edges. General areas should be the values you want before you start the calligraphy.

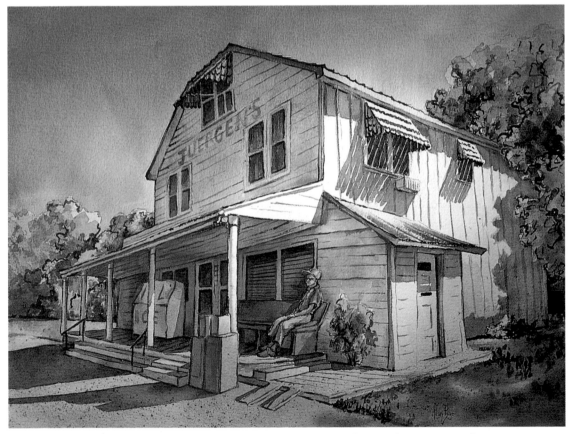

STAGE 8: CALLIGRAPHY AND SPATTERED TEXTURE

In painting, the term calligraphy, meaning "beautiful writing," refers to the use of beautiful lines to portray your subject. Use as much calligraphy as you need to convey the quaintness of the building and the detail in this subject, but don't overdo it. I used calligraphy for the figure of George and for some objects on the porch.

To give the gravel area some authentic texture, you can add a light spatter of paint. To do this, just load your #8 brush with reasonably thick paint of an appropriate color. Before you start, cover any area you don't want spattered. Slightly dampen the paper if you want the spatters to be diffuse.

Stop! It's easy to overwork a painting like this one.

THE OVOID

The ovoid, derived from the sphere, is abundant in nature either as a complete form, such as a lemon or an avocado, or as a partial one, in convex surfaces such as undulating hills or the muscles of the human body (notably the deltoid muscle between the shoulder and arm). The partial ovoid may also be seen in concave surfaces such as flower petals, valleys, and spoons. Our ovoid study covers white eggs on a white ground; sand dunes as an example of a convex ovoid surface in the landscape; magnolias as white concave ovoid surfaces; and bright red amaryllis.

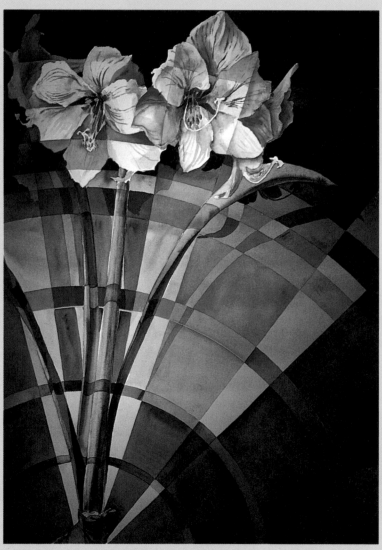

AMARYLLIS '90, 30 × 22" (76.2 × 55.9 cm), collection of Mr. and Mrs. Jesse Perry.

The ovoid reveals itself in this flower in the shapes of the petals. By tradition my son gives me an amaryllis for Christmas every year. He then waits to see the annual amaryllis painting. I solved the problem posed by the long stem by incorporating the blooms into a mirrorlike geometric design.

LESSON 1 *Analyzing the Ovoid Form*

The ovoid differs from the sphere in that it is longer and slightly more pointed at one end while remaining spherical at the other. Its curved surface means that it thus has characteristics of a totally curved form—the perfect sphere—with regard to highlight, light area, core shadow, form shadow, and cast shadow, but the shapes of these characteristics are influenced by the ovoid's deviation from the sphere. When you view the ovoid from its spherical end, as in the center photograph, there is only one way to tell whether the form is an ovoid or sphere. Can you tell from the cast shadows which is which?

Now, first to the refrigerator. We're starting with eggs. A comparison in class showed that unboiled eggs were superior for transparent delicacy to boiled ones. But if unboiled, don't leave them around your studio as long as I did. I noticed not only a greenish cast, but also an unpleasant odor emanating from their direction before I was prompted to discard them. This is one lesson in which we will use smooth-surfaced paper.

DEMONSTRATION
STUDY OF THREE WHITE EGGS ON WHITE

CONCEPT: Realistic rendering of white eggs showing their smooth, curved, transparent qualities

SEEING: Minute value gradations; determining what makes a curved surface appear curved

DRAWING: Five-value sketch in graphite

PAINTING: *Premier coup* wet-on-wet wash on smooth paper

PAPER: 1/8 or 1/4 sheet of 140-lb. Arches hot-pressed (smooth)

BRUSHES: 1" flat, #14 and #8 round, and #3 round or rigger

COLORS: Aureolin, permanent rose, cobalt blue

ALSO: Sketchbook, visualizing mat, 6B graphite, 3B pencil, natural sponge, magnifying glass, spray mist bottle

SEEING

Select three unboiled eggs and lay them on a white matte surface, arranging them at different angles to impart as much information about their form as possible. I have placed the eggs facing front, back, and sideways to show foreshortening and both the pointed and rounded ends.

Also, to create a unified composition, I have made the eggs overlap. In your setup make at least two eggs overlap. The third can be connected to the others by a cast shadow.

To emphasize the smooth, curved nature of the forms, light your subject with soft, indirect light. Direct light flattens form and creates hard-edged cast shadows, destroying the illusion of three dimensions.

To see minute nuances of light and shade it is useful to study the subject enlarged in a magnifying glass. However, you still have to be careful to judge each value relative to the total composition. On a white, matte surface such as the eggshell, the curved *highlight* is not easy to discern, and because of the reduced light reflected off the white paper's surface, the highlight and light will have to be combined in a painting. The *core shadow*, too, is not such a precise arc on an object illuminated by indirect light; it becomes wider and more diffuse. As with a recumbent cylinder, the *cast shadow* of the ovoid is especially dark where the egg rests on the ground because the downward curve of the form reflects little light there.

Compare the ovoid form with the sphere, and compare the shapes of their shadows.

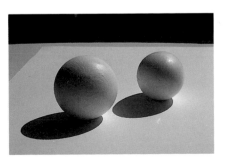

Can you tell which is the perfect sphere, and which is the ovoid viewed from its spherical end?

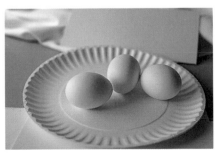

Three unboiled eggs on a white matte surface. Arrange your eggs to show as much about their form as possible. An odd number of objects makes a more pleasing composition than an even number.

DRAWING

The best way to familiarize yourself with the light and shadow behavior of your subject, essential when working wet-on-wet, is to make a five-value sketch similar to the one you did for the onions. The procedure for this is outlined below.

It's harder than you might imagine to draw even, curved surfaces with matching sides. To give you the freedom to erase, work on sketch paper (to scale). Use folded tracing paper for individual eggs to make sure sides are even as you did with the glass study. Transfer your drawing to watercolor paper. Make sure your lines are dark enough, since lines tend to disappear when you apply paint to smooth-surfaced paper in the wet-on-wet technique.

HIGHLIGHTS AND LIGHTS

Squint so you can identify the highlight and light areas on the eggs. Shade everywhere except these two light areas. In the illustration, the area inside the broken lines represents the highlights and lights, which together comprise value 0. The area outside the broken lines represents value 1.

MIDDLE VALUES, FORM AND CAST SHADOWS

Middle values unify a subject. Areas inside this set of broken lines represent value 2. At this stage the cast and form shadows are combined and portrayed as one middle value. Follow the illustration carefully to be sure you don't shade over the light areas.

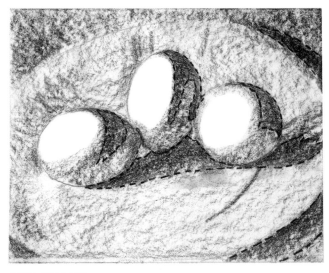

CORE SHADOW

The core shadow is wider and more diffuse on a subject lit with oblique, indirect light because there is less light reflected from the white plate. The areas within this set of broken lines represent value 3.

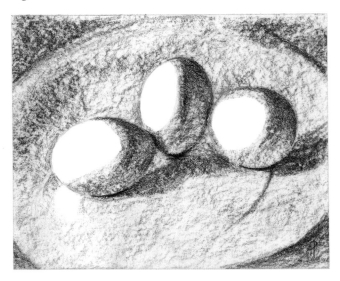

DARK ACCENTS

Dark accents appear underneath the eggs and complete the five-value study.

PAINTING

Mix your colors with water before you start to paint. Use four separate palettes. (More experienced painters can combine palettes.) You will need to squeeze out only a small amount of the individual colors, since this is a small painting. In palette 1, make a slightly mauve, neutral gray from permanent rose, cobalt blue, and aureolin; you will need more of this gray than any other color. In palette 3, make a burnt orange from permanent rose with touches of aureolin and cobalt blue. When you use very wet smooth paper and these particular pigments, the paint will not creep much from where you place it. So long as you gauge your values correctly, you can be quite imaginative in your use of color.

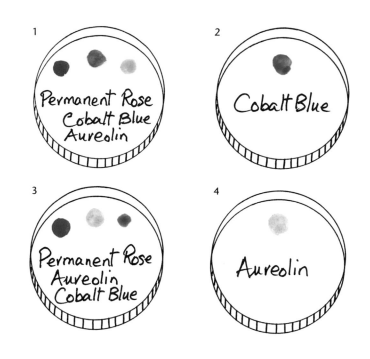

STAGE 1

Using a natural sponge, wet your paper starting with the front, back, and then front again. Spend about seven minutes doing this. Sponge it flat on your Plexiglas board and remove surface water. Your paper needs to be thoroughly wet and absorbent.

Have your value sketch handy. You cannot be interrupted in the middle of painting wet-on-wet.

Using your #14 round brush to portray curved surfaces and your 1" flat for broader areas, lay in your colors, starting with warm yellows and oranges and moving to cool cobalt blue and grays. Referring to your value sketch, start with light values and work into increasingly deeper values. The core shadow is particularly important in giving the illusion of a curved surface. If the paper develops light spots, lay it on a dry surface and agitate the paint with your brush to fill in the spots. This occurs when

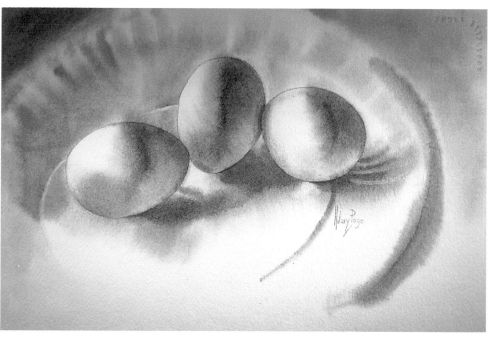

using smooth paper with transparent wet-on-wet.

You can emphasize the eggs' edges by making the forms alternately either lighter or darker than the background.

Add darks directly under the eggs as they rest on the plate. Dry your painting, preferably naturally.

STAGE 2 (OPTIONAL)

For further emphasis you may want to harden an edge by applying pigment to dry paper. With clean water, soften the edge you don't want hard. Do as little of this as possible in your

composition so you keep your painting fresh and spontaneous.

If you want to add soft-edged color, use a spray mist bottle to rewet your dry paper and then drop in pigment. Now do another painting.

LESSON 2 — *Ovoid Forms in a Landscape Subject*

Sand dunes provide a fine example of a partial ovoid surface. Often the curved shadow characteristic of the convex ovoid surface is obscured by dark-valued reeds. Use this as an opportunity to invent shadows to create the illusion of form.

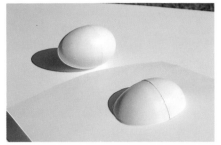

Compare the cast shadow shapes of the whole egg form with the one that has been cut in half lengthwise.

A sand dune is a good example of a partial ovoid form.

DEMONSTRATION
SAND DUNES WITH
RAILROAD VINES

CONCEPT: Hot summer's day in the dunes

SEEING: Underlying convex ovoid surface; depth

DRAWING: Value sketch and line drawing

PAINTING: Using masking fluid and tape for special effects; wet-on-wet; drybrush; using the rigger brush

PAPER: 1/8 or 1/4 sheet of 140-lb. Arches cold-pressed or rough

BRUSHES: 1" flat, #8 round, #3 rigger

COLORS: Gamboge, permanent rose, permanent blue, Prussian blue; yellow ochre optional

ALSO: 3B pencil, 6B graphite

As an artist, you are free to take elements from various sources and arrange them into a more pleasing composition than nature itself sometimes presents.

SEEING

No matter what size your ovoid form is, a vast hill or a tiny ant mound, the shadow shapes formed by sunlight will be the same. Thus, you can study the shadows of a small model like the cut egg from every viewpoint in an instant and apply what you see to a larger subject that has the same underlying form. Study the photograph of the two models, a complete ovoid and one that has been cut lengthwise in half. Note that the cast shadow of the half egg is much smaller than the cast shadow of the complete egg.

Look out your window and gauge where the blue sky is darkest. Barring unusual conditions, it will be darkest high in the sky and lightest at the horizon. To give a feeling of depth and to indicate the deep sky color reflected on the land, you can darken the hues at the top and bottom of your painting and lighten them near the horizon. Deep blue sky will reflect in the ocean and in shadow colors on the dunes, further emphasizing depth.

DRAWING

When you arrive at a scene, invariably conditions and lighting will not be at their most impressive. This is when you, as an artist, can use your knowledge and imagination to create a composition that will catch the eye of the untrained viewer, who won't even realize that the scene is mostly fictitious. Make a creative value sketch by taking elements from various sources such as the photographs shown here of dunes, fence formations, railroad vines, and sea oats. Start your value sketch by drawing a frame measuring about 5 × 7" on your paper. Put an arrow outside the frame to indicate an imaginary light source; then shade values.

The line drawing required for a dune scene is relatively simple; thus, you can use a straightforward grid system to enlarge and transfer your drawing to watercolor paper. Make a cross on your sketch and a cross on your watercolor paper. Copy the dunes and horizon from the sketch onto your watercolor paper one quadrant at a time. The horizon needs to be perfectly level or your viewers will be disturbed as the tilting ocean continually tries to flow off the paper. Two tall fence posts are placed so they break up the otherwise monotonous horizon line. Black pen lines on sea oats, gulls,

fence posts, and vine blooms in the line drawing indicate where to put masking fluid for the scene.

PAINTING

Mix your colors with water. In palette 1, combine gamboge with a touch of permanent rose and permanent blue to make the dune colors. In palette 2, mix colors for the sky and ocean from permanent blue and a small amount of Prussian blue. In palette 3, mix greens from gamboge with a touch of Prussian blue, permanent blue, and even less permanent rose. Palette 4 contains permanent rose for the railroad vine flowers.

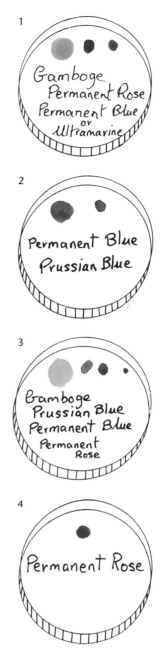

Value sketch of sand dune scene.

Line drawing squared off for transfer to watercolor paper. The black areas on the sea oats, gulls, fence, and flowers indicate where you should apply masking fluid. The black dotted lines on the dunes enclose the horseshoe-shaped areas you should leave unpainted in the first wash.

STAGE 1: DUNES AND SKY UNDERPAINTING

Apply masking fluid to objects that need to stand out from a dark background. In transparent watercolor, brightly colored details have to be painted on white paper, which is why here you need to mask out small elliptical and round flower shapes.

Wet the paper all over. Lay in color over the dune areas, but leave the paper white inside the horseshoe shapes indicated by dark broken lines on the line drawing; these are the parts of the dunes facing the light source. Also drop in a little dune color along the horizon. While the pigment is wet and shiny you can drop in deeper pigment on the shade side of the dunes and in the foreground. If the shine has already disappeared, dry your painting, then repeat the procedure, but this time lay in pigment in the dune area only. Spattering works well at this stage, before the dunes are completely dry. Cover areas on your paper that you don't want bespeckled. Dry your painting.

STAGE 2: SKY AND OCEAN

Rewet sky and ocean. Drop in sky color, making the pigment deeper at the top of your paper. Leave small white areas for clouds. Paint over the ocean but do not make a horizon at this stage. Drybrush waves with the side of your brush at the shoreline. Dry your painting.

STAGE 3: OCEAN, DUNE FORM SHADOWS, REED CAST SHADOWS

Lay in the ocean so it reflects your sky color. Again drybrush waves near the shoreline. Dry your painting.

Lay in form shadows on the dunes. Soften the edges.

Reeds may cast a shadow of a deeper value than the rest of the shadow on the dunes when the sun is at a specific, oblique angle, creating an interesting effect. If you want to include this phenomenon, paint the reeds' cast shadows with a rigger brush before you put in the reeds themselves.

STAGE 4: SEA OATS, REEDS, AND RAILROAD VINES

Depending on their age, sea oats vary in color from a light yellowish green to brown. Add permanent blue or rose to your dune color for the sea oats according to their hue. Permanent blue with gamboge makes a light green; add Prussian blue with a touch of permanent rose for a deeper hue. Some reeds will be the same hue as the sand. Work from light to dark. Painting reeds can be fun, especially if you use a rigger brush. Start painting at the base of the reed and let it grow out as you make a quick flick of your wrist. Dry your painting.

Lift masking fluid. You may now need to darken some reeds slightly.

Permanent rose is a perfect color for the blossoms of the railroad vines; lay this hue in the elliptical white

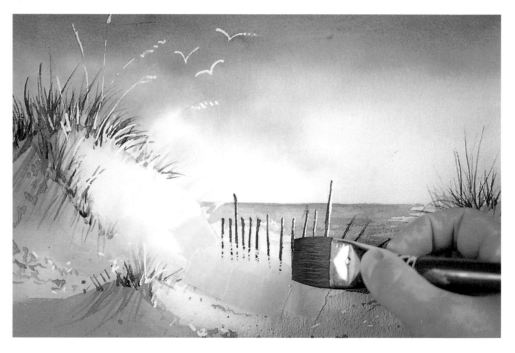

shapes on your paper that had been protected by masking fluid. Vine leaves, painted with a #8 round brush, are a bright green. Use gamboge and a touch of Prussian blue to get this green.

Here is a neat trick for painting the fence: Cover the sloping sand in front of the fence with masking tape. Then, using the straight edge of your 1" flat brush and a deep gray mixed by adding

more blue and rose to the dune palette, paint the shadow side of the fence. Make the fence uneven for interest. Twist the brush as the fence falls. Lift off the tape. Presto! You have a fence behind the dune.

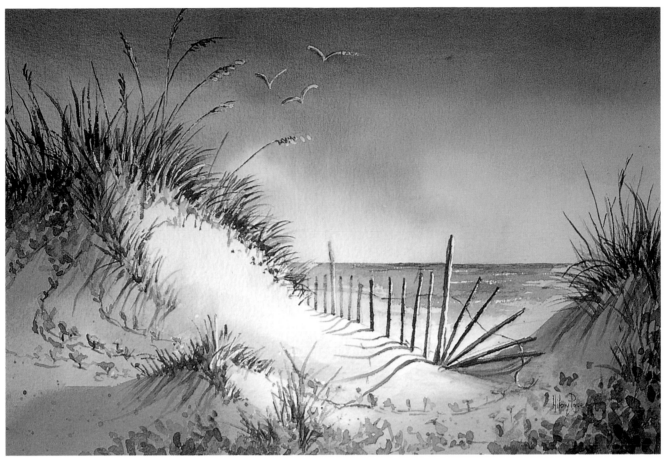

STAGE 5: GULLS, WAVES, ACCENTS, ADJUSTMENTS

Paint the gulls' shadow side in gray. Scrape waves with a blade. Add dark accents and adjust values, making them either darker or lighter where necessary.

Marianne Starbird,
SPINE CONCERTO (panel of a triptych), 22 × 30"
(55.9 × 76.2 cm).

These cacti are examples of upturned ovoid forms. The artist had to mask out each spike individually, then come back in and paint many of the spikes a second time to deepen value and hue.

LESSON 3 *Depicting a Concave Ovoid Surface*

Large, curved white petals of a flowering magnolia tree provide the perfect opportunity for studying the concave, or inside curving, ovoid surface. In the photograph at left below is a sunlit egg sliced in half to reveal the concave interior. You can see that the outer edge of the shadow in this area, where the shadow and light areas meet, is a fraction darker than the rest of the shadow. Away from the edge, the shadow gradually becomes lighter because of reflected light in the form shadow. The point for you to remember is that a shadow on a concave surface is darker on the edge directly adjacent to the light part of the surface.

Like all surfaces, the concave ovoid reflects illuminated colors that face it. The center photograph shows a shadow on a concave surface that is not influenced by an adjacent color. In the photograph at right, an extraneous object casts a shadow onto the concave ovoid; note how much reflected, neutral color appears within the shadow area. This is because bright, sunlit colors can reflect onto less bright surfaces in shadow.

Concave flower petals provide a further challenge in that they are translucent. Because light can pass through a translucent surface, a petal lit from behind can have a lighter value than it might have under different lighting conditions. Once you are aware of how translucency can alter value, you have to consider how it may affect the values of every flower you paint.

DEMONSTRATION
MAGNOLIA MOSAIC

CONCEPT: A mosaic of values and colors of white flowers, dark, shiny leaves, and bright sky

SEEING: Reflected shadow colors and values on a concave white translucent surface; connecting light values

DRAWING: Value sketch using abstract light to dark shapes

PAINTING: Mixing "white" shadow colors; mixing greens; direct painting on dry paper

PAPER: ¼ sheet of 140-lb. Arches cold-pressed or rough (demonstration was done on a full sheet of 300-lb. T. H. Saunders cold-pressed)

BRUSHES: 1" flat, #8 round, #3 rigger; ¼" and ½" flats optional

COLORS: Aureolin, permanent rose, alizarin crimson, cobalt blue, permanent blue, Prussian blue

ALSO: 3B pencil, 6B graphite

SEEING

To become conversant with a subject such as a magnolia you need to study it from life and know the answers to these questions: How many petals are there and how are they placed? What basic structure do the leaves have? If your magnolia has been blooming a couple of days, you will notice that the curved stigmas on the upper part of the pod develop before the straight stamens. Find out as much as you can about a flower prior to painting it.

Before embarking on a magnolia painting, I decided to make a color sketch from my neighbor's magnolia tree, which on that June morning was showing a perfect bloom, perfectly placed for sun and shadows. After taking a minute to pencil broad outline shapes, I stood with a small palette, water container, and rag balanced on my sketchbook and arm and studied the colors as I saw them. The colors reflected in the shadows of the white petals that appeared particularly conspicuous were a cobalt blue hue from the sky, yellows and greens from the surrounding leaves and pod, and pink from the deep red center stem where the stamens had dropped off. I noticed as I squinted that the white

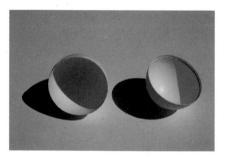

Ovoid model sliced open to reveal concave interior. The model is illuminated by the sun. Study the behavior of shadows on the concave surfaces.

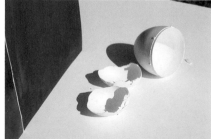

Note how much reflected color (red) appears in the forms' cast shadows and interior shadows.

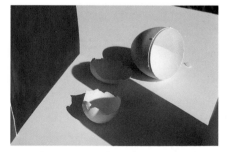

Note how much reflected, neutral color appears within the shadow area when an extraneous object casts a shadow onto the concave ovoid.

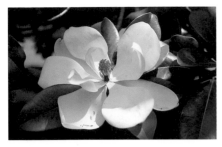

Closeup of magnolia blossom.

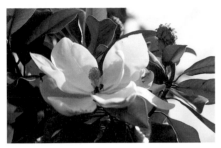

Squint at this photograph to see the mosaic pattern formed by the whites of the flower petals, highlights on the shiny leaves, and sky.

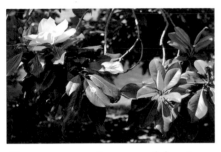

If you want to make a more elaborate composition, study the leaves of the magnolia tree, noting how they grow.

in the flowers, the highlights on the leaves, and the light sky appearing between them were all of the same value and made an interesting mosaic pattern. You will see what I mean if you squint at the center photograph at left. Thus I happened upon a way of portraying the magnolia that seemed appropriate and unusual. I developed this theme and separated individual colors in shadowed petals and leaves to make a more intricate mosaic. This lesson is a wonderful way to sharpen your observation of the nuances of color.

DRAWING

Ideally you need to find yourself a blooming magnolia tree or at least a white flower with large, white petals. If possible, get outdoors and paint the flower as you see it. You will augment your visual memory. Otherwise you can use photographs such as those shown here. If you have fresh cut flowers to work from indoors, a blue plant light focused on your subject will give you acceptably varied shadow colors. Photographs reveal more information if you hold them directly against a light so they are backlit. You will see many more values and colors than you would

under regular lighting conditions.

Make a line drawing of the flower and leaves to scale on sketchbook paper. Crop the flower on your paper if this makes the overall pattern more interesting. Transfer your drawing to watercolor paper using a light table or window.

Using a graphite stick, make a value sketch showing about four values. You not only will be showing the values you see but also will be designing an overall composition. Make sure that your white flower, surrounded by dark leaves, does not become an island on your paper. You must leave some passage of light to provide an escape route for the eye from the flower. Have your value sketch in front of you for reference as you paint. It will be especially useful when you paint the leaves.

PAINTING

A large part of this lesson concerns color mixing, particularly subtle neutral "white" shadow colors, as well as greens. The mosaic is comprised of all the varied patches of hard-edged, not blended, colors you see in the flower, leaves, branches, and sky.

Shadows on a white object contain neutral colors reflected from lighter colored objects. In this instance the shadows on the magnolia contain green reflected from the surrounding leaves, yellow from the center pod, pink from the pod's stem, and blue from the sky. As you will recall, you make a color neutral, or less bright, by adding a touch of its complement to it. Another way to make a color neutral is to make it lighter, which in watercolor simply means adding water to the pigment. If you were to paint with neutrals made this way, the overall painting would have to be very high-keyed, or light in value. Because magnolia leaves are very dark and the flowers are light, I chose to make the painting mid-valued. The translucent

Value sketch, single flower.

petals in shadow are painted in neutrals mixed from unequal amounts of the three primaries, as shown in the color wheel below.

This particular color wheel is based on a light-valued primary triad of aureolin, permanent rose, and cobalt blue. These colors each have a limited, light value range, and thus when mixed will not produce dark hues. The circles of color are darker on the outside and lighten toward their centers to indicate value range. Arrows from one color to another exemplify how some individual colors are mixed. The largest circles on the outside ring are the three primaries. Also on the outside ring are the three secondary colors, orange, purple, and green, mixed from the primaries as indicated by arrows. Neutrals in the middle ring are made by mixing the three primaries in unequal amounts. The length of the arrow indicates the

relative amount of each primary used in the mixture. The shorter the arrow pointing from a primary, the more of that pigment was used in the mix. Dark neutral colors, such as you might use for darker shadows, are shown on the inside ring. They are made by mixing complements, placed opposite one another on the wheel, in unequal amounts. Again, the shorter arrow from the primary indicates a greater amount of that color used to mix the neutral.

For this painting you will need six palettes. In palette 1, for the yellowish shadow color, mix aureolin and a small amount of cobalt blue to make a yellowish blue, then add a touch of permanent rose to neutralize it (make it less bright). The light parts—stigmas and stamens—of the flower's center are a bright version of these colors, which you can simply mix on a separate portion of the palette. In palette 2,

for the bluish shadow color and the light blue sky showing through the leaves, mix cobalt blue with a small amount of yellow. In palette 3, for the pinkish shadow color, mix permanent rose with a touch of cobalt blue and aureolin. In palette 4, mix a yellow-green from aureolin with a small amount of permanent blue and a touch of permanent rose. In palette 5, for the darker leaf greens, start with the same color as in palette 4 and add a touch of alizarin crimson and Prussian blue. In palette 6, mix a brownish green for the undersides of leaves, stem, and darks between stigmas on the pod. Start by combining aureolin and permanent rose to make an orange, then add a touch of permanent blue to make a brown. The base of the pod (where the stamens used to be) is a reddish purple; to get this color, just add more rose and blue to your brown.

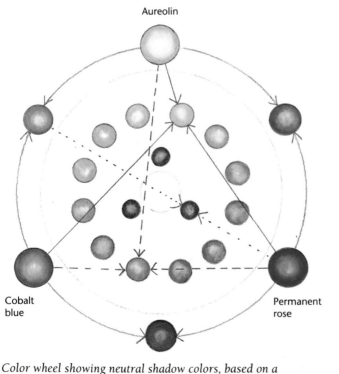

Color wheel showing neutral shadow colors, based on a light-valued primary triad of aureolin, permanent rose, and cobalt blue.

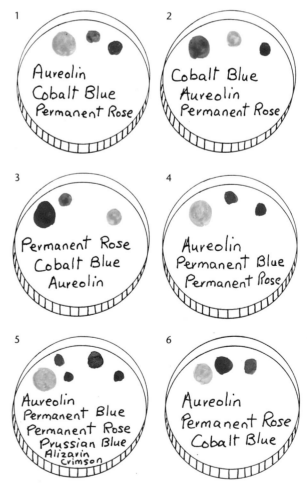

STAGE 1: MOSAIC FLOWERS

Before you start be sure you have in front of you your value sketch, flower and/or color photograph, your six palettes with colors already mixed, two water containers, tissues, rag, and 1" brush. The photograph shows how I set up my reference materials. I used a full sheet of watercolor paper, thus I have more than one flower in my painting. You will have room for only one flower on a quarter sheet of paper.

For this painting your Plexiglas board should lie flat. Paint directly on dry watercolor paper with your 1" flat brush. Lay in paint for the flower shadows in small, hard-edged areas working from light to dark hues. Paint each small color variation you see separately. Refer to your value sketch to make sure that each patch is the appropriate value. If you paint a color too dark you can lighten it by laying a tissue flat on fresh paint while it is still wet and shiny. Then press down on the tissue with your fingers. Do not "dab" while lifting paint, since this action is tentative and will give you a weak painting.

STAGE 2: MOSAIC LEAVES

After you have painted the flower shadows, paint the leaf, stem, and pod colors, taking care to leave the hard-edged patches of light you identified in your value sketch.

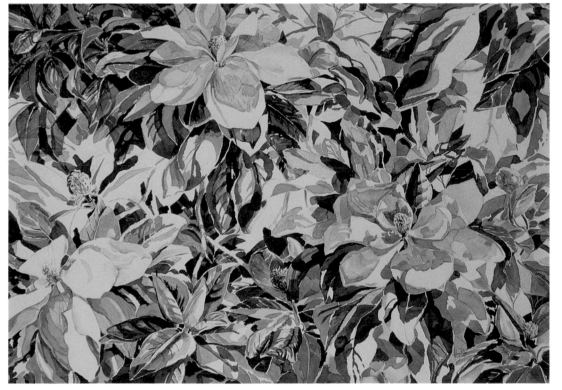

STAGE 3: COMPLETION

Have fun as you watch the mosaic form before your eyes. Magnolia Mosaic took time. At intervals I would hold up the painting in front of a mirror to help me decide where I should go next. I aimed not to have any one area dominate so the viewer's eye could wander at will over the composition.

MAGNOLIA MOSAIC, 22 × 30" (55.9 × 76.2 cm).

LESSON 4 *Combining Color and Form*

Individual petals of an amaryllis, like those of the magnolia, are partial convex and concave surfaces of the ovoid. Portraying brightly colored flowers is the purpose of this lesson. Colored flowers are more difficult to portray than white ones because the petals' translucent quality affects the colors.

One challenge of portraying flower colors is to keep translucent colors bright even in shadowed areas. The photograph of the red hibiscus shows the translucent quality of red petals in shadow, which makes the red in the center of the flower much brighter, or more "saturated," than it otherwise would be in a shaded area, where you would expect the red to be dark and neutral.

Pigments used unmixed and straight from the tube are often, but not always, saturated, or bright, colors. (None of the "earth" colors is bright.) For instance, Grumbacher red, a "yellow" red, is saturated and bright in comparison to Indian red, which is a neutral hue.

Simultaneous Contrast. Color value and intensity can be modified by a phenomenon known as simultaneous contrast, which appears to work because of the eye's proclivity to modify what is seen. The pupil controls how much light is allowed to reach the retina, where rods and cones are located; rods react to brightness, and cones react to color. You can test the phenomenon for yourself. Stare at black paper in sunlight for a minute, then stare at white paper. You will be blinded until the eyes adjust. Equally important is what happens with color perception. Stare at bright red paper and and then at white paper. The white paper will now appear as a "dancing" green afterimage, which the eyes create to neutralize the red.

A green color creates a red afterimage. Simultaneous contrast, which means seeing two contrasting colors such as red and green at the same time, works because the afterimage of one is superimposed on the other, counteracting the neutralizing process so each color maintains brightness.

You can use simultaneous contrast to manipulate the eye's perception of values and colors. In the amaryllis painting, red is made to appear redder because of its juxtaposition to green.

Note: Unlike other demonstrations in this book, this one is not a simple paint-along but an example of a process. Thus, among the colors listed here is cadmium red deep, which is not mentioned in the materials chapter but which I used for the painting.

DEMONSTRATION
RED AMARYLLIS

CONCEPT: Achieving the eye-catching brilliance of a red amaryllis

SEEING: Light and dark values; bright and neutral colors

DRAWING: Value sketch, line drawing, grid system

PAINTING: Glazing

PAPER: ¹/₄ sheet or larger; I used a full sheet of 300-lb. Arches rough

BRUSHES: #14 round, #8 round, 1" and 2" flats

COLORS: Grumbacher red, cadmium red deep (Grumbacher), alizarin crimson hue, Prussian blue or Thalo blue, permanent blue, aureolin

SEEING

Flowers that are round and flat with little depth, such as sunflowers, are effectively portrayed from a frontal viewpoint. A round flower such as

the hibiscus has more depth and thus can be successfully portrayed up to a three-quarter view. When drawing a round flower from an oblique angle, think of the shape as an ellipse. As was illustrated in the glass lesson, an ellipse becomes progressively less rounded as you look at it from a side viewpoint. In the photograph of the hibiscus shown below, each of the three flowers is seen from a different angle, resulting in three different elliptical shapes. The amaryllis, since it has depth, is interesting when

Three hibiscus blossoms seen from different angles. A circular flower appears either rounder or more oval according to the angle from which it is viewed. Note how the red is saturated as the light shines through the flower.

An amaryllis flower appears cone-shaped when viewed from the side and circular when viewed from the front, making it interesting from all points of view.

viewed from all angles. As you look at it straight on, the petals form two triangles set in a circle. As you view it from the side, the circle becomes an ellipse and the triangles become distorted both vertically and horizontally. Viewed in profile, the amaryllis is a cone shape. You can use prepared acetate to help with foreshortening when drawing a flower from an unusual angle.

DRAWING

Before I decided how I was going to paint *Amaryllis '91*, I made three value sketches of the flower in my 11 × 14" sketchbook. The first was drawn looking straight on at my subject, before the side flowers had opened. The second was drawn looking down at the flower; here the side flowers are partially opened. The third was drawn looking up at the flower, which by now, like me, was showing signs of tiredness, so I never completed this sketch. However, I had the information necessary for a watercolor painting.

I still had no idea how I would portray the flower in a composition and had just about decided that *Amaryllis '91* was to remain a study. But suddenly the plant sprung another set of blooms—smaller, not quite so spectacular as the first, but the colors were magnificent! That's how I was prompted to proceed.

From my value drawing, I traced line drawings onto my watercolor paper.

A problem with potted cultivated amaryllis is that the bloom is perched atop a long, thick stem. When these stately plants grow in the wild, however, they do have an abundance of long, pointed leaves. Thus, to solve this problem, I made the stem less prominent in my composition by placing it among the leaves. I penciled in a few background leaves to start with.

The design of *Amaryllis '91* was not carefully worked out in a creative value sketch prior to painting. Sometimes too much preparation kills excitement and leads to boredom, which is reflected in the spirit of the painting. With this painting I had an idea but no guide, so I was challenged throughout.

Sketch of amaryllis drawn looking straight on at the flower.

Sketch of amaryllis drawn looking down at the flower.

Sketch of amaryllis drawn looking up at the flower.

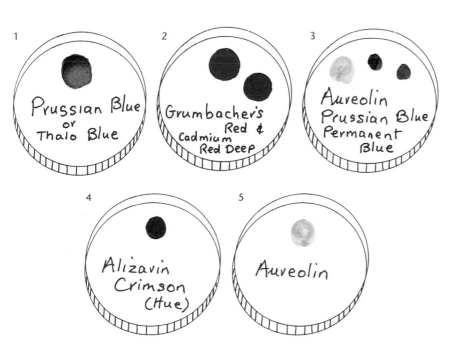

PAINTING

I started with the deepest central blooms, because they interested me most and I wanted be sharpest when I painted them. I used a slow glazing procedure, beginning with a blue underpainting, and worked very small areas at a time.

In palette 1, for the blue underpainting, you can use either Prussian blue or Grumbacher's Thalo blue. Don't mix the colors in your other palettes until you have completed the blue underpainting. In palette 3, mix a green from aureolin, Prussian blue, and permanent blue.

STAGE 1: BLUE UNDERPAINTING

Just as the painting of the red apple in the sphere chapter started with a blue glaze, so the deeper areas of the three most prominent amaryllis blooms are underpainted with Thalo blue. Prussian blue, which is easier to handle, would also have worked for the underpainting.

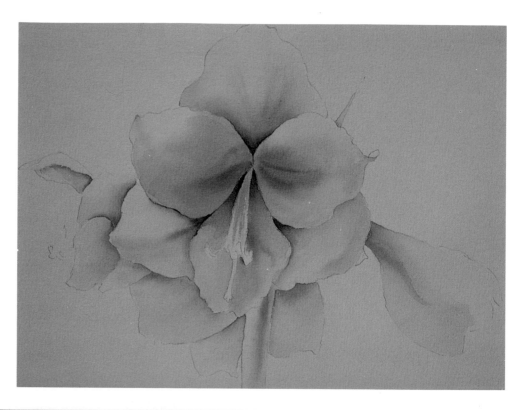

STAGE 2: FIRST WASH ON BLOOMS

(Detail) A deep red is hard to attain on the first application. The reds were applied reasonably heavily, petal by petal, and alizarin crimson was dropped into the shadow areas. The first wash was the light red you see in the leaf grid as it passes over the front petal. I used Grumbacher red where I wanted a bright yellowish red and cadmium red deep where I wanted a deeper, more neutral red.

AMARYLLIS '91, 22 × 30" (55.9 × 76.2 cm).

STAGE 3: SECOND WASH ON BLOOMS

Before applying more paint, I drew leaves that pass in front of and behind the blooms. Then, at the same time I deepened the red on the blooms with the addition of another wash, I negative painted the leaves as they passed across the flowers. The remainder of the painting was completed by working from light to dark hues. The grids were negatively superimposed during progress. I constantly looked at the painting in a mirror to obtain a fresh viewpoint. The painting took a long time to complete. I am pleased to say that it met with the approval of the one who had given me the flower, my son.

Margot Vance, **RED HIBISCUS,** 22 × 30" (55.9 × 76.2 cm).

The artist makes her reds redder by surrounding them with complementary greens, an example of how to put simultaneous contrast to work.

THE CONE

I first encountered the cone when I lived in a small seaside fishing town facing the deadly Goodwin Sands in the English Channel, where the black cone (wind sock) flying above the Coast Guard station betokened gale-force winds. That inauspicious symbol is now long gone.

The subjects chosen for our study of the cone have a variety of surfaces: light, dark, colored, white, matte, shiny, and reflective. They include white drapes, salmon-colored seashells with double cones, and polished copper kettles. Look for other conical forms in everyday objects, such as pears and Easter lilies, which are modified cones.

Karen George, **TIED IN KNOTS**, 15 × 22" (38.1 × 55.9 cm).

Drapery provides many opportunities for studying the cone. In this painting the artist has added stripes, which further describe form and call for skillful handling of shadows and local color.

LESSON 1 *Analyzing the Cone*

The cone is a solid form with a circle for its base and a curved surface tapering evenly to an apex so this surface makes straight lines from the apex to the outside of the circle.

When lit from an oblique light source, their straight surfaces cause both the cone and the cylinder to have the characteristic straight core shadow between the light and shade; but on the cone, the core shadow is tilted inward to the apex. The highlight is like that of the cylinder, except that on the cone it is visible more often because the form's surface tilts toward an oblique light source. I photographed the cone on colored stripes to help isolate the source of reflected light in the form shadow. Because the cone's surface tilts away from the ground on which the form rests, the form shadow is influenced by reflected light from above, which in the photograph is the sky. The cone's form shadow is generally darker than the cylinder's, especially at the top, because it is not influenced by reflected light from the ground.

White drapes, their folds forming cone shapes, are the subject for the practical application of this first lesson. Since drapery is used as background in so many still lifes,

making a separate study of it here will give you the knowledge you need to incorporate it in future compositions. As with other forms, it is helpful to study light and shade on plain white drapes before attempting complex colored and patterned ones in which underlying values are obscured.

Find a piece of crease-resistant white fabric and drape it over a board set up in front of you. Hang the fabric so that some of the folds radiate from a point to form cones. Illuminate the setup with a single indirect, oblique light source to get the full effect of the undulating folds. Your center of interest will be wherever the lightest lights, darkest darks, and hard edges appear.

It may be helpful for you to work from the photograph shown here first so that you understand the process; then you can duplicate the procedure with your own setup of drapery.

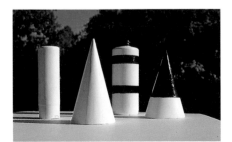

Compare the geometry of the cone and its shadow characteristics with those of the cylinder. The shiny black bands enable you to compare characteristics of the highlights on both forms.

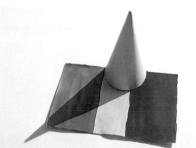

Study the behavior of reflected light and color on the cone.

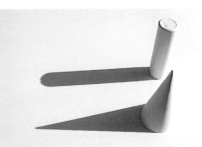

The cone's form shadow is darker than the cylinder's, especially at the top.

DEMONSTRATION
WHITE DRAPES

CONCEPT: Realistic study of value patterns on white drapery

SEEING: Underlying value masses on hanging white drapery; using knowledge of geometric forms to see value

DRAWING: With a brush and watercolor

PAINTING: Wet-on-wet; hard and soft edges

PAPER: 1/8 or 1/4 sheet of 140-lb. Arches cold-pressed or rough

BRUSHES: #14, #8, and #3 round; 1" flat

COLORS: Cobalt blue

ALSO: Sketchbook, 6B graphite, 3B pencil

SEEING

Hanging drapery has four characteristics of which you need to be aware. All are visible in the photograph shown below. These are *cones*, formed as the cloth hangs from a point from which the cone form radiates; *cylinders*, formed as

I recommend that you paint first from the photograph, then paint from your own setup, arranged so it contains the four categories of folds described.

the fabric hangs over a straight surface; *inactive areas*, flatter sections that lie between cones and cylinders; and the *eye of the fold*, formed where the cylinder bends.

View your subject through a visualizing mat, squinting to identify individual conical and cylindrical forms with their characteristic form and cast shadows. First identify the lights, and shade everywhere *except* these lights. Then combine values as you have done previously with the value sketches of individual forms. You need to reduce the composition to about five values.

DRAWING
Make a value sketch, both so you will know where to preserve white paper when you start to paint, and so you can better gauge value relationships as you aim to portray your subject convincingly. This takes practice. If you can't accurately gauge the values of a subject that is in front of you, then you won't be able to alter values creatively for specific effects.

The directions for painting the drapes in the photograph will help you with your value sketch, since the stages are similar. You can see how to work from large, light masses into small, dark areas.

In your line drawing, you utilize some of the functions of line: 1) define the outside edges (contour) of an object; 2) mark differing planes; 3) indicate value changes (as in patterned drapery); 4) indicate color changes (such as stripes that may differ in color but have the same value). Make a line drawing to scale and transfer it to watercolor paper.

PAINTING
The black-and-white diagrams that accompany each of the painting stages show you the five values of the drape composition. The broken lines demarcate the twenty individual washes, progressing from large light to small dark areas, necessary to complete this painting.

So you can concentrate totally on values, we will use just one color, cobalt blue, a luminous pigment that will help convey the translucent quality of the fabric. It is easy to use wet-on-wet, since it stays where you put it and does not creep or blossom uncontrollably. Also, once you lay it on the paper it will not lift, so you can lay any number of washes one on top of another without disturbing previously laid pigment. However, because once applied the paint will not lift, you need to be sure of what you are doing before you start.

I used cobalt blue paint for my line drawing rather than pencil, since this will better merge into the painting to create unobtrusive edges.

Cobalt Blue

STAGE 1: LIGHTEST LIGHTS AND CORE SHADOWS
Using the wet-on-wet technique, wet your paper all over except for the small, hard-edged light area that appears directly below the cone, as indicated by the broken line in the diagram. Lay the wet paper on tissues on a flat board.

Work quickly and lay in the core shadows while the paper is still wet and shiny. If the core shadows don't go on properly the first time, dry your paper. Then rewet it (preferably with a mist spray) and start again.

STAGE 2: MID-LIGHT VALUES

I've noticed that students can easily identify the lights and darks in a subject. The trick is to squint hard enough to be able to see mid-light values, which are combined with darker values into large masses. Middle values bind a composition into a cohesive whole. The diagram shows three sections of mid-light values. Work each one individually and dry your painting before moving to the next section. Broken lines in the diagram indicate the areas of your paper you need to prewet. To make soft-edged areas, apply paint inside the broken lines, but not up to their edges, as in the diagram. To make hard edges— where the folds in the drapes have decisive edges—paint up to the edge of the broken line as indicated in the illustration.

STAGE 3: SMALLER MID-VALUE MASSES

Continue to identify smaller masses of mid-values and note where you have hard and soft edges. Broken lines in the diagram indicate the area to wet, then drop in paint.

STAGE 4: DARKS AND ACCENTS

This stage will really make your drapery jump off the paper if your previous stages have been gauged correctly. Notice in the diagram how the areas you paint have become progressively smaller with each successive wash.

When you've mastered this process you are well on the way to becoming an accomplished painter!

Studying Double Cone Forms in Nature

As you become more observant, you will see that everything around you consists of geometric forms and their surfaces. Such a subject is the conch shell, which can be seen generally as two cones placed end to end. How many surfaces of other geometric forms can you spot in the conch shell?

Neither during my beachcombing days in England nor during forays along the Texas coast have I found even one sizable conch shell. My shell collection has come from cheap seaside souvenir shops, garage sales, and friends. So don't give up if you, too, are not from shell-rich shores. Just find a way to start a collection, for shells will provide you with myriad information about form.

DEMONSTRATION
CONCH SHELLS

CONCEPT: Realistic yet loose portrayal of shells

SEEING: Evaluate lights and darks on cone-shaped objects placed one in front of another

DRAWING: Value sketch; directing the viewer's eye to a focal point

PAINTING: Wet-on-wet; overlaying washes; hard and soft edges; neutralizing colors; spattering with paint or masking fluid

PAPER: 1/4 sheet of 140-lb. Arches cold-pressed

BRUSHES: 1" flat, #14 and #8 round, #3 rigger

COLORS: Aureolin, permanent rose, Prussian blue, alizarin crimson

ALSO: 11 × 14" sketchbook, 3B pencil, 6B graphite

SEEING
The conch shell consists of two cones placed end to end, as photograph 1 shows. Reflected light in the form

shadow and the breadth of the core shadow are significant features that show up clearly on the model. Also apparent is the contrast between form and cast shadow. Look for these same features as you portray the conch shell. Photographs 2 and 3 show the shells and models in sunlight in the same position as they appear in the study. From the head-on, foreshortened view, it would be impossible to know how the shell appears without prior knowledge of the form. By placing the two shells at different angles, as in photograph 4, you give the viewer most information about the form. Arrange your shells so they and their shadows make an interesting shape. View the setup through your visualizing mat to help you decide on placement. Always avoid monotonous, straight-line configurations.

As you look at your subject, notice how the spikes on the shell spiral to the vertex. These spirals, if the shell is facing sideways, will make elliptical shapes. With

practice, you will see more and more underlying forms.

DRAWING
Do a line drawing of your subject to scale. Utilize any helpful drawing device, such as prepared acetate or a squared-up visualizing mat.

Transfer your line drawing from sketching paper to watercolor paper. To save time, you can use a copy machine to reduce the drawing to about a 5 × 7" size for your value sketch and then trace the lines through in pencil to your sketchbook. Black spots on the line drawing shown on the facing page indicate areas to receive masking fluid.

PAINTING
Since sea and shells are synonymous with blue, I chose to have plenty of blue in the study to offset the coral color of the shells. Also, blue is a near-complement of coral.

Mix your colors with water. In palette 2, combine permanent rose and aureolin to make a coral pink.

Photo 1.

Photo 2.

Photo 3.

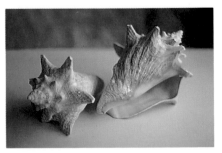

Photo 4. This is the setup for the painting.

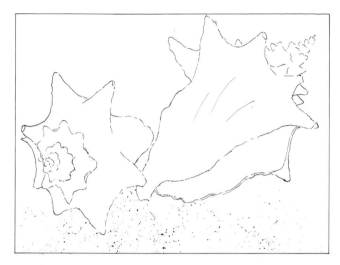

Line drawing; black spots indicate where to apply masking fluid.

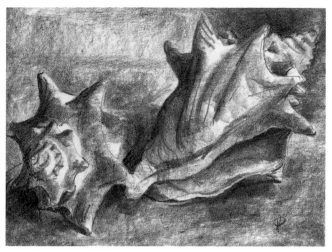

Value sketch.

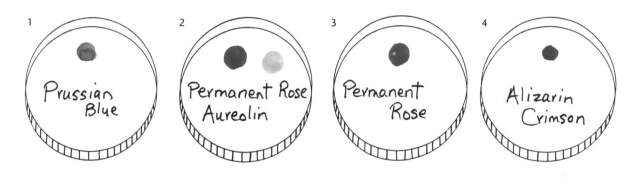

1. Prussian Blue
2. Permanent Rose / Aureolin
3. Permanent Rose
4. Alizarin Crimson

STAGE 1: SAND TEXTURE AND BLUE UNDERWASH

Optional: To create sand texture, cover the shell drawing on your watercolor paper with a tissue. Spatter masking fluid on uncovered areas to negative paint sand texture. Don't forget to protect your brush while using masking fluid as described on page 15.

(This step can be combined with stage 2.) Using the wet-on-wet technique, lay in an underwash of Prussian blue. Drop in paint to indicate shading on the shells. Be sure to leave white areas for compositional effects and where you will add coral pink.

STAGE 2: CORAL UNDERWASH

Rewet your paper and lay in coral pink in the areas you left unpainted. You can add some modeling, too. Remember, you can keep adding paint as long as your watercolor paper has a shine on it. If the shine goes before you lay in all your colors, dry your paper with a hair dryer to set the paint. Rewet it and continue adding colors. Dry your painting.

STAGE 3: MODELING

On dry paper, using Prussian blue, start modeling shadows. Shells have a great deal of surface texture, which you can capture by drybrushing edges rather than softening them with water.

Negative paint some background to emphasize the shells. It is pleasing to create lost and found edges—edges that are alternately hard and soft—according to what you want to emphasize or deemphasize.

STAGE 4: ADDING DARKS TO THE SPIRAL OF SPIKES

To achieve the texture of the tops of the shells, drybrush the inside edges of the spikes with your #8 round brush. Use Prussian blue for the dark shadow areas. You can also separately use alizarin crimson for variety. If either color is too bright, neutralize it with a touch of its complement.

STAGE 5: ADDING SPATTER FOR SAND TEXTURE

To give the appearance of sand texture, you can spatter light and deeper colors into the sand area. Use masking tape to mask off lighter protuberances on the shell, then lay tissues on the large areas as shown. Flicking your loaded #8 brush works well for spattering. It's a good idea to practice on a separate piece of paper first.

STAGE 6: DETAILS

Refer to your value sketch (or photograph). Lay in the pink shadow area inside the shell. Make hard and soft edges as shown following the procedures described on page 21. Remember, a viewer's eye is drawn to hard-edged areas of high value contrast. Form shadow and cast shadow colors will be darker and more neutral than colors in direct light. To neutralize a color, add to it a touch of its complement. Thus, to neutralize permanent rose, add a touch of Prussian blue and aureolin (green). To neutralize blue, add a touch of rose and aureolin

(orange). To neutralize yellow, add a touch of blue and rose (mauve). Refer to the illustration for exact placement of form and cast shadows. Remember, "When in doubt, dry it out." In other words, dry every small stage before you proceed to the next to avoid unwanted watermarks and to have more control. Dry your painting.

Use a blade to retrieve whites and to scratch out other textures on the shell emphasized by the light. Finally, if you spattered on masking fluid in stage 1, lift it off now. Add dark accents in shadow areas for emphasis.

LESSON 3 *Rendering Metallic Conical Forms*

Copper and brass conjure up memories of an Old World pub, where kettles, warming pans, and horse-brasses would come alive as flames from a roaring hearthside fire danced within their polished, shiny surfaces. It is no wonder, then, that I collect copper for my own hearth. And so it is fitting to choose my Jenny Quick and Barge kettles as the subjects for the copper study. The lesson will work equally well with brass or silver—whatever takes your fancy—so long as your metallic surface is freshly polished; there's the rub! You can adapt the observations and procedure to whatever cone-shaped metallic object you have to work from.

DEMONSTRATION
COPPER KETTLE STUDY

CONCEPT: Portray shining, polished copper kettles

SEEING: Reflections on shiny, curved metallic surfaces

DRAWING: Symmetrical cone-shaped objects; values of reflections on metallic surfaces

PAINTING: Layered masking with fluid and drafting tape; wet-on-wet; direct painting

PAPER: 1/4 sheet of 140-lb. Arches cold-pressed; tracing paper

BRUSHES: 1" flat, 1/2" flat, #8 round, #3 round

COLORS: Gamboge, alizarin crimson, permanent rose, Prussian blue, Winsor green

ALSO: 3B pencil, kneaded eraser, 6B graphite, drafting tape, masking fluid, blade

SEEING

A reflective surface such as copper relies on surrounding objects and light for interest. So place plenty of varied yet harmoniously colored objects in front of your subject. I made sure I wore a phthalo green shirt because I thought the reflection harmonized with the pink of the copper. Since metallic surfaces reflect precisely what is in front of them, your composition will be much more interesting if you have multiple light sources. Otherwise, a metallic surface can be rather dark. So turn on the lights.

You'll probably be overwhelmed when faced with the wealth of distorted images reflected in polished, curved, metallic surfaces. However, such seeming chaos does yield to order with careful study. In the photographs shown here, and in your own setup, observe the following:

1. Smooth, polished metallic surfaces are excellent reflectors.
2. Metal surfaces reflect the metal's hue. For instance, copper reflects pink, brass reflects yellow, and silver and aluminum reflect a very light gray.
3. Metallic surfaces reflect very bright, localized light when directly facing the light source. These highlights are of a brightness that far exceeds the light reflected from other surfaces and cannot be duplicated on paper. Highlights can be made to seem brighter by placement of a dark, hard edge around them, as you learned in the sections on simultaneous contrast in the cylinder and ovoid chapters.
4. A polished metallic surface generally does not appear as light as a nonmetallic surface. This is evidenced by the lightness of the copper-tinted cone next to the copper kettle in photo 1. However, if you squint at the photograph, you'll see that the

light area in the copper is extremely bright. It is likely that the brightness of the kettle's highlight far exceeds the sum of all the lightness reflected off the orange cone.

Photo 1. Compare the amount of light reflected by the shiny metallic copper kettle with the amount reflected by the matte copper-colored cone.

Photo 2. The shape of a metallic surface determines the way images reflected in it are distorted. At left is a Jenny Quick kettle, a straight-sided cone; at center, an antique pitcher whose upper half is a concave cone; and at right, a Barge kettle, a convex cone. Antique objects like these have dents and imperfections that further distort reflections.

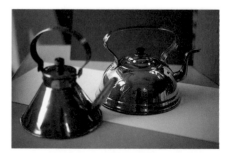

Photo 3. Setup for the study.

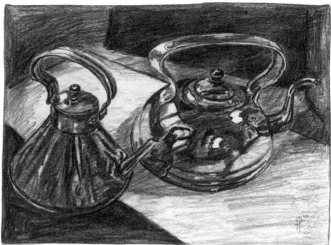

Line drawing. Black areas indicate where to apply masking fluid.

Value sketch.

5. Curved metallic surfaces distort reflected images in these ways, as illustrated in photo 2, opposite:

- *Straight-sided cone* (Jenny Quick kettle, left): images are elongated, condensed, and backward, as they would appear in a flat mirror.
- *Concave cone (top section of pitcher, center):* images are upside down and backward.
- *Convex cone (Barge kettle, right):* images "bulge" with the curve and appear in reverse, as shown by the reflected lettering on the blue egg cup. The letters are the right way up.

DRAWING

To achieve symmetry in your curved, cone-shaped objects, it helps to first imagine the form placed in a cube with a vertical line marking the central axis—just as you did with the striped lighthouse in the cylinder chapter. You will achieve approximate symmetry if you turn your work upside down and/or look at your drawing in a mirror. You can also use tracing paper as you did when drawing the glass.

Trace one completed line drawing (without the cube) onto your watercolor paper. The black areas you see in my line drawing indicate where to apply masking fluid.

Draw an outline measuring about 5 × 7" for your value sketch and then shade from light to dark. Make a hard-edged dark line around the highlights to make them appear lighter, an effective use of simultaneous value contrast.

PAINTING

For many of the lesson studies in this book I have used simple complementary color schemes. The copper kettle study is no exception. Thus, to emphasize the pink quality of copper, I have used a green adjacent to it and within it. I was wearing a green shirt. With experience you can be more adventurous with colors. To achieve harmony, try to make one color dominant—just use more of one color than others.

Mix your colors. In palette 1, create a light pink tint for the copper by mixing alizarin crimson with gamboge and a touch of permanent rose. After the initial washes you will need to neutralize this bright hue. In palette 2, for the deep background color mix Winsor green, Prussian blue, and touches of gamboge and alizarin crimson. In palette 3, for the neutral copper color, mix alizarin crimson with gamboge, permanent rose, Winsor green, and Prussian blue.

1

Alizarin Crimson
Gamboge
Permanent Rose

2

Winsor Green
Prussian Blue
Gamboge
Alizarin Crimson

3

Alizarin Crimson
Gamboge
Permanent Rose
Winsor Green
Prussian Blue

STAGE 1: PINK UNDERWASH

Use masking fluid to mask out highlights.

Using a 1" flat brush, lay in a slightly modulated underwash of light pink, the intrinsic copper color. Dry your painting. Remove masking fluid when the paper is completely dry.

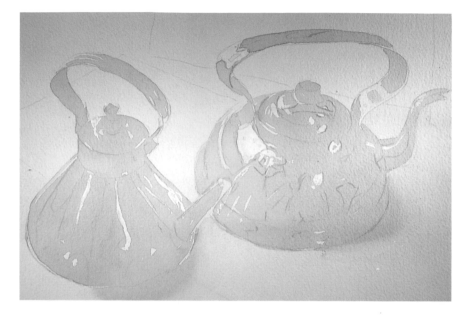

STAGE 2: BACKGROUND

Mask the kettles with drafting tape as shown. Be sure your watercolor paper is completely dry before you apply the tape. Use a sharp, single-edge blade to cut excess tape from around the kettles, guided by the pencil lines of your drawing, which will show through the tape.

Wet your paper, making very sure that it is wet near the outside edges. Place your shiny-wet paper on a flat rag or tissues on your Plexiglas board to avoid backruns around the edges.

Lay in the background according to your value sketch, working from light to dark colors. Dry your painting. When the painting is completely dry, remove the tape.

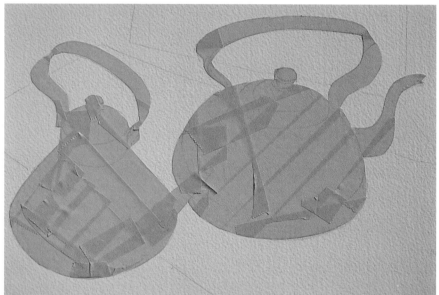

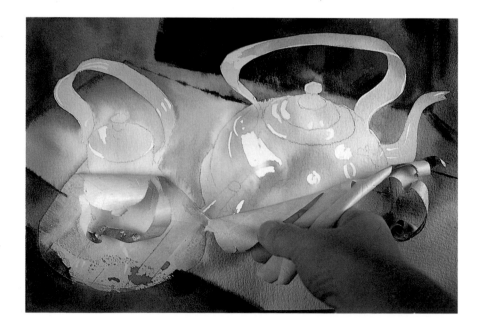

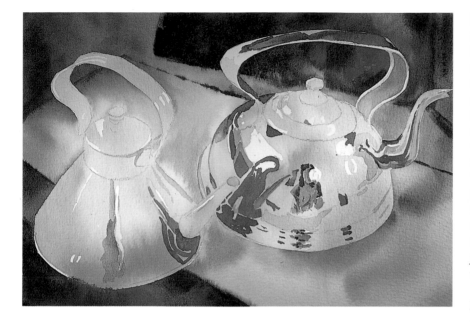

STAGE 3: REFLECTED IMAGES

Squint at your setup and add reflected images using a neutral copper color, which you can make warmer (by adding more alizarin crimson) or cooler (by adding Prussian blue), depending on what is being reflected. Start with the most interesting reflections. Keep in mind the characteristics of reflections on metallic surfaces listed above in the "Seeing" section of the lesson, which will help you decipher the distorted images you see. This stage is detailed and will take time, since in effect you completely repaint the kettles each time you add a reflected image and regauge values one against another.

Surround the highlights with a dark, hard-edged line or shape to help emphasize their brightness.

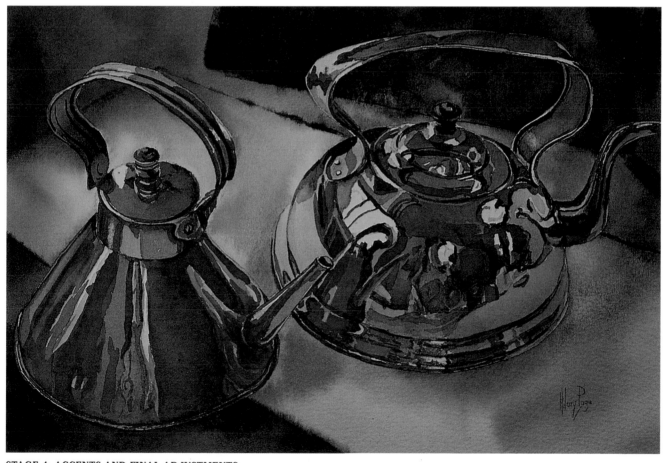

STAGE 4: ACCENTS AND FINAL ADJUSTMENTS

Squint at your subject and once again recheck values and make final adjustments. Dry your painting.

THE PYRAMID

Our final form for study is the pyramid, epitomized by the Great Pyramids of Giza, of which I painted Cheops (below) from my hotel window. The pyramid does not necessarily have to be a balanced, symmetrical form. It can actually be quite varied, ranging from a three-sided structure to a many-sided one. In fact, modifications of the pyramid are plentiful and encompass subjects with one or more flat, slanted sides, including chiseled, rock-faced mountains, small sharp stones, and rooftops. Examples of the pyramid for our study include a mountain composition, jagged-edged rocks, and shrimp boats reflecting in water.

CHEOPS FROM MENA HOUSE OBEROI, 10 × 8" (25.4 × 20.3 cm).

Analyzing the Pyramid

The pyramid, like the cube, is a flat-sided form. The perfect geometric pyramid has five surfaces, of which four are equilateral triangles that slope inward, meeting at an apex above a square base (the fifth surface) whose sides are the same size as those of the triangles. A pyramid can be also be formed with a triangular or polygonal base.

Because of its angled surface, the side of the pyramid facing an oblique light source is brighter than the ground, as the photo at top left

Perfect pyramid and cube.

Compare light and shadow behavior in the pyramid and the cube.

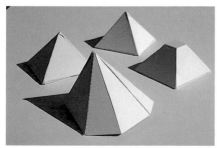

In the foreground is a many-sided pyramid form, the geometric model for the mountains in the painting.

shows. Compare the pyramid with the cube in this and the photo just below it. Note that the side of the pyramid facing away from the light is darker than that of the cube; this is because it is not receiving reflected light from the ground. Also, although the pyramid's cast shadow is darker than its form shadow, the degree of contrast between the two is less than that between the cube's cast and form shadow.

The awe-inspiring grandeur of mountains that I have experienced while hiking in the Peruvian Andes, the Rockies, and the Highlands of Scotland has led me to conclude that even the most unimaginable can actually be found in nature. This demonstration is one of my favorite subjects and one in which you can let your imagination soar.

DEMONSTRATION
MOUNTAIN FANTASY

CONCEPT: Imaginative mountain scene evoking the feeling of mystery

SEEING: Variously toned form shadows on numerous surfaces of pyramids

DRAWING: Direct drawing with paint; combining masses

PAINTING: Graded and flat washes; pigment qualities; working with analogous colors

PAPER: 140-lb. Arches cold-pressed, any size

BRUSHES: Mainly flat brushes of the appropriate size for your paper; for a full sheet (22 × 30"), use a 3" flat brush; for a half sheet, use a 2" flat brush

COLORS: Permanent rose, manganese blue, Prussian blue, alizarin crimson

SEEING
Mountain Fantasy is based on multiple-sided pyramid forms, with each side manifesting a different

value, as shown in the photo at left bottom. The painting also loosely illustrates how mountains reflect in water, characteristics of which you can study in the three photos of models at right below, taken from eye level, medium height, and greater height. Note that as the eye level is raised the reflection becomes progressively smaller.

There is no drawing for this lesson, but you will need to squint as you add mountains and see your subject in terms of combining values to make interesting shapes. It also helps to constantly look at your work in a mirror.

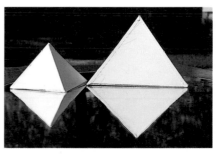

Reflections as seen from a low level.

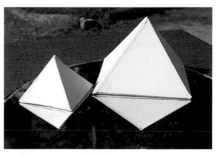

Reflections as seen from medium height.

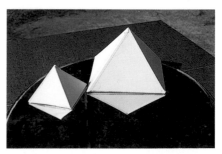

Reflections as seen from high viewpoint.

PAINTING

The colors chosen for this painting—permanent rose, alizarin crimson, manganese blue, and Prussian blue—are known as *analogous colors* because they are adjacent to one another on the color wheel and thus share some common features. These two reds each contain some blue, while the two blues each contain some pink. As such, an analogous color scheme is inherently harmonious. Its one drawback is lack of variety—and variety is a positive attribute in a composition. A composition painted in an analogous color scheme therefore needs to have an intrinsically interesting subject, as well as a dynamic design containing sharp value and shape contrasts to provide variety and prevent monotony.

If you use the colors specified here in your painting, next time try a different color range, such as blues and greens. Have fun!

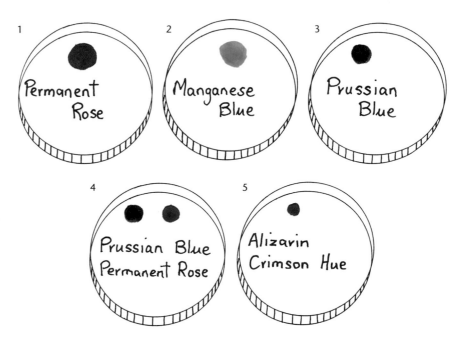

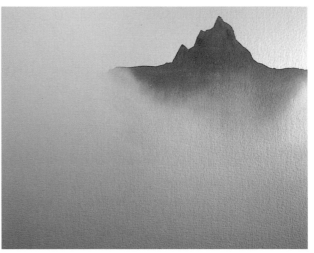

STAGE 1: PINK MOUNTAIN

Tilt your board toward you with about a 2" wedge. Work on dry paper and lay in a pink mountain using permanent rose. Soften the lower edges, as shown on page 21. Dry your painting.

STAGE 2: BLUE MOUNTAIN, PINK MOUNTAIN

Use the same procedure to lay in a second mountain in manganese blue. With granular pigments such as manganese blue, let the paint dry naturally so you don't lose the interesting sedimentary effect.

Lay in another pink mountain so it looks as though it is part of a range.

Lightly pencil in the lightest side of your mountains, which will remain unpainted.

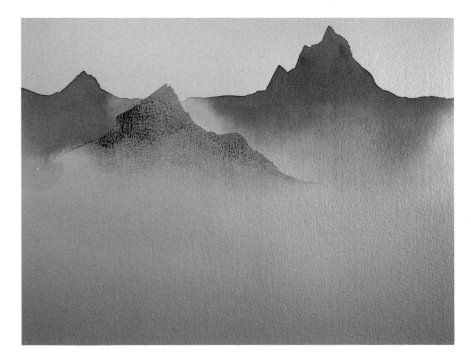

124

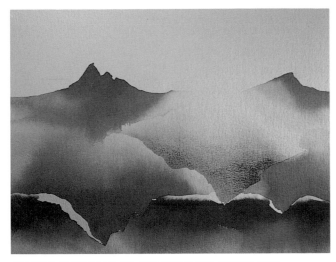

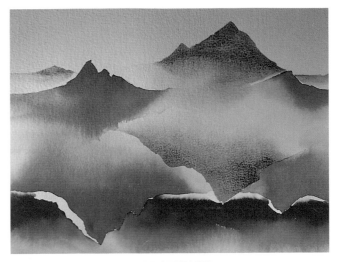

STAGE 3: REFLECTED PINK MOUNTAINS; STORM SKY

Turn your paper upside down and then paint the pink mountains to mirror the upper ones. Dry your painting.

With your tilted board still upside down, wet an area "below" the high horizon line that shows through behind the mountains.

With the paper still wet and shiny, drop in permanent rose mixed with very little water starting just away from the horizon. Quickly dilute the deep pink with water so the sky shows a sharp gradation of color as you draw down the pigment to the bottom of your paper.

STAGE 4: REFLECTED BLUE MOUNTAINS

With your board still tilted and upside down, lay in a blue mountain range in manganese blue. Let your painting dry naturally.

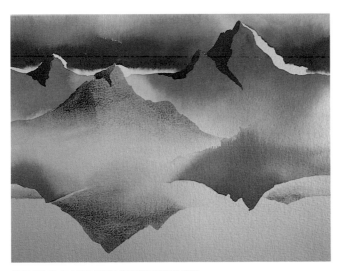

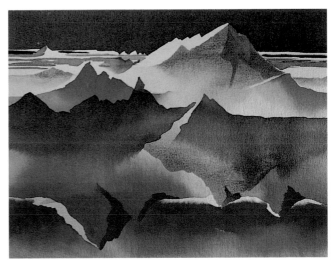

STAGE 5: DARK SIDE OF MOUNTAINS

Turn your paper right side up; then, using thick paint of the same hue as the original wash, indicate the shadowed side of the mountains. Dry your painting.

STAGE 6: OVERLAYING WASHES

Up to this point you have laid in single layers of paint. Now you start overlaying washes. Turn your painting upside down again and, in Prussian blue, lay in a horizontal dark band of color across the "top."

In a mixture of Prussian blue and permanent rose, lay in the middle range of mountains, breaking it in one place for the sake of variety.

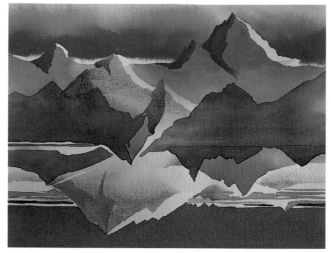

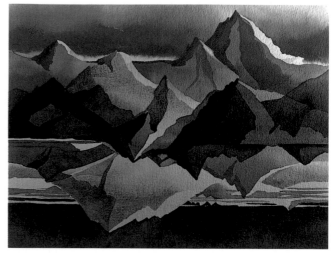

STAGE 7: MODELING MORE MOUNTAINS AND REFLECTIONS
Turn your painting right side up. Use your knowledge of reflections to indicate a mass of mountain ranges reflected in the water. To give the idea of water, break up other areas into bands that are suggestive of ripples. Leave hard edges as shown in the illustration.

STAGE 8: STILL MORE MOUNTAINS
Keep breaking large masses into smaller areas by adding darks. And keep turning your painting upside down and right side up as you work on reflections and mountains, until you feel the composition is complete.

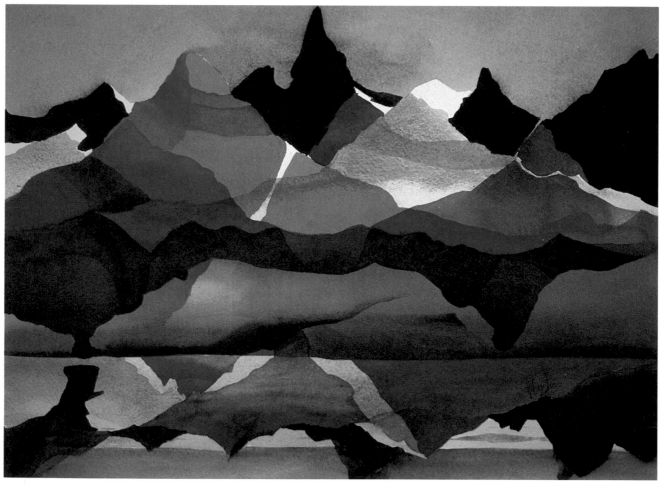

MOUNTAIN FANTASY I, 11 × 15" (27.9 × 38.1 cm).
This painting is part of a series of fantasy mountain ranges reflected in glacial lakes.

LESSON 2 *Interpreting Rock Formations*

A small pile of rocks is, in fact, an accessible microcosm of great rock formations. The light and shade areas will be the same. To enlarge the world around you, go outside and collect some rocks, pile them in front of you, view them through your visualizing mat, and imagine them as a great range. Now if you, like me, live in a low-lying, rockless area with sandy soil, that can be a problem. I had to work from photographs, since the only rock I could find was a broken piece of blue quartz from my stepson's old fish tank. I painted this rock white to better study its inherent characteristics.

Study rocks outdoors to see how they appear and how you might portray them. Sketch, collect pictures, and take photographs of rocks whenever you can. Rockscapes can be evocative and exciting to paint. Remember that any slanting surface, such as the facet of a rock, is related to the pyramid form and will duplicate the light-and-shadow characteristics of the pyramid.

SEEING

As you study rocks, compare your own observations with these, which apply to flat-planed (not rounded) formations:

1. Rocks display many planes, which have to be portrayed in different values (degrees of lightness and darkness), since they are at different angles relative to the light source. Planes directly facing the light source will be the lightest in value, as in photograph A.

2. Rocks have an uneven, rough-textured surface. You can duplicate a jagged surface for study somewhat by scrunching a sheet of white computer paper into a ball for study.

3. In nature, rocks in proximity to one another often, but not always, have similar local color because they are formed from the same minerals. Thus the cast shadow will be darker than the form shadow (form and ground of same local color). This phenomenon is evidenced by the form and cast shadows of the sandstone cliffs at the Valley of the Kings, as shown in photograph B.

4. A narrow space is created as one rock rests on top of another where no light can penetrate. This can be portrayed in a painting as a dark line.

5. Often rocks split, as seen in photograph C. The space thus created can also be portrayed as uneven narrow lines.

6. Shadows cast by straight-edged rocks onto other hard-edged rocks will be similarly straight-edged.

7. Shadowed rock planes are often edged by what appears as a dark line (actually shadows) caused by the rock's irregular, indented surface.

To familiarize yourself with rocks before you start a watercolor, sketch as many configurations as possible of your own rockpile. Then try the following fun exercises and create your own rock structures.

A.

B.

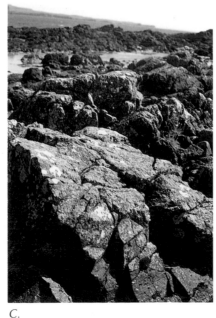

C.

DRAWING

Using your 1" brush as a straightedge, make a jagged outline form in a dark neutral hue. Then "carve" varied rock formations with lines from this one shape. Finally, shade the rocks in different ways as they would look when lit by varied light sources.

Paint an amorphous shadow shape. Then invent various rock forms from the one shadow shape, as in the sketches at left below. You will learn an immense amount about rocks as you invent them.

For this rock lesson you can work from the picture provided at top right or from a photograph of your own, or you can make a pile of rocks and paint them so they appear as a vast rockscape. If working from a photograph, use adjustable viewing mat corners and crop the image to make a dynamic design. The mat opening should duplicate the proportions of your watercolor paper. Make a cross on your paper and on your viewing mat to help you draw

the rocks to a scale relative to the size of your paper. The heavier lines in the line drawing shown below indicate major rock formations.

A value sketch is usually small, ranging from 8 × 10" down to the size of a credit card. Work in the following order when doing your value sketch:

1. Lightly draw overall outlines of rock groups.
2. Delineate individual rocks.
3. Delineate major light and dark planes.
4. Shade values in the order you have followed in previous lessons, leaving the lightest lights as white paper.
5. Work toward progressively dark values, culminating in dark accents.

These value stages often duplicate the order of successive washes in a watercolor painting. Always take care to judge values within the whole composition, not just the one area you happen to be working on.

Mat corners duplicate proportions of a painting.

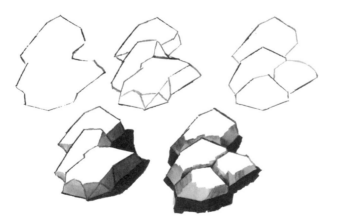

Create your own rock structures out of lines.

Line drawing.

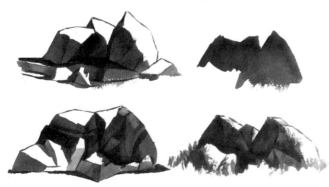

Paint an amorphous shadow shape.

Value sketch.

PAINTING

This demonstration gives you good practice mixing neutral hues. In palette 1, mix a neutral pinkish gray from permanent rose with a touch of permanent blue and gamboge. In palette 2, mix a neutral yellow-gray from gamboge with a touch of permanent rose and permanent blue. In palette 3, mix a neutral blue-gray from permanent blue, permanent rose, and a touch of gamboge. Experienced or impatient painters can combine palettes.

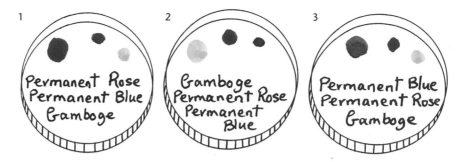

1 Permanent Rose Permanent Blue Gamboge

2 Gamboge Permanent Rose Permanent Blue

3 Permanent Blue Permanent Rose Gamboge

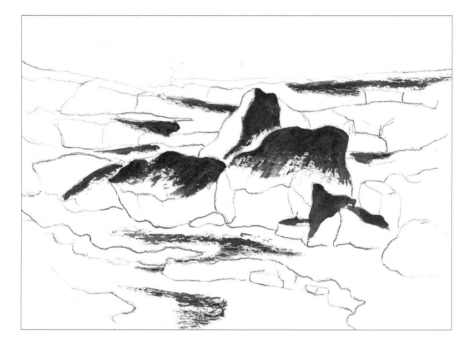

STAGE 1: PRESERVING LIGHTS; LIGHT VALUES

Mask out the white areas you have identified in your value sketch. Hold your brush loaded with masking fluid horizontally over the paper as you did while drybrushing, and then stroke edges that you want to be rough.

Wet any areas of your paper (sky and edges of the paper) that you want to be soft-edged.

Using your 1" flat brush, lay in light neutral colors in the sky. Work your way down the page, varying the hue to make a pleasing composition.

To make a rough edge, drag your brush horizontally across the surface of the paper rapidly so that the "heel," not the tip of the brush, deposits paint. To drybrush a textured surface between the light and darker values, you will need to turn your brush toward you by twisting your wrist, as shown here in the black-and-white illustration. Practice drybrushing rock texture on a piece of scrap watercolor paper. Dry your painting.

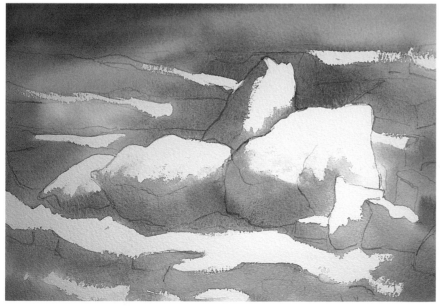

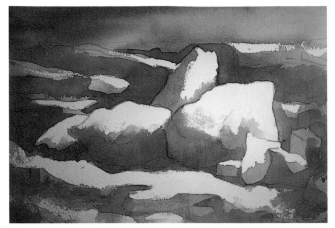

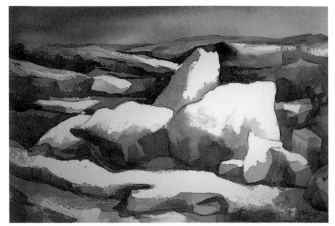

STAGE 2: COMBINED FORM AND CAST SHADOWS

In a darker hue, lay in the middle values. Again make rough edges on the surfaces of the rocks between light and dark values. Dry your painting.

STAGE 3: CAST SHADOWS AND DARK ACCENTS

Knowledge gained from your preliminary rock study, such as how to portray one rock resting on another and how rocks split, will prove invaluable as you paint the details for this last stage. Remember that cast shadows are darker in value than form shadows when the local color of the object is the same as the color of the ground on which it rests.

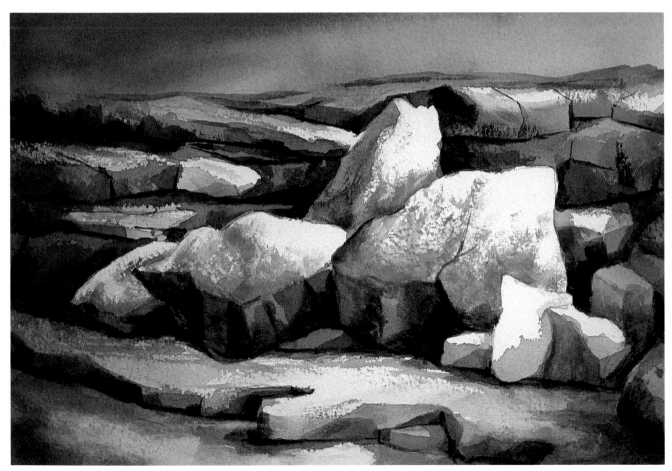

STAGE 4: MORE DARK ACCENTS; VALUE ADJUSTMENTS

Restate values where necessary by adding more drybrush texture. To enhance the illusion of three dimensions, you may want to darken some of the background rocks to make the foreground rocks more prominent.

LESSON 3 *Exploring Reflections*

This lesson explores how light falls on matte white pyramidal surfaces and how reflections work.

Any flat, tilted surface actually echoes the tilted surface of a pyramid and thus duplicates the characteristic behavior of light and shadow on that form. A shrimp boat provides an example of a double pyramid, the cabin with its slanted sides forming an upright pyramid, and the hull with its inward-slanting sides forming an inverted pyramid.

Portraying boats on water involves the problem of reflections. Reflections in calm water are relatively simple to portray, since the water's surface is like a mirror. Reflections in agitated water are another matter. A way to analyze how they behave is to conceive of waves as variously tilted pyramidal mirrors reflecting images from many directions.

DEMONSTRATION
SHRIMP BOAT SCENE

CONCEPT: Romantic painting of a shrimp boat scene

SEEING: How light reflects off a pyramidal surface; reflections in still and moving water

DRAWING: Simplifying and reducing details to create large areas of similar value; designing underlying abstract shapes by combining areas of similar value

PAINTING: Direct and overlaying washes; wet-on-wet; drybrush; masking

PAPER: 1/8, 1/4, or 1/2 sheet of 140-lb. Arches cold-pressed

BRUSHES: 1" flat (2" flat if using 1/2 sheet), #8 round, rigger

COLORS: Aureolin, permanent rose, permanent blue, Prussian blue, burnt sienna, alizarin crimson

ALSO: Masking tape and fluid, 3B pencil

SEEING

Study the photographs shown here and note these observations. The hulls of many boats can be thought of as inverted pyramids.

I used these photos as references to study different aspects of a maritime scene.

A reflection is a mirror image, so a boat reflected in water will appear upside down. A reflection is slightly deeper in value than its source.

A dark line separates the boat (or any other object, like a pole) from the water. When you paint this, your boat really will appear to rest on the water. A shadow cast across the water's surface is more visible if the water is cloudy. Because of perspective, a boat that is not horizontal to you has an oblique baseline.

The white boat featured for the demonstration consists of a modified, upright pyramid for the cabin and an inverted pyramid for the hull.

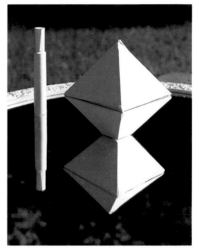

Study the model of the pyramid and its reflection and apply what you see to boats reflected in water. Because it is angled toward the water, an inverted pyramid will appear much larger in reflection when viewed from above the water level. Because of reflected light, the shade side (form shadow) of the lower, inverted pyramid is slightly lighter in value than the form shadow of the top triangular surface.

All reflections appear as the boat in this inverted photograph—as if you are looking up at it from the water's surface.

Study the illustrations shown here to learn about the behavior of reflections.

The way a reflection appears is governed by the position of the viewer and the position of the object relative to the reflective surface. The rule is that the angle of incidence equals the angle of reflection; that is, the angle of the light ray from the object as it strikes the water's surface relative to a perpendicular from this point is equal to the angle of the reflected ray coming to your eye from the same point on the water's surface.

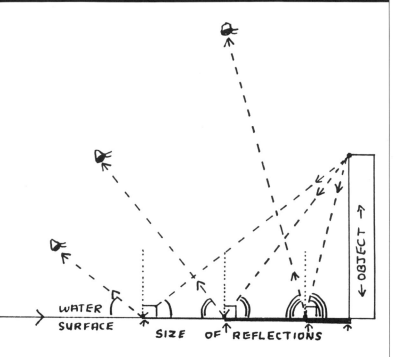

When viewed from a high vantage point, the reflection appears small.

When viewed from a medium height, the reflection appears medium-sized.

When viewed from a low angle, the reflection appears larger.

The reflection of an object appears directly below the object itself even when the object faces the viewer at an angle.

Reflections travel in a straight line and appear to the viewer directly below the object being reflected. Thus, whatever the angle of an object, its reflection will be directly below any given point on the object. For instance, a mark on a pole will reflect in the water directly below.

The reflection of an object set back from the water's edge is measured from the point where the base of the object and the imagined extended water surface meet.

Gently moving water causes a reflected image to become wavy. This is because the waves create a series of angled planes, each of which reflects the object. Here I have re-created the effects of rippling water with foil. Note how the reflections of the upright pole and the tilted pole appear on both sides of the wave where the poles are closest to the rippled surface. As the distance between the poles and the waves increases, the poles are reflected on only one side of the wave.

Reflections on very agitated water are very distorted because the water's

surface is no longer smooth but comprised of hundreds of differing planes, becoming, for all practical purposes, nonreflective.

DRAWING

On sketch paper, using a 3B pencil, make a line drawing of your boat and building to scale. Use your own visual references or the photographs shown here. Take time planning the painting. With a common subject like boats, try to be original in your approach. Decide whether your painting will be vertical or horizontal, or even round, which would make it seem as if you were viewing the scene through a porthole.

To work out my design for the composition, I cut out the shapes of the background buildings, middleground boat and docks, and foreground and moved the pieces around one in front of another until I came up with a pleasing overall configuration. Each shape, including the sky shape, can represent a different value in the composition. I then redrew the composition before transferring the line drawing to watercolor paper. The black areas on the drawing shown here indicate where to apply drafting tape or masking fluid.

Line drawing.

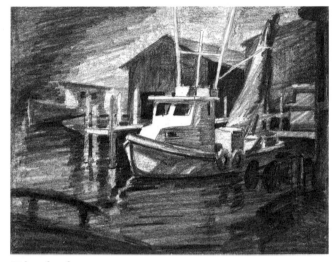

Value sketch.

Black areas indicate where to apply drafting tape (for straight edges) and masking fluid.

I cut out the three major shapes of my composition and shifted them around to determine the most pleasing design.

133

PAINTING

One of the problems you must solve in painting a scene such as this one is to simplify all of the elements so the image does not look fragmented. The effect to aim for is one of stillness and peace.

Mix your paints with water in readiness for the wet-on-wet technique. After stage 1 you can dab into various palettes to achieve the desired color.

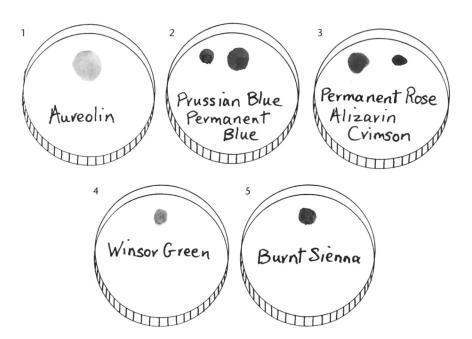

1 Aureolin

2 Prussian Blue
Permanent Blue

3 Permanent Rose
Alizarin Crimson

4 Winsor Green

5 Burnt Sienna

STAGE 1: FIRST WASH

Mask out the light shapes on the boat and the masts using masking fluid and/or drafting tape (tape gives you straight edges).

Using the wet-on-wet technique, lay in the first wash, starting with yellow and rose, followed by Winsor green—especially over the fishing net and surrounding areas—then blues and purples. You don't have to mix the purple separately; just add a touch of permanent rose and alizarin crimson to the blue on your paper and you will have an interesting purple. Leave light areas as indicated in your value sketch. Remember that water will reflect the sky's colors. Dry your painting.

Note: Do not add paint or try to change your original wash once the shine has gone from the paper's surface; otherwise you will get watermarks. If you want to make a change, dry your painting first, then rewet the paper, preferably with a spray bottle, and continue to paint.

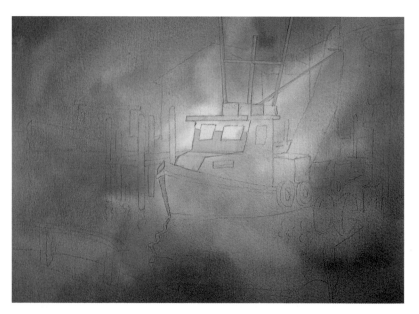

STAGE 2: BUILDINGS AND FOREGROUND

On dry paper, with your board slightly tilted, use your 1" flat brush to lay in the second wash over the building, starting with a watery burnt sienna. Keep a puddle of pigment at the base of the wash and continue downward, modulating colors and values as you go. You will negative paint the shrimp boat, net, and pylons as you paint the buildings adjacent to them. The water will mirror the sky colors, but reflections will be darker in value than the actual image. Dry your painting.

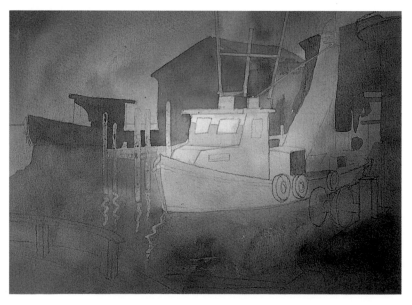

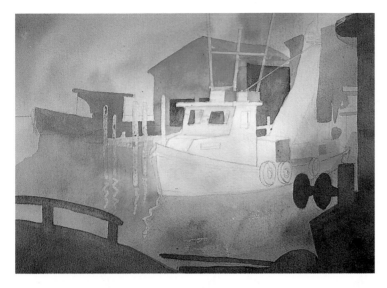

STAGE 3: FOREGROUND AND PRELIMINARY DETAILS

Using your flat brush, paint the dark, solid boat shapes in the foreground. This will immediately give a sense of depth.

Next, paint the dark, rusty shadowed shapes of the buildings.

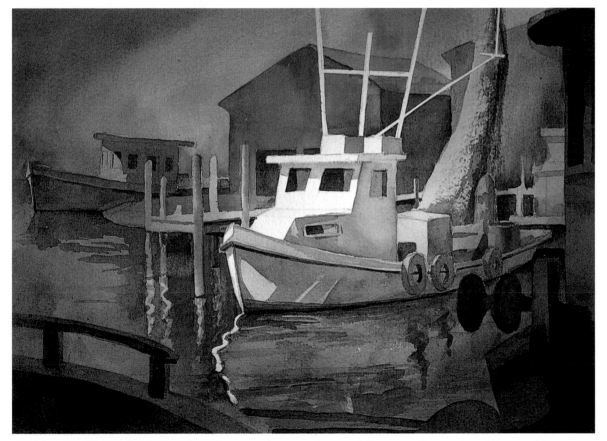

STAGE 4: DARKS AND FURTHER DETAILS

The shadows on the boat can be a neutral gray leaning toward your sky color. Negative paint pylons under the pier by painting the water around them darker. Edges in the reflections will be wavy because of movement in the water. Refer back to the section on reflections to refresh your memory about their behavior.

Continue to add more details in the middle ground and background. You can add as much or as little detail as you like. Always bear in mind that sharp-edged color and value contrasts draw attention. Where do you want your focal point to be? I didn't paint the boat's name on the bow, since words draw the eye and would have

distracted the viewer from noticing the rest of the painting, especially the subtle shadows on the boat.

Drybrush the shadow side of the net to imply texture. Dry your painting. Remove masking fluid and drafting tape.

Paint a dark, angled line along the bottom of the hull to really make your boat rest on the water. Movement, reflection, and ripples in the water can be loosely portrayed with your rigger brush. Merge edges with the other ripples if necessary. You may want to slightly darken the white reflection cast by the bow.

Details on foreground boats can be indicated with just a few extra dark shapes.

COMPOSITION

The artist, through an involved process, creates a painting. The viewer scrutinizes the created painting. Both the artist and the viewer are intrinsically bound, for the artist uses a work of art to convey an idea or vision to a viewer, who then reacts to the stimulus, which is the painting. The message of the painting is conveyed through the artist's use of compositional guidelines.

Composition is the process of putting together several elements so as to make a unified statement, or gestalt. In this chapter we will explore aspects of composition, including format and principles and elements of design.

FREEWAY I, 40 × 60" (101.6 × 152.4 cm).

From Concept to Execution

Sometimes an artist conceives of an idea, such as the passage of time, and then decides what symbolism to use to convey this idea. Most often you, as an artist, are moved to make a painting because an idea for a subject, such as an amaryllis, appeals to you and you want to communicate the spirit or essence of that subject to your viewers. Following the initial stage comes consideration of how to portray the subject and how best to communicate your *concept*. Will you use recognizable or abstract symbols to convey your idea? The wealth of associations and the complexity of emotions connected with recognizable symbols lead me to favor them. However, I can appreciate the fascination of creating a painting through which the eye can wander as the mind imagines. Either approach starts with the artist's ability to portray form.

BASIC PRACTICAL CONSIDERATIONS

Having chosen a subject and decided whether you will use recognizable or abstract symbols for your painting, you then have to make the following practical decisions:

- *Format.* What configuration will best convey your idea? Does your painting need to be large or small? Horizontal, vertical, square, or even round?

To accommodate the expansive size of the subject of *Freeway I,* the painting on the facing page, I chose a large format of 40 × 60". For an intimate painting such as *Heartfelt,* below, a very small format is appropriate.

- *Paper.* Which paper is most suited to conveying your idea? Will it be smooth (hot-pressed), as used for the egg study in the ovoid chapter, or textured (rough), as

used for the jagged rock study in the pyramid chapter?

- *Viewpoint.* Viewpoint is significant. If you want to convey drama, you might try a closeup view of your subject seen from an angle that calls for three-point perspective, as in *Freeway I.* If you want to convey peace, a distant viewpoint may be more appropriate, as in the plowed field study in the cube chapter.

HEARTFELT, 11 × 7"
(27.9 × 17.8 cm).

TYPES OF COMPOSITION

Once your practical decisions about format, painting surface, and viewpoint have been made, next you have to consider the type of composition you will utilize. What do you need to create a unified image, or *gestalt*?

There are two main types of composition, though usually each will contain a mitigating element to prevent monotony. A *symmetrical* composition is one that is balanced and feels stable, enduring, and formal. Symmetrical compositions can be vertical, horizontal, cruciform (cross-shaped), or any balanced, centripetal configuration. An example of a symmetrical composition is Shirley Sterling's *Nautilus,* in which the round nautilus is set within a square placed in the exact center of the picture format.

An *asymmetrical* composition is one that is set off center, unbalanced, and exciting. Diagonals placed off center epitomize an asymmetrical composition. Few compositions are totally asymmetrical, since balance is a requirement to satisfy the viewer. An example of asymmetry is *A Day at the Zoo,* below. The dominant pond shape is a diagonal set asymmetrically off center, but the vertical human figures lend stability and make this a very satisfying composition. At the outset you need to ask yourself, "Do I need symmetry or asymmetry to convey my idea for the subject?"

ELEMENTS OF DESIGN

There are six important elements of design, or component parts, to help you achieve successful composition. We have utilized them in paintings throughout the book; now review them and ask yourself how to make them work for you. The mnemonic SCVLTS, made from the first letter of each of the six terms, will help you remember the elements:

- *Scale.* Will the shapes be large or small? What size best conveys my idea? The use of scale is interesting in *Wabash Feed,* facing page. The chickens are large, yet because of the strength of the lettering on the building and the way the animals are woven into the composition, they do not totally overpower the building.
- *Color.* What colors are best suited to convey my idea? Will I use

Shirley Sterling, **NAUTILUS,** 21 × 21" (53.3 × 53.3 cm).

A DAY AT THE ZOO, 15 × 22" (38.1 × 55.9 cm), collection of Mr. and Mrs. Benjamin Aderholt.

138

WABASH FEED, 22 × 30"
(55.9 × 76.2 cm).

Marianne Starbird, STARBURST II,
22 × 30" (55.9 × 76.2 cm).

warm or cool colors, bright or neutral? Warm colors, such as reds and yellows, express heat and power; cool colors, such as blues, express mystery and depth; bright colors express joviality; neutral colors express pensiveness.

- *Value*: Will the painting be high key or low key, light or dark?

How will I design the overall pattern of lights and darks?

- *Line*. Will the lines be straight or curved? Will I utilize lines at all? *Starburst II*, above, by Marianne Starbird, illustrates the use of line to guide the viewer's eye to the focal point.

- *Texture*. Does the subject require the use of a particular texture

such as smooth or rough to create a mood?

- *Shape*. How can I use the underlying abstract shapes created by value or line to guide the viewer to perceive what I wish to convey? Do the forms, the three-dimensional objects, make pleasing shapes when portrayed in two dimensions on paper?

PRINCIPLES OF DESIGN

Having decided how you will use these six elements of design, you can now consider how to apply to them certain basic principles to achieve a gestalt. These principles of design seem to describe simple, satisfying, and constant human responses to visual stimuli. They guide your use of elements of design. The main principles, which the mnemonic BLVDM will help you remember, are:

- *Balance.* Viewers need balance to feel a state of order and harmony. This can be achieved by repeating or creating a sequence of one or more elements of design. An example of this appears in the painting *Ginning at Damon,* top right, in which the top horizontal of the cotton gin is balanced by the horizontal ground plane. (For this painting I was sitting on the ground so close to the flying, pungent cotton that I had to wear a mask!)
- *Limitation.* There must be some limitation of diversity if the viewer is to be satisfied; too much variety results in confusion. Mary Jane Carpenter makes effective use of this principle in her painting *Still Life with Dutch Iris II,* bottom right, by limiting the number of colors and their ranges, as well as the number of shapes so she makes a strong statement.
- *Variety.* To break the monotony of too much order, we must create variety in our use of the elements of design. In her painting *The Blue Coffee Pot,* facing page, Judy Richardson Gard has achieved this by varying the size, shape, color, and value of the symbols in her composition.
- *Dominance.* Variety and balance can be made more acceptable if one aspect is dominant. Viewers need to be guided in one direction.

When Winston Wheeled, at top right on the facing page, illustrates the principle of dominance in the use of the elements of shape (round) and color (yellow) to convey the heat of action.

- *Movement.* To keep the viewer entertained and forestall boredom, you must devise a way to move his or her eye through a composition. *Astros Glory,* at bottom on the facing page, painted in a moment of enthusiasm when the team won the pennant, exemplifies the principle of movement. Here the players move centripetally,

GINNING AT DAMON, 22 × 30" (55.9 × 76.2 cm).

Mary Jane Carpenter, **STILL LIFE WITH DUTCH IRIS II,** 22 × 26" (55.9 × 66.0 cm).

Judy Richardson Gard, **THE BLUE COFFEE POT**, 30 × 22" (76.2 × 55.9 cm).

WHEN WINSTON WHEELED, 30 × 22" (76.2 × 55.9 cm).

leading the eye to the center of the composition where the main interest, the ball and bat, are placed.

You can test the principles of design as you use two or more elements. Ask yourself, "Have I applied *scale, color, value, line, texture,* and *shape* according to the design principles *balance, limitation, variety, dominance,* and *movement* so my viewers are satisfied and my composition is unified?"

Even more important than compositional guidelines is your idea, your vision, your emotional response to a subject that you want to convey to the viewer. Composition gives you, the artist, the means to stimulate a response from the viewer who surveys your work, your watercolor painting.

ASTROS GLORY, 22 × 30" (55.9 × 76.2 cm).

141

Where Do You Go from Here?

So. You are conversant with watercolor materials and techniques, with form and composition. You are in a position to dispel the myth that painting in watercolor is "too hard." You now have learned it right—from the start. Where do you go from here?

First of all, you need to practice. Much knowledge about seeing, drawing, and painting in watercolor is lost unless you put it to frequent use. I recommend setting aside a time and place each day to paint. At first you will have to push yourself as you procrastinate, making yourself yet one more cup of coffee before you start. But once you become involved, the painting will draw you along and you won't want to stop. I encourage my students to bring energy and enthusiasm to painting. If you have to push yourself too much, or if you become bored, then start another painting and try another approach so you maintain enthusiasm.

Encouragement is another vital part of the learning process. Part of my job as a teacher is to help students find the spark of life and originality in their paintings that will encourage them to strive for more. I extend the classroom process and set assignments to encourage progress, for it is perseverance and practice that ensure a successful outcome and make an accomplished painter.

The goal of entering paintings in shows often spurs the student into action. I recommend this approach simply because it challenges you and raises the level of your work to new heights. However, once you have attained reasonable proficiency in the medium, whether or not a painting is accepted in a show or wins an award is largely based on the taste of the juror. Thus I advise my students to be neither too ecstatic if a painting is accepted or wins an award, nor too depressed if a painting is rejected. You have already achieved your goal, because you raised the standard of your work by deciding to enter in the first place.

What is it that motivates students to learn to draw and paint? For some it is a course of study they have decided to take at a university or community college because of an early positive experience in the field. For others it is the relaxation and the feeling of well-being brought about by the process of painting. I had one student who would say, "This is my therapy session." There are many who, like her, come to class to learn what they can in a relaxed setting, and every so often produce a painting with which they are pleased. They come to experience the happiness of art. To paraphrase the great teacher Robert Henri, there is an artist in every man, and the happiness of creation is as much his right and as much his duty to himself as it is the full-time artist's.

What is it that motivates the few who, having learned all they can from books, classes, and workshops, are compelled to achieve even greater, unique artistic expression? Perhaps the desire stems from a need to experience the exhilaration of creation and the timeless quality that makes a life more complete. If you have to paint, you have to paint. That is what painting is all about. That is the essence of art.

THE OPEN HEART, 22 × 27" (55.9 × 68.6 cm), private collection.

 # *Index*